In the Light of Italy
Corot and Early Open-Air Painting

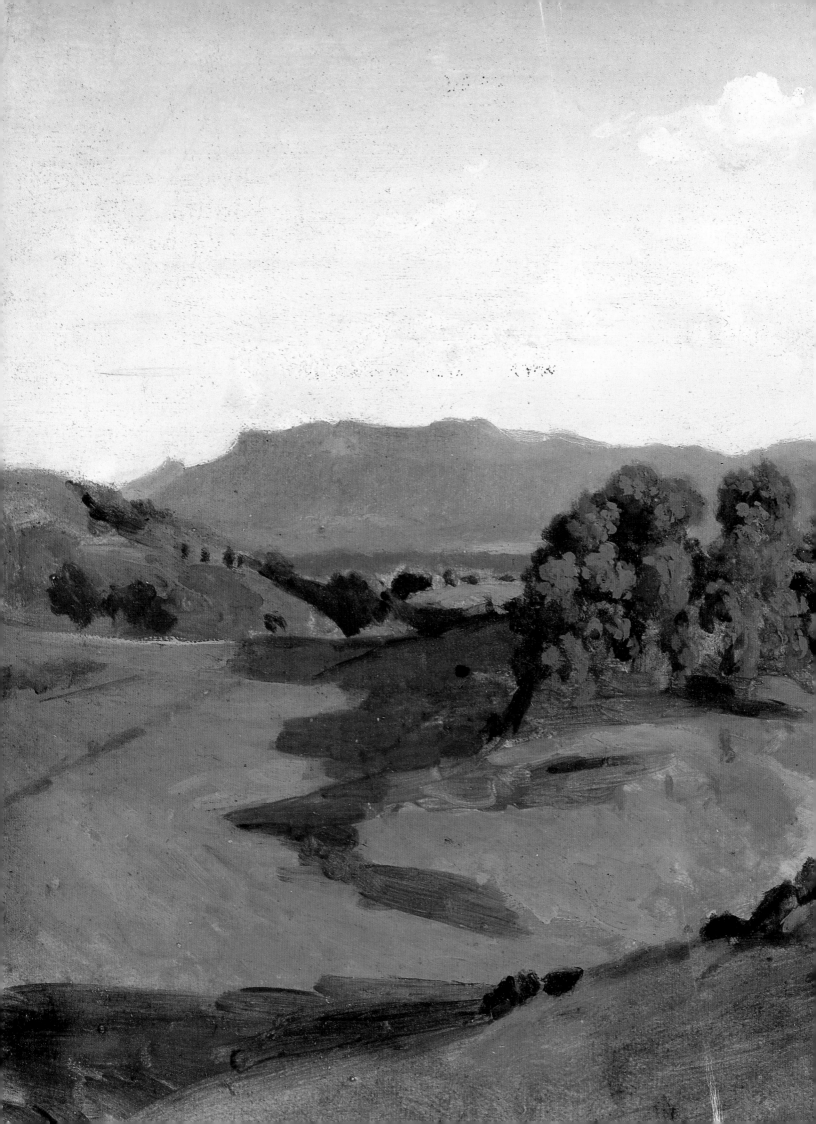

In the Light of Italy

COROT AND EARLY OPEN-AIR PAINTING

Philip Conisbee

Sarah Faunce

Jeremy Strick

WITH

Peter Galassi, guest curator

NATIONAL GALLERY OF ART, WASHINGTON

YALE UNIVERSITY PRESS, NEW HAVEN AND LONDON

*The exhibition in Washington and Brooklyn is made possible
by a grant from The Florence Gould Foundation*

The exhibition was organized by the National
Gallery of Art, Washington in association with
the Brooklyn Museum and the Saint Louis Art
Museum

The exhibition is supported by an indemnity from
the Federal Council on the Arts and the
Humanities.

In Brooklyn, funding has been provided by the
National Endowment for the Arts, a federal
agency.

EXHIBITION DATES

National Gallery of Art, Washington
26 May–2 September 1996

The Brooklyn Museum
11 October 1996–12 January 1997

The Saint Louis Art Museum
21 February–18 May 1997

The book was produced by the Editors Office,
National Gallery of Art
Editor-in-Chief, Frances P. Smyth
Editor, Susan Higman
Designer, Chris Vogel

Typeset in ITC and Bitstream Galliard by
WorldComp, Sterling, Va.
Printed on 150 gsm Gardamatt Brillante by
Amilcare Pizzi, S.p.A., Milan, Italy
The clothbound edition is distributed by Yale
University Press

COVER: cat. 90, Corot, *View of St. Peter's and the
Castel Sant'Angelo* (detail), 1826–1828, The Fine
Arts Museums of San Francisco, museum
purchase, Archer M. Huntington Fund

TITLE PAGE: cat. 99, Corot, *Olevano, La Serpentara*
(detail), 1827, Rudolf Staechelin Family
Foundation, Basel

LIBRARY OF CONGRESS
CATALOGING-IN-PUBLICATION DATA
Conisbee, Philip.
 In the light of Italy : Corot and early open-air
painting / Philip Conisbee, Sarah Faunce, Jeremy
Strick.
 p. cm.
 Exhibitions: National Gallery of Art,
Washington, May 26–Sept. 2, 1996; Brooklyn
Museum, Oct. 11, 1996–Jan. 12, 1997; Saint Louis
Art Museum, Feb. 21–May 18, 1997.
 Includes bibliographical references and index.
 ISBN 0–89468–224–5 (paper)
 ISBN 0–300–06794–1 (cloth)
 1. Landscape painting, European—
Exhibitions. 2. Landscape painting—18th
century—Europe—Exhibitions. 3. Landscape
painting—19th century—Europe—Exhibitions.
4. Corot, Jean-Baptiste-Camille, 1796–1875—
Exhibitions. I. Faunce, Sarah. II. Strick, Jeremy.
III. National Gallery of Art (U.S.) IV. Brooklyn
Museum. V. St. Louis Art Museum. VI. Title.
ND1353.4.C66 1996 95-47753
758'.145'09407473—dc20 CIP

Contents

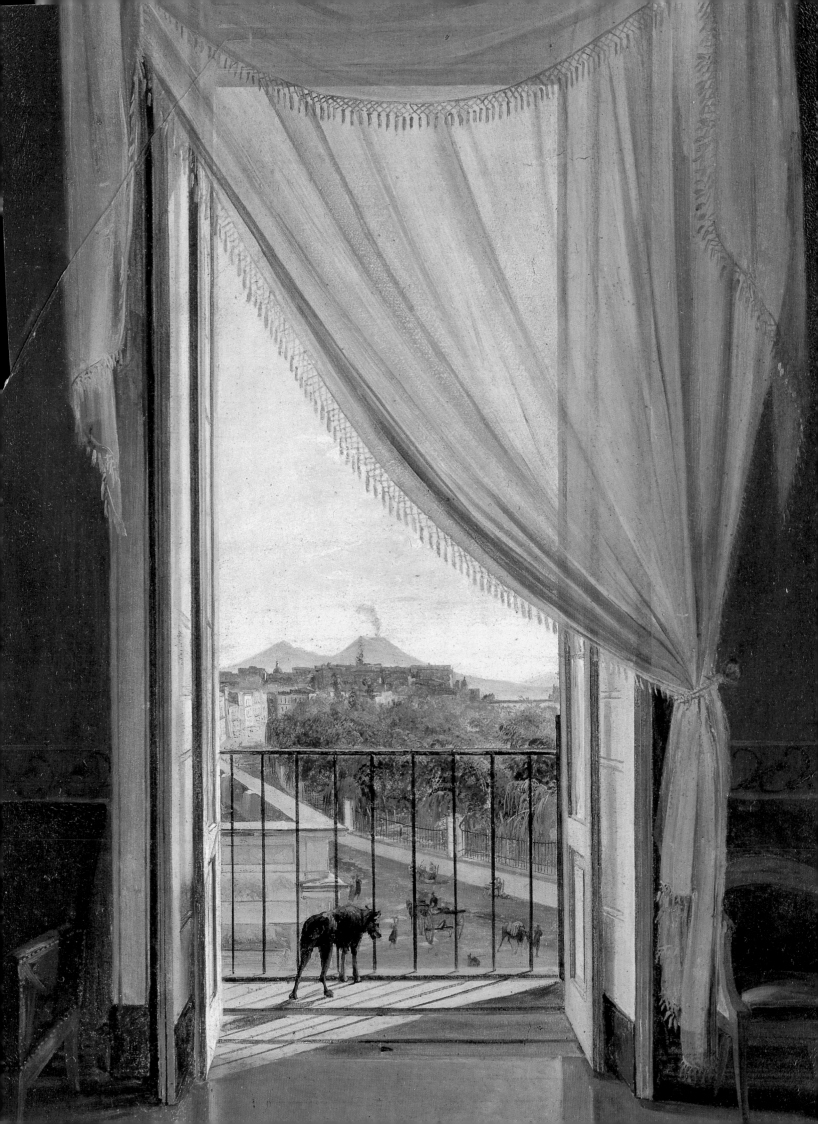

Foreword

*I*n the Light of Italy: Corot and Early Open-Air Painting explores the work of two generations of European artists between about 1780 and 1840, who were the pioneers of painting in oils directly from nature in the open air. These young painters were drawn from many different countries and backgrounds to work in Italy, especially around Rome and Naples, by the rich historical, literary, and artistic traditions embodied in the Italian landscape since ancient times. Their common intentions in working outdoors were to be literally and pictorially as close as possible to nature, in all its untrammeled beauty but also with all its classical associations; it was their inspiration and the primary object of their study. Their aim was to respond as immediately as possible to the scene before them, to avoid conventional ways of seeing, and to fill their works with a sense of open air rather than studio light. However, a surprising element for the modern spectator is that their works were made for private study, as part of the working process, and were not intended for public viewing. Indeed, most of these paintings were virtually unknown outside the artists' immediate circle until their "discovery" in the twentieth century.

By the time that the twenty-nine-year-old Camille Corot made his first trip to Italy in 1825, a tradition of open-air painting was already well established there. This exhibition shows the development of that tradition, from its origins in the work of British and French artists in the 1780s to its maturity in the works of Corot between 1825 and 1828. Corot, his predecessors, and his contemporaries in the open-air tradition anticipated the freshness, immediacy, and sensitivity to changing light and atmosphere of impressionism, as well as the radical compositional innovations of photography.

The exhibition's curator at the National Gallery is Philip Conisbee, curator of French paintings, who has worked jointly with Sarah Faunce, curator of European painting and sculpture at the Brooklyn Museum of Art, and Jeremy Strick, curator of modern art at the Saint Louis Art Museum. Planning for this exhibition began several years ago when Dr. Strick was on the staff of the National Gallery. Guest curator Peter Galassi, chief curator of the department of photography at the Museum of Modern Art in New York, has given invaluable advice on the concept of the exhibition and the selection of works, and has assisted in negotiations with lenders. Each of the curators has contributed an illuminating essay to the catalogue, as has Vincent Pomarède, conservateur au département des peintures at the Louvre, which has been a generous supporter in lending an important group of works by Pierre-Henri de Valenciennes.

In the Light of Italy: Corot and Early Open-Air Painting coincides for some of its duration with the bicentennial *Corot* exhibition organized by the Louvre, The Metropolitan Museum of Art, and the National Gallery of Canada. Cooperation among the

Detail, cat. 79, Catel, *View of Naples through a Window*, c. 1824

7

curators of both exhibitions has assured that they are complementary events, with the present exhibition celebrating an important aspect of Corot's art in the wider context of European landscape painting in his time.

We are very grateful to The Florence Gould Foundation for a generous grant which made the exhibition possible in Washington and Brooklyn. The Brooklyn Museum is pleased to acknowledge support for both planning and implementation from the National Endowment for the Arts. We all thank the Federal Council on the Arts and the Humanities for granting an indemnity for the exhibition. Finally, we are deeply indebted to our many lenders, whose generous cooperation made this exhibition possible.

Earl A. Powell III
Director, National Gallery of Art

Robert T. Buck
Director, The Brooklyn Museum

James D. Burke
Director, The Saint Louis Art Museum

Detail, cat. 71, Dahl, *Scene from the Villa Malta,* 1821

8

Lenders to the Exhibition

Aarhus Kunstmuseum

Mr. Howard F. Ahmanson, Jr.

Angermuseum, Erfurt

Ashmolean Museum, Oxford

Banca Nazionale del Lavoro SpA, Rome

Bayerische Staatsgemäldesammlungen, Munich

Birmingham Museums and Art Gallery

The Brooklyn Museum

The Cleveland Museum of Art

The Fine Arts Museums of San Francisco

The Fitzwilliam Museum, Cambridge

Glynn Vivian Art Gallery, Swansea, Wales

Göteborgs Konstmuseum

Hamburger Kunsthalle, Hamburg

Kimbell Art Museum, Fort Worth

Kunsthalle Bremen

Kunsthaus Zürich

Kunstmuseum Düsseldorf im Ehrenhof

Kurpfälzisches Museum, Heidelberg

Mr. John Lishawa

The Metropolitan Museum of Art

Minorco Services (UK) Limited, London

Musée d'art et d'histoire, Ville de Genève

Musées d'Angers

Musée des Beaux-Arts, Nantes

Musée des Beaux-Arts, Orléans

Musée Granet, Aix-en-Provence

Musée du Louvre, Paris

Museum Boymans-van Beuningen, Rotterdam

Museum of Fine Arts, Boston

Nasjonalgalleriet, Oslo

The National Gallery, London

National Gallery of Art, Washington

National Gallery of Ireland, Dublin

National Museum and Gallery, Cardiff

Nationalmuseum, Stockholm

Niedersächsisches Landesmuseum, Landesgalerie, Hannover

Philadelphia Museum of Art

The Phillips Collection, Washington, DC

The Phillips Family Collection

The Rasmus Meyer Collection, Bergen

Ratjen Foundation, Vaduz

Ribe Kunstmuseum

Rudolf Staechelin Family Foundation, Basel

Statens Museum for Kunst, Copenhagen

Staatliche Kunsthalle Karlsruhe

Staatliche Museen Kassel, Neue Galerie

Staatliche Museen zu Berlin, Preussischer Kulturbesitz

Städtische Kunstsammlung Darmstadt

Stanford University Museum of Art

Tate Gallery, London

Von der Heydt-Museum, Wuppertal

Private collections

Detail, cat. 33, Denis, *View on the Quirinal Hill, Rome,* 1800

Among the many lenders and others who have helped in special ways, we would like to thank Colin Anson, London; Marie-Madeleine Aubrun, Paris; Jörn Bahns, Heidelberg; Joseph Baillio, New York; Pierre Caillau-Lamicq, Paris; Faya Causey, Washington, D.C.; Anna Ottani Cavina, Bologna; Denis Coutagne, Aix-en-Provence; Jean-Pierre Cuzin, Paris; Sabine Fehlemann, Wuppertal; Ormilla Francisi-Osti, Rome; Charlotte Gere, London; Christoph Heilmann, Munich; Marianne Heinz, Kassel; Hugh Honour, Lucca; Andreas Kreul, Bremen; John Leighton, London; Helmut Leppien, Hamburg; John Lishawa, London; Bruce and Angelika Livie, Munich; James McKinnon, London; Olivier Meslay, Paris; Eric Moinet, Orléans; Peter Nathan, Zürich; Anne Norton, New York; Francesco Petrucci, Ariccia; Vincent Pomarède, Paris; Gottfried Riemann, Berlin; Joseph Rishel, Philadelphia; Charles Rosen, New York; Matthew Rutenberg, New York; Peter-Klaus Schuster, Berlin; Carl Strehlke, Florence; Stefano Sussini, Rome; Bernard Terlay, Aix-en-Provence; Gary Tinterow, New York; Wheelock Whitney III, New York; Guy Wildenstein, New York; and Henri Zerner, Cambridge, Massachusetts.

At the National Gallery of Art we thank D. Dodge Thompson, chief of exhibitions, and Ann Bigley Robertson, exhibition officer, who was assisted by Jennifer Fletcher; Sally Freitag, chief registrar, and Michelle Fondas, assistant registrar for exhibitions; Gaillard Ravenel, senior curator and chief of design, Donna Kwederis, design coordinator, and John Olson, production coordinator; Frances P. Smyth, editor-in-chief, Susan Higman, editor, Chris Vogel, designer and production manager, and Jennifer Wahlberg, production assistant; Susan Arensberg, head, and Isabelle Dervaux, assistant curator, in the department of exhibition programs; Sara Sanders-Buell, coordinator for photography requests; Marilyn Tebor Shaw, associate general counsel; Nancy Hoffmann, treasurer's office; Laura S. Fisher and Melissa McCracken, development office; Kate Haw, departmental assistant, Florence Coman and Kimberly Jones, assistant curators, CAA Professional Development Fellow Eik Kahng, and Felicia Rupp and Katherine Hamm, summer interns, in the department of French paintings; Linda Johnson and Sara Kuffler, former assistants, department of twentieth-century art; Neal Turtell, executive librarian.

At the Brooklyn Museum we thank especially Sylvain Bauhofer of Lausanne, department intern and indefatigable researcher; Elizabeth Easton, associate curator, European paintings and sculpture; Maureen Cross and Elaine Cohen, departmental assistants; Dorothy Ryan, manager of grants; Elaine Koss, vice director for publications; Ed Lai, designer; Tina Lauffer, graphic designer; Elizabeth Reynolds, registrar;

Sally Williams, public information officer; Dean Brown, photographer; Sarah Himmelfarb, acting vice director for development; Deborah Schwartz, vice director for education; Dierdre Lawrence, principal librarian; Carol Long, library cataloguer.

At the Saint Louis Museum we wish to thank Sidney Goldstein, associate director; Nick Ohlman, registrar, and staff; Jeanette Fausz, assistant registrar; Dan Esarey, building operations, and staff; Larry Herberholt, engineering; Jeff Wamhoff, designer; Jim Weidman, director of development; Judy Wilson, assistant director of development; Mary Ann Steiner, editor; Susan Rowe, administrative assistant; Theresa Bondurarn, intern; and Stephanie Sigala, librarian.

There is nothing comparable in beauty to the lines of the Roman horizon, to the gentle slope of its planes, to the soft, receding contours of the mountains by which it is bound. The valleys in the Campagna often take the form of an arena, a circus, a hippodrome; the hills are carved like terraces, as if the mighty hand of the Romans had moved all this earth. An extraordinary haze envelopes the distance, softening objects and concealing anything that is harsh or discordant in their forms. Shadows are never heavy and black; no mass of rock or foliage is so obscure that a little light does not always penetrate. A singularly harmonious tint unites earth, sky, and water: all surfaces, by means of an imperceptible gradation of colors, coalesce into their extremes without one being able to determine the point at which one nuance ends or where the other begins. You have, no doubt, admired in the paintings of Claude Lorrain this light which seems ideal and more beautiful than nature itself? Well, that is the light of Rome![1]

Chateaubriand, 1804

In the 1850s and 1860s, painting landscapes in oils directly from nature moved from the margins of artistic activity to become a central creed and practice for many radical young European painters. In England around 1850, the Pre-Raphaelites attempted to render every blade of grass with almost scientific precision, and introduced a sensation of outdoor light into their works by painting on canvases prepared with white grounds. In France in the 1860s, the early impressionists also painted on light-toned grounds and worked in the open air, but with more spontaneous and sketchy brushwork to convey the transient light and atmosphere of a particular moment. For these artists, a work painted in the open air, whether minutely or brushily executed, was something complete in itself, ready for public exhibition and hopefully destined for the walls of a sympathetic collector. However different their final products were, these advanced young painters shared several common goals: to be literally and pictorially as close as possible to nature; to avoid traditional methods of representation; and to replace the conventional illumination of the studio with the natural daylight of the outdoors.

These later artists legitimized painting in the open air, and in time saw their works accepted both on a critical level and in the marketplace. But they were by no means the first to practice painting in the open air. For two generations before them artists had been setting off into the countryside and painting extraordinarily fresh landscapes on the spot, illuminated by the natural light of the sky. But for these earlier generations of artists, the direct study of nature was merely part of the working process, the results of which were intended to be seen only by the painters themselves, their friends, and perhaps students. Their freely painted oil sketches, executed "sur le motif,"

Detail, cat. 85, Corot, *View of the Roman Campagna,* 1826

as Paul Cézanne would later say, were not considered finished works, but rather studies through which a painter trained hand and eye in matching his palette with all of nature's effects, and in the process acquired and recorded the knowledge of a particular place and moment in time.

The open-air paintings of these artists, active during the sixty years between 1780 and 1840, are the subject of this exhibition. Italy is the focus, because it was there that a tradition of open-air painting developed in the later eighteenth and the early nineteenth centuries. This tradition grew over a period of time and involved the activities and inventions of many artists from different parts of Europe, who began coming to Rome in increasing numbers in the 1780s. These were artists who, for the most part, had a primary interest in landscape painting, and who spent the majority of their time there making drawings and oil studies in the numerous sites in and around that city, as well as in the region of Naples. Part of the Italian experience was meeting and exchanging ideas and information with those who had been there before them. By the time Corot arrived in Rome, in 1826, the tradition was at its peak, enabling him to learn what he needed to know without any waste of time. His own contribution to the tradition, which proved to be its high point, is represented here by twenty of his finest paintings made during his first visit to Italy. That Corot is the most widely known and respected open-air painter of the early nineteenth century is partly a result of his ability to maintain that tradition when he returned to France, where his work as a landscape painter remained solidly based on the practice of outdoor painting. This exhibition brings together works by Corot and other artists who contributed to this tradition.

Although the art of Edgar Degas (1834–1917) was produced well outside the date limits of the present exhibition, he was the one impressionist painter to make the conventional trip to Italy in his youth. There, in the mid-1850s, he painted a handful of exquisite open-air landscapes in thinned-down oils on prepared paper, such as *Italian Landscape Seen through an Arch* (fig. 1), which form a coda to the Italianate tradition and a bridge to the generation of the impressionists.[2] Indeed, Degas expressed his admiration for Corot by collecting no less than seven of his paintings, including the open-air sketch *The Roman Campagna with the Claudian Aqueduct* (cat. 88).

The works in this exhibition betray different degrees of finish. But all of them, whether sketchy or more finished, share a sense of immediacy and a vitality that come from the close relationship between the painter's visual experience of nature and the rendering of it, the finding of a match or equivalent for the engagement in "the oleous paste in its sticky inconvenience."[3] The descriptive and expressive possibilities of oil paint are quite distinct from those of drawing, because the paint conveys color at the same time; they are also distinct from watercolor, because oil paint has real substance and physicality, enabling the painter to apply "the touch that not only describes but associates the material of paint with the liveliness of the world."[4] Many of these paintings are unequivocally oil *sketches*, rapidly noted on prepared, light-toned paper, which would have fit easily into the lid of a painting box, which usually also served as a portable easel. Corot's brushy and rather informal *The Tiber near Rome* (cat. 104) or his *View of the Roman Campagna* (cat. 85) are of this type. Also included in the exhibition are some more highly finished pictures, which are, however, small in scale and usually painted on canvas. They are more precisely executed than the sketches, but nevertheless may have been begun outdoors and completed in the studio—or begun in the studio on the basis of a drawing made from nature but completed in oils in the

fig. 1. Edgar Degas, *Italian Landscape Seen through an Arch*, 1856, oil on paper, mounted on canvas, 37 × 32 cm. Private collection.

open air, as was the practice of Christoffer Wilhelm Eckersberg (cats. 54–57). Corot's carefully meditated pendants *View of St. Peter's and the Castel Sant'Angelo* and *Island of San Bartolommeo* (cats. 90–91) fall into the category of small finished pictures, surely considerably worked in the studio, although his style is always more painterly and less precise than that of Eckersberg.

Rome, the surrounding Campagna, and the nearby hill towns are the chief topographical points of this exhibition, because Corot and many other artists followed fairly well-beaten paths to those places. The natural beauty of Italy had been sanctioned by literary and artistic traditions since antiquity, and for the educated visitor in the eighteenth and nineteenth centuries, these associations, as well as historical ones, were part of the attraction.

A lively expression of these sensations and memories of nature, art, and history appear in the journal of the Welsh painter Thomas Jones, a remarkable sketcher in oils of the Italian scene (cats. 7–13) and a pupil of Richard Wilson, also represented in this exhibition (cat. 1). After returning from a walking tour of the ancient towns in the Alban Hills, near Rome, Jones recorded:

We then continued Our route through *Marino*, through, *Castello Gondolfo, L'arici* and arrived at *Gensano* in the Evening—This walk considered with respect to its classick locality, the Awful marks of the most tremendous Convulsions of nature in the remotest Ages, the antient and modern Specimens of Art, and the various extensive & delightful prospects it commands is, to the Scholar, naturalist, Antiquarian and Artist, without doubt, the most pleasing and interesting in the Whole World—And here I can not help observing with what new and uncommon Sensations I was filled on first traversing this beautiful and picturesque Country—Every scene seemed anticipated in some dream—it appeared Magick Land....[5]

Charles-Nicolas Cochin, giving advice to young French artists setting off for Italy in the 1770s, encouraged them to work out-of-doors there:

In Italy nature is so beautiful and so picturesque, that you must take advantage of your stay to study a variety of things, landscape and architecture among them....It was through such efforts that Monsieur Vernet was able to make nature so familiar to us. Despite the difficulties of always having the necessary equipment at hand, he has always painted directly from nature.[6]

In the first and second decades of the nineteenth century, oil painting from nature became a more common practice throughout Europe and often developed independently from the Italianate tradition: for example, in England in the work of J. M. W. Turner and John Constable, or in Denmark in the work of Christen Købke. A pioneering exhibition in 1969, *A Decade of English Naturalism, 1810–1820*,[7] explored English open-air painting with special reference to the work of Constable and Turner, who were working at a time when British artists were insulated from the Continent by the Napoleonic wars. Indeed, Britain's virtual isolation from Europe in the mid-1790s until Napoleon's defeat in 1815 fostered native painting to the extent that the British contribution to this exhibition is quite limited.

Two other exhibitions in 1980 and 1981 explored the theme of open-air painting: *Painting from Nature: The Tradition of Open-Air Oil Sketching from the 17th to the 19th Centuries* took a broad view of the subject,[8] and *Before Photography: Painting and the*

LEFT: fig. 4. Carl Johan Lindström, *The Italian Painter*, 1828–1830, pencil and watercolor on paper, 14.9 × 10.9 cm, inscribed "Più presto di me, non farà nessuno." Nationalmuseum, Stockholm.

RIGHT: fig. 5. Carl Johan Lindström, *The English Painter*, 1828–1830, pencil and watercolor on paper, 14.9 × 10.9 cm, inscribed "The effect I am sure of, when I first have the lineaments." Nationalmuseum, Stockholm.

Invention of Photography took a narrower and deeper look at the influence of open-air painting on the earliest photographers.[9] Collectors, led by the late John Gere, were becoming interested in what was still a byway of the history of art, while dealers such as Jack Baer and Wheelock Whitney played an important role in the formation of taste through exhibitions such as *The Lure of Rome* in 1979.[10] A 1990 exhibition in Berlin on Carl Blechen presented that leading Romantic painter in a wider German and even European context, and revealed especially the work of a number of less well-known German artists who, like Blechen, made landscape sketches in oil during their trips to Italy in the early decades of the nineteenth century.[11] The most complete and scholarly study of open-air painting to date is Peter Galassi's *Corot in Italy*, published in 1991, which has largely inspired our exploration of the tradition that Corot found in place on his arrival in Italy.[12]

Since the seventeenth century, Rome had been the meeting place for artists and other international visitors. The second half of the eighteenth century saw an even greater influx of foreign artists and tourists that continued into the next century. Broadly speaking, however, each national group tended to keep to itself. In the 1820s, Ludwig Richter was painting and drawing at Tivoli with a group of German artists, delineating nature as precisely and objectively as possible. On the arrival of some French artists, the Germans were struck by the contrasting approach of the Frenchmen, who sketched broadly in oils using large brushes, rendering nature in a more dramatic and generalized style.[13] This perception of even open-air work as having definable national characteristics is confirmed in a set of caricatures made by the Swedish artist Carl Lindström, where the Frenchman looks for drama in nature (fig. 2), the German seeks precisely observed detail (fig. 3), an Italian paints too rapidly and superficially (fig. 4), and the English artist is interested only in general "effect" (fig. 5).[14]

British, French, and German artists tended to stay within their own national groups, although there are some notable exceptions. In the nineteenth century Germans and Danes associated with each other, united by their common Baltic heritage, their *lingua franca* of German, and also by the sphere of influence and patronage around the Danish sculptor Bertel Thorvaldsen, the most famous northern European artist in Rome during his long residence there from 1796 to 1838. When François-

Marius Granet arrived in the city in 1801, he sought the advice of the Belgian painter Simon Denis, who in any case was close to the French community because he had studied art in Paris before commencing his stay in Rome in 1786. The Swedish painter Söderberg struck up a friendship with Achille-Etna Michallon in Rome, and together the two traveled to Sicily. On several occasions they sat down and painted the same sites. Painting studies from nature had been an integral part of Michallon's artistic education with Valenciennes. For Söderberg it was a novelty but only a pleasant diversion during the relative freedom of his time in Italy. There was neither occasion nor tradition in Sweden for such open-air work, and Söderberg did not continue the practice after he returned home in 1821.[15] Corot met the German Ernst Fries at Civita Castellana in 1826, when Fries made a drawing showing the Frenchman sitting and musing on his portable sketching stool.[16] These and other acquaintances are mentioned in the brief biographies of the artists in this catalogue.

For northerners who made the trip south of the Alps, there was a sense of both artistic and personal freedom, but for some artists, the freedom of life in Rome was a mixed blessing. Eckersberg, for example, expressed his complicated emotions in a letter to a friend in Copenhagen, describing the exhilaration of this liberation. At the same time, he missed a sense of responsibility and was depressed and bored by the moral indifference engendered by his situation abroad:

> As an artist and a foreigner here you have all possible advantages, because you live in the greatest freedom and can do or leave what you will, so it follows that you must be happier here than anywhere else. But because of that you must be indifferent to everything or else a complete egoist; I have never in my entire life had such a boring and disagreeable time than the past two years I have spent here; one is not always happy to live without cares and without any personal concerns; my happiest hours have been when I run out into the open air to paint a little, with my paintbox and stool under my arm, to paint after nature.[17]

Painting from nature was essentially a private act. The studies and sketches in this exhibition rarely contain figures: the artist himself is the figure in the landscape, so to speak, giving it an immediate, even urgent presence. We as spectators are also granted that privileged role. Although conceived for private reference, as quasi-scientific studies, as means to an end, or as mere exercises, these oil sketches, studies, and occasional small finished landscapes exert a strong appeal. Many modern viewers will prefer them to the more finished and monumental studio works to which most of their creators attached greater artistic and financial value. They offer a more immediate sensation of nature and therefore convey a more authentic experience. These studies retain some of the moral resonance that was present when they were done. For Valenciennes, a painter's excursions into the open air were both morally uplifting and delectable experiences, "where the pure air and the spectacle of nature at once simple and noble elevate the mind and produce delicious sensations."[18] There is nothing like being out-of-doors just after a storm, when everything takes on a new life and "the birds seem, by their chirping, to be thanking the Supreme Being and singing the marvels of nature."[19] Citing the example of Jean-Jacques Rousseau's novelistic hero Émile, Valenciennes states that the landscape painter should travel on foot, not by carriage, "leaving this luxury to the rich ignoramuses who travel the world like trunks and who,

closed up in their vehicles, only see the country they are passing through as if in a magic lantern, framed by their doorway."[20]

Through the immediacy and authenticity of their experience, the early open-air painters have entered the mythology of the heroic struggle of modern art in its quest for originality and unity of feeling and expression. It is no accident that Lionello Venturi, the scholar of impressionism and author of the catalogue raisonné of Cézanne's paintings, felt compelled to write an article on the open-air studies of Valenciennes.[21] Lawrence Gowing's moving tribute to an admired fellow artist, in a memorable lecture on Thomas Jones, who represented to Gowing "individuality in its primal state,"[22] is perhaps the finest and most Romantic example of this assimilation of these artists and their open-air work into the history of our own sensibility. PC, SF, JS

Notes

1. Chateaubriand 1951, 6–7: "Rien n'est comparable pour la beauté aux lignes de l'horizon romain, à la douce inclinaison des plans, aux contours suaves et fuyants des montagnes qui le terminent. Souvent les vallées dans la campagne prennent la forme d'une arène, d'un cirque, d'un hippodrome; les coteaux sont taillés en terrasses, comme si la main puissante des Romains avoit remué toute cette terre. Une vapeur particulière, répandue dans les lointains, arrondit les objets et dissimule ce qu'ils pourroient avoir de dur ou de heurté dans leurs formes. Les ombres ne sont jamais lourdes et noires; il n'y a pas de masses si obscures de rochers et de feuillages, dans lesquelles il ne s'insinue toujours un peu de lumière. Une teinte singulièrement harmonieuse, marie la terre, le ciel, et les eaux: toutes les surfaces, au moyen d'une gradation insensible de couleurs, s'unissent par leurs extrémités, sans qu'on puisse déterminer le point où une nuance finit et où l'autre commence. Vous avez sans doute admiré dans les paysages de Claude Lorrain, cette lumière qui semble idéale et plus belle que nature? eh bien, c'est la lumière de Rome!"
2. See Kendall 1993, especially 14–28.
3. Gowing 1985, 3.
4. Gowing 1985, 4.
5. Jones 1951, 55.
6. Cochin 1774.
7. Gage 1969.
8. Conisbee and Gowing 1980.
9. Galassi 1981.
10. Whitney 1979.
11. Schuster 1990.
12. Galassi 1991.
13. Richter 1985, 99.
14. Jungmarker 1934, 84–85, figs. 45–48.
15. See the biography of Söderberg, below, and Gunnarsson 1989, 232–239, summary in English, p. 303.
16. Dresden, Staatliche Kunstsammlungen; reproduced, Galassi 1991, frontispiece.
17. Christoffer Wilhelm Eckersberg in Bramsen 1974, 78.
18. Valenciennes 1800, xxiii.
19. Valenciennes 1800, 627.
20. Valenciennes 1800, 426–427.
21. Venturi 1941, 89–109.
22. Gowing 1985, 7.

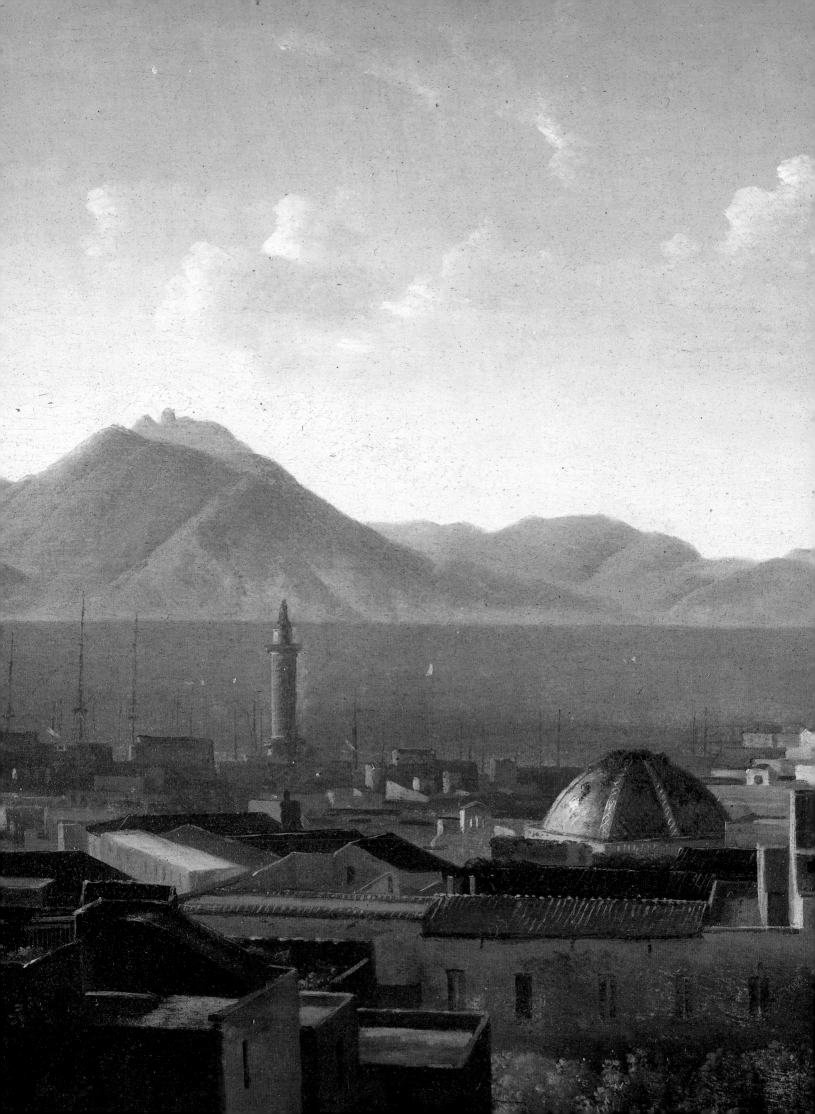

A Tribute to J. A. Gere

PETER GALASSI

J ohn Gere died in London in January 1995, at the age of seventy-three. Were he still living you would be reading his words instead of mine, for he had agreed to write an essay for this catalogue. It was to have been a general introduction, cast as the story of the progressive discovery of early open-air painting as a coherent episode in the history of art.

John was uniquely qualified to write such an essay, because he had played a key role in the story. This turned out to be a problem, however, for his deeply inquisitive mind was drawn to virtually all subjects except modern technology, its commercial applications, and himself. In a typical passage of self-deprecation, he once wrote in a letter, "as you must have realized, I am not an *art historian* at all, but, rather, a dilettante enthusiast." When pressed by friends and by Charlotte Gere, his wife and partner in oil-sketch connoisseurship, John made an effort to include himself in the essay. The discomfort this caused him is palpable in the following sentence from the resulting draft: "It is difficult to reconstruct the growth of a spontaneous change of taste except by the unavoidably egotistic and inevitably incomplete method of recalling my own experience."

John's underscoring of the term "art historian" was indeed self-deprecating, but it was also a disparagement of modern professional specialization. That may seem odd, coming as it did from a celebrated connoisseur of Italian drawings and distinguished former Keeper of Prints and Drawings at the British Museum. The disparagement was quite sincere, however, and well justified. John's vast erudition dismissed the strictures of academic scholarship as petty impediments to his curiosity. That curiosity, together with a loving respect for the unique objecthood of works of art and a mischievous affection for objects that scholarship had overlooked, led John to make an original and lasting contribution to the appreciation of early open-air painting.

He did it above all by collecting. Eventually he and Charlotte assembled a splendid collection of more than eighty small landscape studies in oil (several of which Charlotte has generously lent to this exhibition), ranging in date from the late seventeenth to the early twentieth century. In the process they accumulated a rich store of attendant knowledge, from the scholarly to the anecdotal, but their passion remained focused on the objects themselves. The collection contains many outstanding works (including studies by Pierre-Henri de Valenciennes, Thomas Jones, Simon Denis, and others now recognized as masters of the form), but it is most fascinating and compelling as an organic whole — as a laboratory for connoisseurship. Visitors were welcome, for the Geres always were eager to share the collection, to compare, to discuss, to look again, to teach, and to learn.

Detail, cat. 5, Attributed to Dunouy, *Rooftops in Naples,* c. 1780

In his draft essay, directly after the sentence quoted above, John went on as follows. (The reference to the *Donation Croÿ* is to the bequest to the Louvre, in 1930, of more than one hundred previously unknown oil studies by Valenciennes, the event John had selected as the beginning of his story.)

> I came to the sketch not so much by the obvious English route of Constable as by way of Turner's Roman sketchbook of 1819 and Corot's Italian, also chiefly Roman, landscapes of 1825–28 — but these I saw as a group of separate small views, without at all appreciating their significance in the artist's development or their place in the tradition of French neoclassical landscape. It was only after reading Lionello Venturi's article on the *Donation Croÿ* (published in *The Art Quarterly* in 1941) and the sight of the sketches themselves and–also in the Louvre and a telling comparison–his large-scale idealised view of Agrigentum, that I came to see that the sketches were paintings of a unique kind, resembling drawings (my own professional field) in their freshness, their informality, their directness of vision, and their emphasis on effects of light and atmosphere, but having a resonance of color beyond the reach of all but the greatest watercolorists. This must have been in about 1955, for to my lasting regret it did not occur to me to take advantage of the dispersal of Thomas Jones's sketches in 1954; and I have a note recording my first purchase of a landscape oil-sketch in 1956 — not a romantic view in Rome, but of a London suburb in about 1860, *The Crystal Palace from Penge*, by William White Warren — which I still cherish and which I bought for less than £10 from Jack Baer. A successful art dealer must have antennae exceptionally sensitive to the movement of taste, and it would not have been possible to find the material to study this subject without the active assistance and co-operation of Jack Baer, John Lishawa and James Mackinnon in London, Jacques Fischer in Paris and Bob Kashey in New York.

It is our loss that John went no further in committing his recollections to paper. Between that first purchase in 1956 and 1980, when I met him, he had elaborated his perception "that the sketches were paintings of a unique kind" into a deep understanding, at once visceral and sophisticated. In this period of uncharted adventure and discovery, the progress of his self-education was aided far more by sympathetic personal encounters than by the more formal exchanges of scholarship. Charlotte Gere recalls, for example, the infectious enthusiasm of Pierre C. Lamicq, a prescient collector with a particular interest in the work of Corot's teacher, Achille-Etna Michallon. Also important were John's friends at the Fine Art Society, who helped the Geres eventually acquire ten landscape studies in oil by Frederic Leighton, such as *The Villa Malta, Rome* (fig. 1).

Part of John's special interest in Leighton, as in François Desportes, was that large numbers of the painter's oil studies had been preserved together, providing the sort of collective record of artistic experiment that so appeals to the connoisseur of drawings. Some of these large holdings were in museums (the studies of Valenciennes in the Louvre, for example, or of François-Marius Granet at Aix-en-Provence), but the exploration of public collections was in itself something of an adventure, even in the 1980s. I remember a delightful evening at the Lamont Road Museum, as I came to think of the Gere home in Chelsea, when Lawrence Gowing shared with John, Charlotte, and me color slides he had made surreptitiously of the Granet studies, which the then-director of the Musée Granet regarded as a personal preserve and refused to exhibit or publish or even to have photographed. There was the persistent hope, often in fact

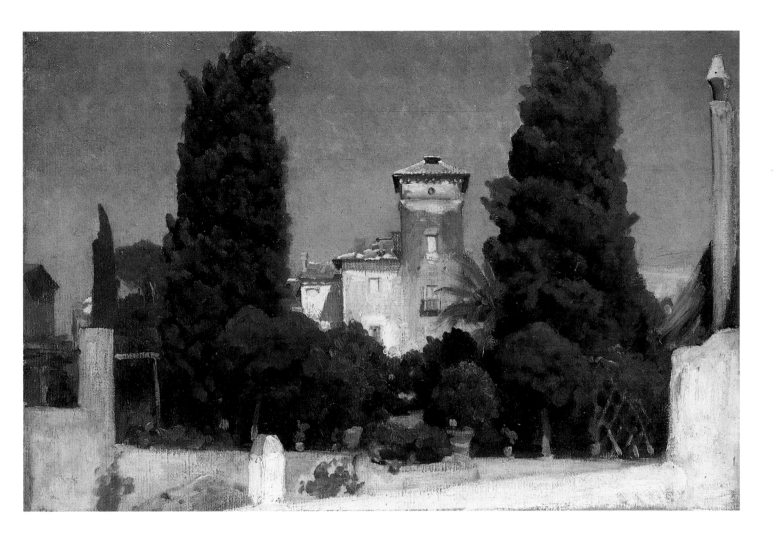

fig. 1. Frederic, Lord Leighton, *The Villa Malta, Rome,* 1853–1854, oil on canvas, 26 × 40.6 cm. Private collection.

rewarded, that a visit to some provincial museum would yield a new piece of the ever-expanding puzzle. A report of the discovery, accompanied by a slide or a photograph or a thumbnail sketch, soon would be sent to one or another member of the still tiny circle of enthusiasts.

Within that circle, alert and imaginative dealers played a crucial role, which John was right to stress. The landscape oil study had fallen into oblivion in the second half of the nineteenth century. Recovering it meant assembling many widely scattered, frequently misidentified or entirely unidentified works, and inevitably dealers formed the advance guard in this campaign. Recovering early open-air painting also meant recognizing that the individual works belonged to a larger whole, to a form of artistic practice whose coherence and meaning had been forgotten. Here, too, the most thoughtful dealers were ahead of many curators and scholars, whose indifference John explained in characteristically down-to-earth terms:

> One practical reason for the neglect of the oil-sketch was the problem of classification. These small paintings, usually on paper, are not pictures in the sense of having been in-tended for exhibition and for display on the walls of picture galleries or private houses. They were not even meant to be framed. They were part of an artist's private working-material, kept in a portfolio in his studio and shown only to pupils and fellow-artists. Curators of paintings dismissed them as not being pictures in the true sense, since they had the function of drawings; curators of drawings tended to reject them because of

their technique. The landscape oil-sketch was thus relegated to the critical limbo from which it has only recently emerged.

A further difficulty was the problem of attribution. Authorship can sometimes be established by provenance (as in the case of the *Donation Croÿ*) or by a studio stamp or a contemporary inscription (though rarely by a signature), but when the contents of an artist's studio were dispersed his sketches, particularly if not signed or inscribed, tended to gravitate, scattered and unconsidered, to the *marché aux puces* and the portfolios of the small dealer. They record an immediate reaction to a landscape, and their similarity of purpose and technique gave them a general resemblance which often permits no more than an approximate conclusion about their origin and date....There are many oil-sketches of Rome and its neighborhood of which it is still impossible to say more than that they must date from the late eighteenth or early nineteenth century. In view of the importance of Rome as an international artistic center at that period it would be rash to guess about their origin, but one's first instinct is always to ask "Is it French?"

He was not exaggerating the primitive state of attribution. In the late 1970s an Italian dealer classified an unattributed study as *anonimo tedesco* (anonymous German), presumably on the basis of its rather painstaking execution — until a cleaning revealed an inscription in English. Such difficulties doubtless played upon the insecurities of some collectors, but they only whetted John's appetite. He liked nothing better than to acquire an anonymous study and then set about puzzling out what it was. Here is an abbreviated passage from a letter he wrote in February 1993:

> I think I told you when I last wrote that I had bought the sketch of Tivoli...[A friend] suggested that it might be by Simon Denis, and it does seem to go well with our *Torrent*. Also a particularly beautiful sketch by Frederic Leighton — beautiful because it has no subject, simply a hillside with a wood on top — from Sotheby's sale at the end of last November. And, as a final extravagance, the original of the enclosed photograph. I wonder what you think of it, and what you will think when you see it: its date is a matter of some argument.

I knew this meant that John had a very precise idea of the date of the study — and of its author. Having spent decades brilliantly classifying Italian drawings, he couldn't resist assigning a name, no matter how provisionally, to each new treasure. He knew perfectly well that there might never exist a sufficiently large secure corpus of oil studies and related documents to permit the sort of masterful analysis that he and his great colleague Philip Pouncey had applied to the Italian drawings in the British Museum. I believe, however, that the sea of uncertainty not only pleased but motivated him, that his eye and mind were thrilled and sharpened by the impossible challenge. Also at work was his instinct in favor of the neglected — the same instinct that had led him to rescue the sixteenth-century artist Taddeo Zuccaro from the shadow of his brother Federico or, still earlier, to give serious attention to the Pre-Raphaelite painters, then thoroughly out of fashion. If each oil sketch had come with a certain attribution John would have loved the paintings no less, but he would not have so enjoyed collecting and studying them.

In 1977, at John Gere's instigation, the British Museum presented *French Landscape Drawings and Sketches of the Eighteenth Century*, an exhibition drawn from the collections of the Louvre, which included open-air oil studies by Desportes and Valen-

ciennes. Three years later, with Lawrence Gowing and Philip Conisbee, he organized the exhibition *Painting from Nature* at the Royal Academy in London. Together, those exhibitions and their catalogues began the process through which both scholars and a broad public have come to embrace John's private passion. It is in order to pay tribute to that passion that I have resorted to "the unavoidably egotistic and inevitably incomplete method of recalling my own experience."

It is the historian's job to shed new light on old problems, to revise our understanding of them and thus to keep them alive. As a collector and connoisseur of early open-air painting, J. A. Gere did something a great deal more original. He discovered a splendid problem where none had existed before.

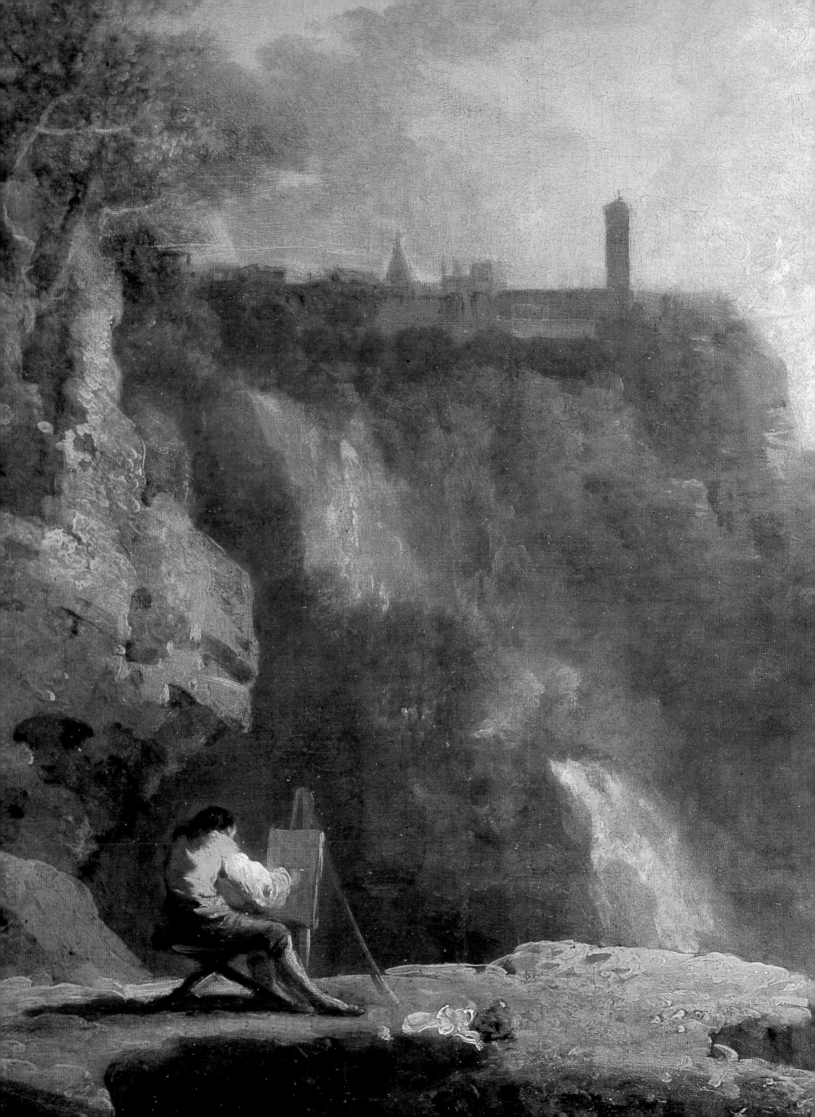

The Early History of Open-Air Painting

PHILIP CONISBEE

N one of the landscapes in this exhibition, except possibly for a few of those which are more highly finished and may have been worked up in the studio, was publicly exhibited or sold in its creator's lifetime. They were rarely seen outside the studio until after the artist's death — and even then, in some cases, they remained concealed in portfolios until the twentieth century. Yet for us they are among the most accessible works by these artists. Indeed, Corot has been more loved in our century for the open-air oil sketches and small finished landscape studies he made during his first visit to Italy, from 1825 to 1828, than for the larger and more elaborate works he subsequently offered for sale or sent for exhibition at the Salon. Peter Galassi has carefully charted this critical history in a recent book, pointing out that Corot's sketches and studies were known only to a limited circle, although one which included such influential critics as Théophile Silvestre and Paul Ganz.[1] But these works did not begin to receive public recognition until the memorial exhibition and the subsequent sale of Corot's estate after his death in 1875. At that moment another sympathetic critic, Philippe Burty, wrote:

> Some of these studies, very personal works and marked by the delicacy of the drawing
> and the keenness of the overall structure, are famous in the studios. Corot lent them
> willingly, and they have had a happy influence on the contemporary school.[2]

Note that the Corot exhibition and auction took place just one year after the first impressionist exhibition in 1874, which had announced the end of "finish" in painting.

Corot was not unique when he made his open-air paintings in Rome and the surrounding Campagna: he was part of a tradition that had been gathering strength since the late eighteenth century, and which he and his contemporaries brought to a high point of development. But why did their open-air works remain hidden from general view for so long? Today it is understood that landscape painters work out-of-doors at least part of the time; for us, a landscape painting is the artist's response to nature, or at least an attempt to capture, to some degree, an actual scene in paints on canvas. It is now nearly forty years since E. H. Gombrich dispelled any illusions that the art of landscape, even a naturalistic scene by John Constable or an impressionistic one by Claude Monet, is anything other than a construct, an invented visual scheme, or a form of painterly shorthand, however much it might be based on intense study in the open air.[3] As Constable observed, "It is the business of a painter not to contend with nature & put this scene (a valley filled with scenery 50 miles long) on a canvas of a few inches, but to make something out of nothing, in attempting which he must almost of necessity become poetical."[4]

Detail, cat. 1, Wilson, *Tivoli: The Cascatelli Grandi and the Villa of Maecenas*, 1752

Humanistic art theory, developed during the Renaissance when artists were struggling to gain social and intellectual respectability, carried weight well into the nineteenth century. Still life and landscape painting were placed at the bottom of the hierarchy of the genres, because lowly nature was their subject and their basis in perception was contradictory to the more cerebral, conceptual approach of ideal, imaginative art, which was invested with a moral dimension. In seventeenth-century academic theory, the direct observation of nature was regarded as a potentially danger-ous process, because too subjective an approach might lead away from the established norms of the ideal. But Henri Testelin, speaking before the Academy and its founder, Louis XIV's powerful finance minister Jean-Baptiste Colbert, had to admit that the effects of light and shade could only be fully understood by the empirical study of nature: "la contemplation des choses naturelles."[5] The relationship of light and shade in landscape, for example, should be observed in a single regard, "pour en repre-senter la véritable sensation (si l'on peut user de ce terme)."[6] While Testelin recognized that everyone perceives the world differently, "selon la disposition des organes & du temperament," the purpose of art was not to seek beauty on the basis of "inclinations particulières," but rather to apply judgment, choice, and the rules of art — the norma-tive standards of the accepted masters — and to avoid the "oppositions extravagantes" and "obscuritez excessives" that might result from a purely subjective response to nature.[7] From the tension already inherent in Testelin's position as a spokesman for the ideals of the Academy to Emile Zola's celebrated definition of a work of art as "a corner of creation seen through a temperament,"[8] or Paul Cézanne's "I paint as I see, as I feel — and I have very strong sensations,"[9] is a history of naturalism in European landscape painting.

Before the rise of impressionism, any spontaneous or subjective response to the thing seen remained carefully absorbed and integrated into standard academic practice. Pierre-Henri de Valenciennes, for example, an advocate and practitioner of open-air painting, is quite clear about this in his influential treatise *Elémens de perspective pra-tique*, published in 1800. For Valenciennes, the painting of immediately observed and spontaneously executed *études* or studies was but one stage in the larger process of an artist's education, the ultimate objective of which was the finished exhibition picture. His observations on such exercises only occupy a dozen pages of a book that runs to more than five hundred, and are absorbed into what is both a wide-ranging dis-cussion of landscape painting and an often highly technical and scientific treatise on perspective. But open-air landscape studies do, nevertheless, have an important role for Valenciennes. On one level, they were a way of studying and recording different aspects of nature in a wide variety of climatic conditions. On another, they were a means of training the hand to render in paints on paper the observed effects of light, color, and form. They could also teach the painter how to select and compose a coherent pictorial image from the bewildering variety of perceptual experience.[10] Valenciennes kept his own studies for reference and as models for his students. There is no perceptible correlation between the informal type of work Valenciennes painted in the open air and the finished, conceptual, formal works he undertook in the studio. He maintained the academic distinction between study from nature and the serious business of the history painter or, for him, the painter of the *paysage historique*. But there is no reason to think that Valenciennes, or Corot, or indeed any of the artists in this exhibition felt constrained by such conventions of artistic practice, or saw their

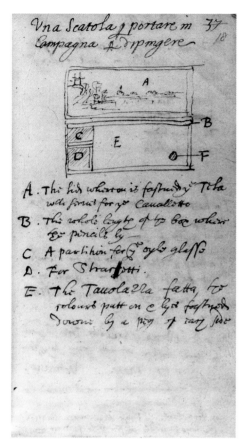

fig. 1. Richard Symonds, diagram of a box for open-air painting, from a notebook used in Rome, 1650–1652. British Library, London, Department of Manuscripts.

fig. 2. Alexander Cozens, diagram of a box for open-air painting, from a sketchbook used in Rome, 1746. Yale Center for British Art, New Haven, Paul Mellon Collection.

landscape studies as anything other than one element of their overall production. That is why such works were hardly known outside Valenciennes' studio during his lifetime. They came to public view only briefly in April 1819, when Valenciennes' estate was sold at auction after his death, but then disappeared into a private collection until the 1920s, an even longer period of relative obscurity than that suffered by the studies and sketches of Corot.[11]

All the works in this exhibition were painted in Italy, particularly in and around Rome, because that is where the tradition of open-air painting became established in the second half of the eighteenth century. Since the early sixteenth century, artists had been drawn increasingly to Italy to study the remains of ancient Rome and the wonders of modern art that were being created by masters such as Raphael and Michelangelo. From the late sixteenth century onward, landscape painting in Rome was dominated by northern artists, who were less constrained than their Italian colleagues by the humanistic idealism of the Renaissance, which emphasized the human figure. The actual landscape of Rome and the surrounding Campagna and the nearby Alban and Sabine Hills was in itself a tremendous draw, because of the rich historical and literary connections of antiquity. Almost any walk, any prospect, could arouse associations with an emperor or a poet, a military triumph or a defeat, or the mythic presence of ancient gods, goddesses, and heroes. It was also a landscape of considerable natural beauty, a warm southern paradise, a rich mixture of nature and art, interspersed as it was with picturesque ruins, and enveloped with exquisite light and atmosphere. The climate was amenable to working out-of-doors, with relatively steady, constant effects of light and shade and a long, reliable summer season, without the almost hourly changeability of northern climates. Moreover, the steady and reliable light of the Mediterranean sun and the sharp shadows it cast gave a simplicity and monumentality to form and already suggested a reduction to essentials before they were put down on a piece of paper or canvas a few inches square.

According to several sources, artists in seventeenth-century Rome already were painting in oils in the open air. A piece of material evidence is found in the notebook kept by the English traveler Richard Symonds during his residence in Rome from 1649 to 1651. In it he illustrates a painting box specially designed for outdoor use, "Una Scatola p. portare in Campagna p. dipingere" (fig. 1).[12] The case was divided into sections for the brushes ("B" in Symonds' diagram), an oil glass ("C"), and paint rags ("D"), with a palette ("E") to fit over the top during transit ("F" designates a thumbhole in the palette). It seems from Symonds' annotations that the oil colors were arranged on the palette before the artist set off, although we cannot rule out the possibility that more small compartments to contain the colors, such as those marked "C" and "D," continued across the case underneath the palette. The lid ("A") of the case, when opened, served as a small easel, to which a canvas was attached. Such equipment has been common enough since the early nineteenth century, but documented examples are rare before the Romantic era. The next one does not appear until 1746, but again significantly in Rome, where the British landscape painter Alexander Cozens made some drawings of his open-air painting equipment in a sketchbook. His most informative drawing (fig. 2) shows paper mounted in the center of a rectangular board, which serves both as easel and paint box. It is surrounded by twenty small pots for containing and mixing pigments; the "pastboard" must have been laid over the top, and the whole strapped together for carrying. In this same sketchbook Cozens

noted that he had been painting outdoors both in watercolors and oils, and that he had been taking instruction from the French painter Claude-Joseph Vernet.[13]

Just as northern artists had become the specialists in landscape painting in early seventeenth-century Rome, so their freedom from humanistic and academic restraints enabled them to explore new modes of seeing and representing nature and to pioneer working out-of-doors. All the eighteenth- and nineteenth-century artists in this exhibition are northerners who went to Italy to study and, either with previous intentions or from a sense of discovery when they got there, painted outdoor landscapes.

If Symonds' painting box is rather concrete evidence of the practice of open-air painting in seventeenth-century Rome, Joachim von Sandrart's *Teutsche Academie*, published in 1675, provides early written accounts of the custom, if we accept his descriptions of Claude Lorrain's painting practice during the early 1630s. Sandrart has Claude walking out into the Campagna to contemplate nature profoundly and to prepare his colors in the field, before returning home to paint with them:

> He tried by every means to penetrate nature, lying in the fields before the break of day and until night in order to learn to represent very exactly the red morning-sky, sunrise and sunset and the evening hours. When he had well contemplated one or the other in the fields, he immediately prepared his colors accordingly, returned home, and applied them to the work he had in mind with much greater naturalness than anyone had ever done. This hard and burdensome way of learning he pursued for many years, walking daily into the fields and the long way back again.[14]

Lawrence Gowing was the first to note the importance of this passage and its full implications in the context of conventional painting techniques in the seventeenth century.[15] What is unusual in Claude's procedure as described by Sandrart is his mixing of pigments to match observed colors in nature, rather than layering and glazing paints, one over another, to achieve a cumulative effect. Colors mixed on the palette in this way could be directly and rapidly applied *alla prima*, while layers and glazes of paint require time to dry between several painting sessions. Sandrart seems to be still referring to this novel technique when he writes:

> As a master of perspective [i.e., aerial perspective], he knew how to break the hard quality of the colors and to mix them so that they no longer resembled those colors, but what he wished to represent.[16]

However, if we are to believe Sandrart, it was his own example that was to lead Claude away from the presumably inconvenient business of mixing colors outdoors and later applying them to canvases in the studio; for Claude was soon to follow him in actually painting out-of-doors before nature:

> ...he finally met me, brush in hand, at Tivoli, in the wild rocks of the famous cascade, where he found me painting from life, and saw that I painted many works from nature itself, making nothing from imagination; this pleased him so much that he applied himself eagerly to adopting the same method.[17]

A certain credibility is lent to this account by the fact that Sandrart continues to distinguish between the type of scene which he himself painted from nature, and the features that attracted Claude:

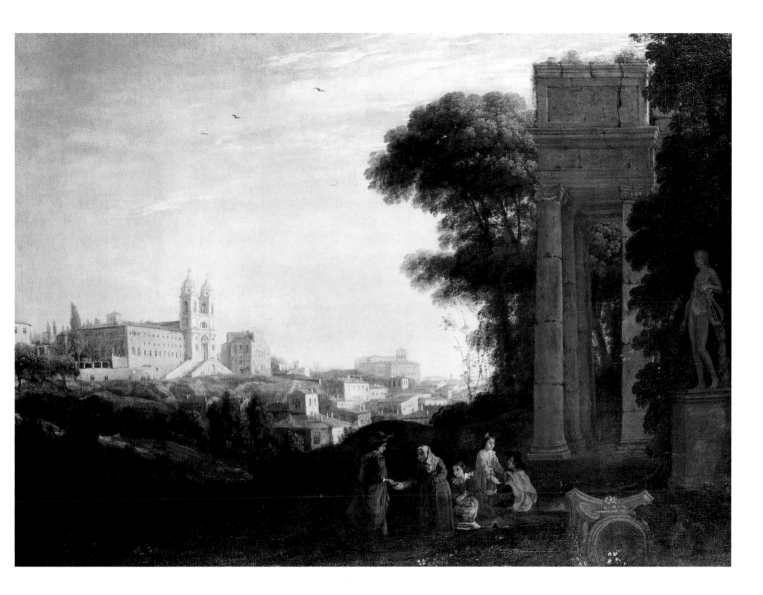

TOP: fig. 3. Claude Lorrain, *A View of Rome with the Church of Santa Trinità dei Monti*, 1632, oil on canvas, 59.5 × 84 cm. National Gallery, London.

BOTTOM: fig. 4. Claude Lorrain, *View of Santa Trinità dei Monti*, 1632, ink on paper, 14 × 21 cm. Hermitage, Saint Petersburg.

We loved each other very much and lived for a long time together in Rome, often also painting together from life in the field. But while I was only looking for good rocks, trunks, trees, cascades, buildings and ruins which were grand and suited me as fillers for history paintings, he on the other hand only painted, on a smaller scale, the view from the middle to the greatest distance, fading away towards the horizon and the sky, a type in which he was a master.[18]

In other words, while Sandrart sought out picturesque features of the natural scene, Claude focused on the light of the sky and its effects on the more distant parts of the landscape. The natural features studied by these two artists remained in the repertoire of all the open-air painters who succeeded them through the next two centuries.

Claude's oil studies from nature described by Sandrart await rediscovery. Gowing drew attention to the purely tonal painting of the background in his *A View of Rome with the Church of Santa Trinità dei Monti* (fig. 3), which dates from the period early in the 1630s discussed by Sandrart. Such a passage might indeed have been painted from nature, and we can almost hear Sandrart before it, "...on a smaller scale, the view from the middle to the greatest distance, fading away towards the horizon and the sky...." A drawing (fig. 4) of the church and part of the panorama seems to have been made from the edge of the Pincio, approximately in front of the Villa Medici, above

Claude's house in the Via Margutta.[19] Claude has adapted the view slightly in the painting, pushing it back into space. But in any case a comparison of the drawing and the painting rather demonstrates the difference between the types of information that can be recorded by graphic and painterly means, as Sandrart and later advocates of open-air painting were at pains to point out. By contrast with the picturesque *coulisse* of transposed antique ruins and the scene of mercenary love going on in their shadow, evidently painted in the studio, the attics, rooftops, and chimney pots in the slanting rays of the evening sun are rendered with astonishing sensitivity and truth of tone; the touch of the brush is broad and economical, yet deft and precise, while the unifying effect of the evening atmosphere means that the range of the palette is very restricted. We can understand the development of Claude's sense of tone in respect of such an intense observation and its equivalent matching in pigment. But identifiable views of given spots are uncommon in his work, and there are no convincing candidates as real oil studies from nature.[20]

Sandrart returns to the practice of making oil studies from nature in his chapter on landscape painting. This is illustrated with an engraving by Sandrart himself (fig. 5), which is adapted from Claude's 1636 etching of the *Campo Vaccino*. A significant modification is that the spectators in Claude's print are joined in the Sandrart by an artist sitting in the open air at an easel, holding brushes and charged palette, *painting* the scene before him. To the left of the easel leans a youth, apparently taking down the master's words. The illustration serves to underline Sandrart's justification in the text for painting from nature:

> In the open country at Tivoli, Frascati, Subiaco, and other places such as San Benedetto, we [i.e., Claude and Sandrart] began to paint entirely from nature with colors on prepared papers and cloths, the mountains, grottoes, valleys and deserted places, the terrible cascades of the Tiber, the Temple of the Sybil, and the like. This is in my opinion the best manner to impress the truth precisely on the mind; because body and soul are as it were brought together in it. In drawings, on the other hand, one goes too far back, since the true shape of things no longer appears really as pure.[21]

RIGHT: fig. 6. Claude Lorrain, *Landscape with a Goatherd*, c. 1636, oil on canvas, 52 × 41 cm. National Gallery, London.

LEFT: fig. 7. Claude Lorrain, *Trees in the Vigna Madama*, 1636, ink on paper, 33 × 22.5 cm. British Museum, London.

All later writers on open-air oil sketching echo this assertion of the value of painting rather than drawing from nature, because only then are color and drawing combined simultaneously in the creative act, as they are, in effect, in the act of perception.

Landscape with a Goatherd (fig. 6) is probably the picture that Baldinucci describes Claude working on in the Vigna Madama, and which the artist kept all his life.[22] The subject and the composition are so close to some of Claude's luminous wash drawings made in the Vigna Madama (fig. 7) that maybe at least the lovely trees in the painting were worked from nature; such a partial working from nature was later recommended by the theorist Roger de Piles and practiced by several artists in this exhibition. But the physical substance and the manner of the painting's richly textured, brushy execution are, of course, quite different from Claude's drawings. It is not surprising that John Constable loved this painting—"his Study from Nature...[which] diffuses a life & breezy freshness into the recesses of the trees which make it enchanting"—and paid homage by copying it.[23]

If for Sandrart the admirable characteristic of Claude's art was its "greater natural-ness" than earlier landscape painting, then no doubt the notion of naturalness in art was discussed in the circle of mainly northern painters frequented by Claude and Sandrart in Rome around 1630. Sandrart's engraving can be compared with a drawing by Jan Asselijn, who arrived in Rome in 1635, the year Sandrart departed; it shows a group of artists working together outdoors, one at a large easel, and may well illustrate an axiom of the northern fraternity in Rome, the Dutch members of which are here gathered together as the Bentvueghels (Birds of a Feather).[24]

When Velázquez visited Rome and spent two months at the Villa Medici in the summer of 1630, he may have executed the two views made in the grounds of the villa that have been connected by some scholars to the open-air painting practices described by Sandrart, although it is possible that they were painted on a later visit to Rome.[25] Each painting is in quite a different style, and they form a contrasting pair. The one (fig. 8), with an archway framing the famous antique statue of *Ariadne* with a visitor behind, is thinly and loosely brushed in. It is essentially a study of the flickering dance of dappled sunlight, as it filters through the trees arching overhead and plays across forms to break them up into shifting patterns of light and shade. The other (fig. 9) is more meditative in its observation, with a thicker, more patient application of the pigment that matches the more static conditions of direct sunlight falling onto the solid surfaces of masonry and wood. It is a moving rendering of a quite inconsequen-tial subject: an abandoned loggia boarded up as a makeshift garden store.

Artists in Naples in the seventeenth century were less subject to the theoretical restrictions of idealist art theory that prevailed upon native painters in Rome, so it was perhaps easier for Salvator Rosa to leave the studio for the countryside.[26] He certainly enjoyed the solitude of nature and had a lively appreciation of wild and remote natural

LEFT: fig. 8. Velázquez, *View in the Garden of the Villa Medici, Rome, with a Statue of Ariadne*, c. 1630?, oil on canvas, 48 × 42 cm. Prado, Madrid.

RIGHT: fig. 9. Velázquez, *View in the Garden of the Villa Medici, Rome*, c. 1630?, oil on canvas, 48 × 42 cm. Prado, Madrid.

fig. 10. Salvator Rosa, *Landscape with Figures*, 1630–1640, oil on paper, mounted on board, 28.4 × 42.1 cm. Private collection, London.

sites, which he often expressed in his correspondence and in his dramatic studio landscapes. Passeri, who knew the artist, tells us that in his youth Rosa went out on open-air painting expeditions:

> He went *in giro* in the environs of Naples, where he saw various views of landscape and marine, which suited his genius, and he settled himself in such a place as he could do his best, and copied with oil colors such a site from nature (*copiava con li colori ad oglio quel sito dal naturale*).[27]

A small oil landscape painted on paper (fig. 10) may be one of Rosa's open-air paintings, with figures added for scale; the type of site and the viewpoint recall some of Claude's more audacious drawings of sandy banks, although the way in which Rosa has introduced physiognomic formations into the rocky overhang is characteristic of his more quirky genius.

Gaspard Dughet's contemporaries admired him for producing relatively natural-looking landscapes, if not exactly studies from nature. Filippo Baldinucci tells us that in the early 1630s Gaspard's brother-in-law Nicolas Poussin encouraged him to paint views (landscapes?) in a natural manner: *in disegnar vedute al naturale* (not *dal naturale*, from nature) — presumably in contrast with Poussin's own more conceptual and idealist ambitions. Baldinucci adds that Gaspard owned some country properties, including a house at Tivoli, *per poter dipinger belle vedute al naturale*.[28] If examples of Dughet's open-air work have so far proved hard to find, it is, nonetheless, significant for our story that his reputation followed him well into the eighteenth century. Pierre-Jean Mariette was one of the best informed connoisseurs of the mid-eighteenth century and wrote in his notes toward a biography of the artist:

> Gaspard was not content merely to draw his studies after nature as most landscapists are. He also painted from nature a good number of his pictures [*une bonne partie de ses tableaux* could also mean a large part of any one picture]. A little donkey, which he kept at home, and which was his only servant, was used by him to carry all his painting equipment, his provisions, and a tent, so that he could work in the shade, or sheltered

from the wind: he was often to be seen thus, passing whole days in the countryside around Rome.[29]

The fragmentary literary remains gathered above and in a handful of paintings mark the tentative beginnings of a tradition of open-air painting in Italy during the seventeenth century. The amenability of the climate surely helped this development, in addition to the northern artists' detachment from the constraints of academic theory. Yet north of the Alps there was virtually no comparable activity at this time, which makes the case of Alexandre-François Desportes in France all the more remarkable. For the first time there is sound documentary evidence that an artist worked in oils directly from nature in the open air, supported by a surviving group of his painted studies. The document comes from his son, Claude-François, in a biographical lecture given at the Paris Academy in 1749, six years after the death of his father. Here Claude-François gives a detailed account of his father's remarkable sketching practice:

> Previously he had made many of his studies in pencil, but subsequently reflecting on the importance of uniting exactitude of form with precision and truth of local color, he made it a custom to paint them on a strong paper which was not oiled. What he painted was at first absorbed, thus making it easy to retouch and finish immediately, with the speed required on such occasions. He did the same thing with regard to landscape: he took into the countryside his brushes and a loaded palette, in metal boxes; he had a stick with a long pointed steel tip, to hold it firmly in the ground, and fitted into the head was a small frame of the same metal, to which he attached the portfolio and paper. He never went to the country, to visit friends, without taking this light baggage, of which he never tired nor failed to make the best use.[30]

The contents of Desportes' studio were purchased from the painter's nephew in 1784 by the Direction des Bâtiments, and deposited at the Manufacture Royale de Sèvres, where the dozens of painted and drawn studies of animals, birds, and plants were probably intended to serve as models for the decoration of porcelain.[31] Desportes made oil studies after every aspect of the natural world that might concern a painter of still life, animals, the hunt, and landscape. While it is historically misleading to isolate the landscapes from Desportes' work as a whole, as Hal Opperman has pointed out, they nonetheless have a special appeal for modern taste.[32] Nevertheless, a visit to the Musée de la Chasse in Paris, where studies of all kinds and related finished works hang close together, gives a sense of the completeness and the interrelationship of Desportes' works and shows how some of the studies of animals and birds found their way directly into pictures commissioned as decorations for the royal palaces. This is also true for some of the landscape studies. One of several identified examples is the remarkably open and unpicturesque study of a river winding through a valley (fig. 11). It was used in the background of a large picture of Louis XIV's bitches *Folle and Mite*, painted in 1702 for the royal Château de Marly.[33] Desportes painted numerous landscape studies, including several views of this favored river valley, which has yet to be identified. This landscape sketch has a place in the history of originality for its rejection of picturesque composition and any academic conventions of perspective in favor of a perceptual response of remarkable directness. Yet for Desportes, painting from nature was not just a matter of training hand and eye but also a direct source of material for the larger, monumental studio works, which he proudly regarded as the principal end

fig. 11. François Desportes, *Valley with a River and a Clump of Willows*, c. 1702, oil on paper, mounted on cardboard, 28 × 53 cm. Musée national du château, Compiègne.

of his art. Insofar as a few of his outdoor studies were employed as models for parts of his finished studio works, Desportes was unusual among the artists under discussion. Prolific open-air painters later in the century such as Thomas Jones (cats. 7–13) or Valenciennes (cats. 14–23) did not intend to incorporate their open-air studies into studio landscapes. The younger Desportes does not indicate the precise relation his father saw between studies and studio works. But he does suggest that the close observation involved in painting from nature played a part in making the studio works so convincingly naturalistic that Louis XV's physician was able to identify for the king the different varieties of plants—a feature that distinguished Desportes' works from the more decorative conventions of the seventeenth century.[34] Here are the beginnings of a more empirical, scientific appreciation of nature (as opposed to a merely picturesque one), which was characteristic of the Age of the Enlightenment: the very word "étude," study, carries a scientific resonance.

Desportes' landscape, plant, and animal studies can be compared with the painted or drawn figure studies of contemporary history painters, as preparations for studio work; but one difference is that most other painters generally made their figure studies with a specific work in mind, whereas Desportes made a wide range of studies as a repository of images, only some of which he might use. Desportes' oil studies cover a wide selection of subjects, including different species of birds and animals, and ranging from the pattern of a woodman's ax-marks on some tree stumps, to a patch of worm-eaten cabbages nibbled into an almost rococo grace, to tufts of grass, roses, individual trees or groups of trees, and so on. Together they form an almost scientific inventory of nature in its manifold variety, although this is no evidence that he conceived or ordered them with any taxonomic intent.

Desportes appears less isolated in his sketching activities at the turn of the seventeenth and eighteenth centuries when we consider him in relation to Roger de Piles' celebrated *Cours de peinture par principes* of 1708. Desportes was forty-eight when de Piles died in 1709 at the age of seventy-four, and the two men must have been quite well acquainted in the small Parisian art world of their day. De Piles' book, which

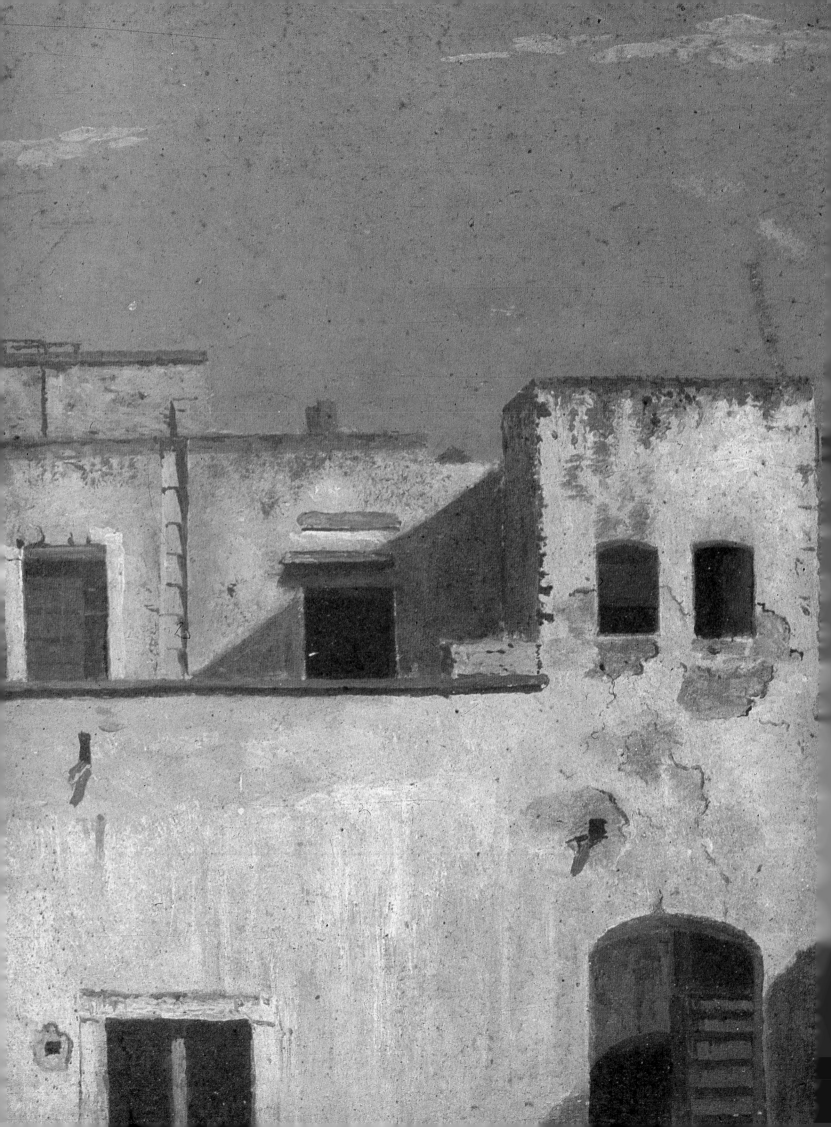

went into several editions, contains a long chapter on the theory and practice of landscape painting, which became a standard text for more than a century. De Piles emphasizes the dignity of the landscape painter among artists, making his book a significant document in the long struggle to give greater academic recognition to this relatively lowly genre. The landscape painter is a privileged being whose pursuit offers considerable creative freedom to choose and dispose a whole pictorial world as he pleases; and he is at particular liberty to wander in the solitude of nature, to take his rest there and to muse agreeably. In addition to discussing landscape painting in a theoretical way, de Piles offers a certain amount of practical advice. He urges the painter to study the changing light effects to be observed in nature, especially "Accidents," which are the "obstructions of the sun's light by the interposition of clouds"; this creates "wonderful effects of claro-obscuro, as seem to create so many new situations. This is daily observed in nature."[35] There follow several influential pages "Of the Sky and Clouds," where he discusses the different weathers and times of day; he sees the sky as the principal source of light, the major determining factor in the appearance of nature. There are so many changing effects that they are best studied by painting them: "there is an infinity of particular (observations) which the painter must make upon the natural, with his pencil in his hand, when occasion offers" (*le pinceau à la main sur le naturel*).[36] De Piles recommends both drawing and painting after nature and lists a variety of subjects such as rocks, trees, water, and so on, that recall the objects of Sandrart's studies in Rome. These studies should be kept together by the artist, so that he may reference them when the need arises. When it comes to the practice of painting, he writes:

> There are some artists who have designed after Nature, & in the open fields, and have there quite finished those parts, which they had chosen, but without adding any colour to them. Others have drawn, in oil colours, in a middle tint, on strong paper; and found this method convenient, because, the colours sinking, they could put colour on colour, tho' different from each other. For this purpose they took with them a flat box, which commodiously held their palette, pencils, oil and colours. This method, which indeed requires several implements, is doubtless the best for drawing nature more particularly, and with greater exactness, especially if, after the work is dry and varnished, the artist return to the place where he drew, and retouch the principal things after nature.[37]

De Piles' words seem to reflect the practice of Desportes, whose activities are surely those he refers to as "ceux que j'ai vu pratiqué" ("those I have seen practiced") in the original French edition of the text. The recommendation of de Piles to paint rather than draw from nature echoes the words of Sandrart, and indeed sets a refrain that was taken up by most subsequent writers on landscape painting.

The *Cours de peinture* remained the fundamental essay on landscape painting — in France, certainly, but John Constable also read him in the English translation — until the end of the century, when it was replaced, but by no means invalidated, by the *Elémens de perspective* of Valenciennes. Thus, Watelet and Lévesque's *Dictionnaire des arts de peinture* (1792), the most serious French artistic treatise of the decade, appropriates de Piles' discussion of landscape for its own article on "Paysage," paraphrasing and substantially quoting page after page from the *Cours de peinture*. In the *Dictionnaire*, the landscape and marine painter Vernet is subsequently presented as the model open-air painter: "M. Vernet, as much as he could, always painted his studies from nature."[38]

Detail, cat. 8, Jones, *Rooftops, Naples, 1782*

By thus connecting the recommendations of de Piles with the practice of Vernet in their dictionary, Watelet and Lévesque conveniently return us to Italy, the principal field of open-air painting. The study of landscape had already been encouraged early in the eighteenth century at the French Academy in Rome—no doubt with relatively good conscience because of the distance from the more doctrinaire constraints of Paris—by the director Nicolas Vleughels in the 1720s and 1730s (and later by his one-time pupil and successor as director Charles Natoire in the 1760s and through the 1770s). It was drawing, not open-air painting, that Vleughels encouraged, although an artist in French circles may have painted the deftly handled oil sketch showing Santa Trinità dei Monti in the evening light (fig. 12), which probably dates from early in the eighteenth century. Certainly Vleughels created a sympathetic context for a young landscape painter such as Vernet when he arrived there in 1734 and encouraged him to go off and study in the open air. Much later Sir Joshua Reynolds recalled seeing Vernet painting from nature in Rome early in the 1750s, and advised the young marine painter Nicholas Pocock to do the same:

> I would recommend, above all things, to paint from Nature, instead of drawing; to carry your palette and pencils to the Waterside. This was the practice of Vernet, whom I knew at Rome. He there showed me his studies in colours, which struck me very much for the truth which those works only have which are produced while the impression is warm from Nature: at that time, he was a perfect master of the character of Water, if I may use this expression.[39]

A group of oil studies made in Rome and Naples was included in the 1790 sale of effects after Vernet's death, and what is very likely one of these, painted at Tivoli probably in the 1740s, has recently come to light (cat. 2). It bears comparison with

small finished pictures that Vernet made in Rome, such as his celebrated view of *The Ponte Rotto, Rome* (fig. 13), where the exquisite nuances of the soft light are evidence of his close scrutiny of the scene before him. Vernet himself wrote an extremely interesting text, in which he argues for painting directly from nature as the best way to avoid the dry mannerisms of academic art education and the studio.[40] Moreover, like the other writers on oil sketching before him, Vernet says that painting from nature is also an excellent way to train the eye and the hand, to learn how to match exactly in pigment what is perceived in the world; further, the student also learns the effects that light and atmosphere have on the perception of distance, on the appearance of objects outdoors, and on the overall visual harmony of a scene.

Vernet passed on his own interest to a number of artists who encountered him in Rome, especially British painters such as Reynolds and Cozens and the landscape painter Richard Wilson. Indeed, it was Vernet who encouraged Wilson to take up landscape painting, when the two artists met in Rome and shared lodgings at the Palazzo Zuccari on the Via Sistina. They also shared patrons such as Lord Dartmouth (through a common agent, Thomas Jenkins) and Ralph Howard, later earl of Wicklow. Vernet's influence must lie somewhere behind two works Wilson painted for Howard in 1752, where in one scene we see a painter at his easel at Tivoli (cat. 1 and fig. 14), and in the other his assistant subsequently staggering home with an enormous canvas or portfolio (fig. 15). A few years later the young (and short-lived) Jonathan Skelton set off from Rome to Tivoli in July 1758 with the intention of working from nature in watercolors, "as they do not shine on the picture...which will make the study more commodious than that of painting in oil-Colours for in the open Day-light they shine so much when they are wet that there is no such thing as seeing what one does."[41] One solution was to employ a parasol, such as the one shading an open-air painter at Tivoli in a drawing attributed to Wilson (fig. 16).[42] Another was to paint the

fig. 13. Claude-Joseph Vernet, *The Ponte Rotto, Rome*, 1745, oil on canvas, 40 × 77 cm. Paris, Musée du Louvre.

LEFT: fig. 14. Richard Wilson, *Tivoli: The Cascatelli Grandi and the Villa of Maecenas*, 1752, oil on canvas, 49.5 × 64 cm. National Gallery of Ireland, Dublin.

RIGHT: fig. 15. Richard Wilson, *Tivoli: The Temple of the Sibyl and the Campagna*, 1752, oil on canvas, 50 × 66 cm. National Gallery of Ireland, Dublin.

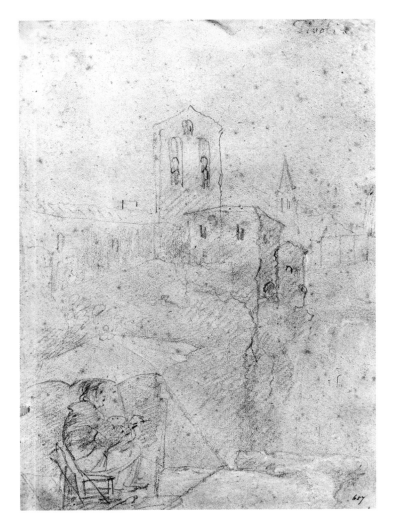

fig. 16. Attributed to Richard Wilson, *An Artist Painting at Tivoli*, c. 1752, chalk on paper, 25.8 × 19.7 cm. Victoria and Albert Museum, London, Dyce Collection.

view from a window, as Skelton eventually did from his room in the Villa d'Este in August: "I have half finished another [picture] in Oil from Nature, from the Window of my Bed Chamber."[43] François-Marius Granet painted a small study of himself, or perhaps a friend, sketching from the window of a Roman gallery in 1792 (fig. 17). Several works in this exhibition are testimony to this continuing practice, for example, by Thomas Jones, Léon Cogniet, Johan Christian Dahl, Franz Ludwig Catel, and Friedrich Wasmann.

Circumstantial evidence suggests that Vernet may have put his thoughts on paper in his "Letter" during the mid-1760s, when he was settled in Paris and young French artists were beginning to seek instruction from their most celebrated landscape painter. Among them in the next decade was Valenciennes. He had already been in Italy since 1777, where "Having studied perspective in Rome, down to the minutest details under an excellent professor of mathematics, and having filled more than five hundred folio pages with drawings and perspective figures, I thought that I knew this science inside-out."[44] But on a return visit to Paris in 1781 Valenciennes sought out Vernet, who, on seeing the younger artist's first efforts, told him that he had little understanding of perspective, in spite of his studies. In a single lesson, Vernet taught him about "le véritable point de distance, et...l'application de ce principe à la Peinture"; and also about the importance of the sky and clouds and their effects on the appearance of a landscape. In making open-air studies the painter should begin with the sky, the source of light in nature that sets the overall tone of a landscape.[45] It was surely Vernet who encouraged Valenciennes to work in such a way that led the younger painter away from the neat, tight, academic drawings of trees made before and during his first visit to Italy, such as those in the Louvre (fig. 18), to the open and broadly painted oil studies, which he began on his return to Rome in 1782 (cats. 14–23). In these works Valenciennes comes to terms with the problems of rendering aerial perspective, develops a versatile and eloquent pictorial vocabulary to capture the changing effects of light and atmosphere, and finds a painterly equivalent for the rich variety of texture and matter in the nature he observed. With the extensive practice of Valenciennes and his subsequent codification of open-air painting in his *Elémens de perspective*, discussed above, the tradition became established.

fig. 17. François-Marius Granet, *An Artist Working from a Window*, 1792, oil on panel, 28.5 × 21.5 cm. Musée Magnin, Dijon.

fig. 18. Pierre-Henri de Valenciennes, *Study of a Tree*, 1773, red chalk on paper, 31.4 × 20.3 cm. Musée du Louvre, Paris, Département des arts graphiques, inv. R.F. 13001.

Notes

1. Galassi 1991, 1–8.
2. Galassi 1991, 3, citing Burty 1875, 7.
3. Ernst H. Gombrich, *Art and Illusion* (London, 1960).
4. Beckett 1962–1975, 6:172.
5. Testelin 1696, 29.
6. Testelin 1696, 32.
7. Testelin 1696, 40.
8. Emile Zola, "Mon Salon" (1866), in Hemmings and Neiss 1959, 73.
9. Quoted in Rewald 1973, 246.
10. Valenciennes 1800, 404–417; on p. 410 he makes it clear that *studies* are not *pictures*: "Il est vrai que ces études ne forment pas des tableaux; mais on les garde dans le porte-feuille pour les consulter et en faire son profit dans l'occasion." For recent discussions of studies and sketches in relation to finished pictures see Boime 1971, Lacambre 1976, and Radisich 1977.
11. On the rediscovery of Valenciennes' oil studies see Guiffrey 1930; Lacambre 1976; Whitney 1976, 225–227; Pomarède 1994, 81–86. At the 1825 estate sale of the painter Anne-Louis Girodet-Trioson, who had a studio and rooms neighboring Valenciennes in the Louvre from 1796 onward (just after Girodet's return from a tour of Italy), were forty-eight or fifty landscape studies by Valenciennes: see *Catalogue des tableaux* 1825, lot nos. 451, 452, 454, 458–460.
12. Beal 1984, 73–74 and 232, where Symonds' annotations are carefully transcribed. At the time I first published Symonds' open-air painting equipment (Conisbee 1979, 414–415, fig. 25), I was unaware of Beal's Ph.D. dissertation submitted to the University of London in 1978. Parts of the present essay are adapted from Conisbee 1979.
13. See Oppé 1928, 81–93.
14. Sandrart 1675; his life of Claude Lorrain is translated in Roethlisberger 1961, 1:47–50.
15. Gowing 1974, 90–96.
16. Roethlisberger 1961, 1:48.
17. Roethlisberger 1961, 1:48.
18. Roethlisberger 1961, 1:48.
19. Roethlisberger 1968, 1:91–92, no. 48.
20. Gowing 1974, 94, for a discussion of some of Claude's works he felt were done from nature.
21. Roethlisberger 1961, 1:51.
22. Roethlisberger 1961, 1:127–131, no. 15; Kitson 1969, 17–18, no. 11; Kitson 1978, 61–62.
23. Beckett 1962–1975, 2:297, 6:143. Constable's copy is in the Art Gallery of New South Wales, Australia.
24. Hoogewerff 1952, fig. 26a.
25. Kitson 1958, 266; the much-discussed dating of these works to Velázquez' first visit to Rome in 1629–1630 or his second visit in 1649–1650 is reviewed by Gallego 1990, 374–383, nos. 64 and 65, who leans toward the later date.
26. Kitson 1973, 19, no. 3.
27. See Rosa's letter to his friend Ricciardi, 13 May 1662: Bottari 1822, 1:450; Passeri 1934, 386.
28. Baldinucci 1728, 473.
29. Mariette 1851–1860, 1:127.
30. Dussieux 1854, 2:109.
31. Engerand 1901, 611–614; Hourticq 1920, 117–136; de Lastic Saint-Jal and Brunet 1961; Duclaux and Préaud 1982.
32. Opperman 1994, 171–189.
33. Opperman 1994, 177, fig. 4.
34. Dussieux 1854, 2:110.
35. de Piles 1708, 208; English translation, de Piles 1743, 127. See the excellent discussion of de Piles in Roland Michel 1994, 213–229.
36. de Piles 1743, 129; de Piles 1708, 210.
37. de Piles 1743, 149–150; de Piles 1708, 247.
38. Watelet and Lévesque 1792, 4:37.
39. Northcote 1819, 2:90–91; see Conisbee 1976, and the biography of Vernet in this catalogue.
40. See the biography of Vernet in this catalogue, including excerpts from his "Letter."
41. Ford 1960, 51.
42. On Wilson and Vernet see Constable 1953, 28, citing the first biography of Wilson by his pupil William Hodges, 1790; see Farington 1978–1984, 7:2597 (28 July 1805); for the drawing of an artist at work, see Constable 1953, 109, and Smith 1983, 143–152, fig. 9.
43. Ford 1960, 55; however, Skelton completed this painting only a month later on 25 September 1758, Ford 1960, 60.
44. Valenciennes 1800, xviii.
45. Valenciennes 1800, 219–220, 259–260, 407.

SARAH FAUNCE

There are certain natural phenomena and certain confused ideas which can be understood and straightened out only in this country." Thus wrote Goethe in his journal on 17 March 1787, a month after he had arrived in Naples after a stay of four months in Rome.[1] This lucid yet loaded remark might only have been made by this poet and civil servant who, at age thirty-seven, had suddenly—or perhaps finally—decided that what he must do was run off to Italy. With only a by-your-leave (no destination named) from his duke, he slipped out of Carlsbad, where he had been staying with the duke and other members of the Weimar court, at three in the morning, caught the early mail coach, and headed south.[2] He spent the next year and a half arriving at the many realizations of why he had come, and of how deeply grateful he was that he had made that decision. His *Italian Journey* is, among many other things, an account of these realizations and an elucidation of that remark. For him the time in Italy was a voyage of discovery of his own mind, through the activity of close observation of both nature and art. One of the most important reasons that he came to Italy was to learn to see.

Goethe's creative intellect ranged from botany and geology to poetry, history, and art, and every aspect of the Italian landscape and culture had something from which he could learn; but he shared with other active, if less universal, minds of his time the idea of Italy as an aim, an expectation, and finally a satisfaction, a crucial experience in the development of mind and sensibility. On 3 December 1786, a month after his arrival, he wrote: "...the entire history of the world is linked up with this city, and I reckon my second life, a very rebirth, from the day when I entered Rome."[3] This image of Italy, and of Rome in particular, as essential to a complete education has become such a familiar aspect of the cultural history of the eighteenth century that it can be easily ironized and dismissed as banal. The stereotypes of the English milords on the Grand Tour, for example, or the undeniable fact that some important artists of the period were not formed by Italy, may combine to reduce, in contemporary minds, the seriousness of the role played by the idea and the experience of that journey. But we lose an important key to the understanding of the period if we do not take seriously the serious feelings of those who lived it.

These feelings were not confined to artists and poets. Charles Mercier Dupaty, a brilliant public servant (who doubtless would have been better known had he not died in 1788 at the age of forty-two), traveled in Italy in 1785, just a year before Goethe. His *Lettres sur l'Italie* already had been translated into English and published in London by 1788; like other early travel writings, the account of his experiences, although not intended as a guide, was often used as such by later travelers, one of whom was Lord

Byron.[4] Dupaty writes of spending a first sleepless night in Rome, imagining all that he is going to see, and telling himself—using a still fresh metaphor of expectation—"Here there is not a stone that does not conceal some precious information, that is not capable of helping to build the history of Rome and of the arts: learn how to question them, because they know how to speak."[5] He later visits an ancient fountain outside the city walls, then thought to be the Nympheum of Egeria, a goddess of health-giving waters and childbirth, said to have been the counselor of Numa, the son of Romulus. Meditating on the murmuring water, ancient stones, and twining plants, he writes:

> Others may bring home from Rome paintings, sculptures, medals and productions of
> natural history: as for me I will bring back sensations, feelings, and ideas; and above all
> those ideas, feelings and sensations which are born at the foot of ancient columns, on
> the top of triumphal arches, in the depths of ruined tombs, and on the mossy banks of
> fountains.[6]

Through the Romantic rhetoric one can see the writer setting himself apart from the conventional travelers to Rome, such as those English on the Grand Tour who seem interested only in the number of treasures they can transport to their ancestral homes. For Dupaty, the experience of Rome is one in which history, imagination, and the knowledge of the senses make a powerful mixture that has a unique and indelible effect on the self. It is not what he takes from these sites, either in the form of objects or pure information, that matters; it is, rather, what his own spirit makes of the experience of Rome.

This idea is echoed some thirty years later by another traveling French writer, Philippe Petit-Radel, a physician whose successful career was interrupted in 1793 by the need to leave France for political reasons. He traveled in the East Indies and the Americas until it was possible to return in 1796. In 1812–1813, he made a different kind of trip: what he called a "philosophical voyage" to Italy, the land which, unlike his other exotic destinations, spoke to him of his earliest education.[7] Following Dupaty, elaborating upon the earlier text in his own words—a not uncommon practice among the travel writers of the period—he writes:

> proud favorites of Fortune will talk, on their return, of their acquisitions of paintings,
> medals, and engraved stones; others will show off their diamonds and their precious
> vases...as for me, I will bring back only my sensations; these are my riches...acquired...
> at the foot of those immense monuments...in the depths of those ancient tombs in
> ruins...on the shady edge of fresh fountains....[8]

These sensations must be rendered into language with feeling, to convey something of the color of the objects that inspired them: "A travelling observer must, like any painter, feel thoroughly before he picks up his pen."[9] This remark indicates his interest not only in the historical significance but also the visual qualities of the places he describes. At Tivoli he writes of how nearly impossible it is to describe "the lively countenance of these beautiful places," which have so often been given visual form by the painter's art; but for a writer, despite his limitations, "how can he remain silent at the sight of this view which awakens so many feelings, even in the most indifferent!"[10] The views of Tivoli, he writes, are so many pictures in themselves. This phrase, already current in the travel literature, is the writer's way of establishing the intrinsic

and authoritative beauty of the sites, and this beauty is the source of the feelings that will be his permanent treasures.

The attraction of Italy for transalpine culture was, of course, well established by the middle of the eighteenth century; from the sixteenth century onward, a growing number of scholars and artists, collectors and prelates, were drawn to the city that was the center of both the Christian church and the classical civilization it had displaced and was in the process of rediscovering. In their wake developed a vast literature of travel, which, in time, became a subject of study in itself.[11] The emphasis on subjective experience and feeling that begins to emerge in this literature in mid-century goes hand in hand with a new awareness of landscape. Earlier writers focused firmly on monuments and works of art, with all their attendant history; those of the second half of the eighteenth century, while not necessarily neglecting the monuments, give increasing attention to their natural settings, and to the thoughts and feelings that these juxtapositions can arouse. This attention takes many forms. It is still rudimentary in the eight majestic volumes of Joseph-Jérôme Lalande's *Voyage en Italie*, first published in 1768 with several later editions (it was Goethe's guidebook, in its German adaptation by J. J. Volkmann). Lalande was thoroughly versed in the travel literature of his time, and concerned primarily with providing all of the information available in a period when interest in archaeology was high, but the science was in its infancy. Occasionally he will stop to point out the "belles vues" that should not be missed; of the villages near Lago Albano he writes that "the landscapes that one sees there are very suitable for painters' studies."[12] It is a long way from this to the soul-expanding experience at Tivoli described by Petit-Radel; and longer still to that of Madame de Staël's fictional lovers, as they wend their way through the hilltop villas of Rome in *Corinne ou l'Italie* (1807):

> One sees from there [the Villa Mellini] in the distance the range of the Apennines: the transparency of the air colors these mountains, unites them and shapes them in a singularly picturesque manner. Oswald and Corinne stayed in this place for a while in order to enjoy the charm of the sky and the tranquility of nature. One can't have an idea of this exceptional tranquility without having lived in the southern countries....
>
> Don't you think, said Corinne as she and Oswald contemplated the Campagna that surrounded them, that nature in Italy inspires the imagination more than anywhere else? One could say that here nature exists more in relation to mankind, and that the Creator makes use of it like a language between himself and his creation.

Of the view of the Campagna and its ruined aqueducts from the Villa Borghese, de Staël writes: "Everything is there for thought, for imagination, for reverie. The purest kind of sensation mingles with the pleasures of the soul and permits the idea of a perfect happiness."[13]

Such excerpts may create the impression that the author and her surrogate central character were possessed of an entirely idealizing view of the Italian environment, with no awareness of such darker aspects as the backwardness and poverty of the citizens of the ill-managed papal states. Such awareness is in the novel, but here the focus is on an idea of the concurrence between nature and the human mind that de Staël had developed from her reading and in conversations with the German writers, particularly the brothers Friedrich and August Wilhelm von Schlegel, who consciously used the term "Romantik" to describe their philosophical and literary project. Accepting the

Romantic idea of nature not as Other but as being in a coherent and knowable relation with mankind, she both uses the idea to express the beauty of Italy and uses Italy to demonstrate the truth of the idea. That *Corinne* is a novel does not make it a surprising place for the expression of such ideas. Travel writing took varied forms, from the epistolary to the didactic; the novel was another, and for Byron, so was the epic poem. In this romantic tale of doomed love (in itself rather protracted) de Staël took on large issues of the cultural differences between South and North, and constructed a complex picture of all the qualities that gave Italy such an importance to her own time. The combination of an evocative past, present in the form of majestic ruins, a topographical setting that presents vistas into space as well as time, and a natural abundance generous to the body and spirit, provides the mixture of which the Italian experience was made.

Some of the impulse to write a novel set in Italy, and the consequent five-month sojourn there (primarily in Rome), came through her literary friendships with such admirers of the country as Goethe and August Schlegel (her childrens' tutor and traveling companion to Rome in 1805).[14] There she found a ready guide in Wilhelm von Humboldt, the brilliant scholar from Berlin, recently appointed as Prussian ambassador in Rome. Humboldt's letters from Rome are another locus for the expression of the profound feelings aroused by the experience of the city and its countryside:

> You too, like me, have often heard about the charm of Italian places. I had always made little of this, and considered it as unfounded. But on the sites I was convinced. The secret is that things here are so shaped, or their position is so delicious, that the Great does not have to be large in order to seem so. What one sees here, one dares to say, bears the shape of art and imagination. One sees it again and again and always with pleasure, one looks at the details and finds nothing which would be exceptional in itself—not the high rocks of the mountains, not the old oaks of our forests, not the big romantic lakes of Switzerland—but one looks at its totality and it is a picture...that makes the soul quiet, causes melancholy but also increases clarity of mind and does not destroy happiness.... I feel also happier here myself....I am more awakened to ideas and more productive in all points of view. I have lost nothing of the sense I had formerly, and for many things a new sense has developed in me.[15]

These writers, and others like them, experienced Italy—and the Roman region in particular—as a kind of laboratory for the profoundly new ideas of the relation between man and nature that were emerging in their own northern countries and to which they were contributing in their own work.

Something akin to this could be said about the open-air painters in this exhibition, who like the writers were both responding to and helping to create this new understanding. Of the painters who came to Rome to study, those interested primarily in landscape were in a distinct minority. Their numbers increased after 1800, particularly after 1815 with the end of the Napoleonic empire, and by the 1820s the landscape painter was a distinct type on the Roman scene. As Peter-Klaus Schuster has said of the German landscape painters in Carl Blechen's time, they looked to Italy as their academy of realism; it was the place to go to learn from fellow artists and to participate in the search for the painterly equivalent to their experience of light and landscape.[16] This was also true for the French painters, though they were shaped more powerfully by the theoretical tradition of the Academy, which, though it dominated the rest of

Detail, cat. 40, von Rohden, *The Waterfalls of Tivoli*, 1808–1815

Europe, had its origin and center in Paris. This tradition had long emphasized the distinction between the real and the ideal, nature as it is and nature as it should be. This hierarchical approach inevitably downgraded landscape painting as such, even as it provided a strong visual formation based on the paintings of Claude and Poussin. In these models, nature was presented as it ought to be; at the same time their landscape imagery was synthesized from observations and drawings in Rome and its surroundings. Philip Conisbee's essay in this catalogue traces the way in which artists in Rome were, during the course of the seventeenth and eighteenth centuries, increasingly encouraged to work from the abundance of beautiful sites available to them — a trend that might be summed up in Charles-Nicolas Cochin's advice to a student at the French Academy in the 1770s: "In Italy nature is so beautiful that you must take advantage of your stay to study as much as possible."[17]

This development demonstrates a new insight into the relationship of the painter and his subject, played out in terms of studies directly from nature. It also shows the way in which this insight developed among the sites and terrains in and around Rome. In a sense, Italy came to represent the fusion of the real and the ideal, those concepts that were so strictly segregated by the theory of the Academy. In concrete terms this meant that the real became the ideal; whether it was Johann Georg von Dillis looking out over the panorama of Rome or Corot painting in Civita Castellana, the question at the moment was "what do I actually see, and how can I make an image of my seeing?" The idea of landscape painting for its own sake, as a means of and metaphor for understanding man's relation to the earth, was being born in this process, which was not a simple one. Even as landscape painting rose in academic status, it remained within the limitations of classical composition and narrative content. The young painters studying landscape motifs in Italy were, as Peter Galassi has shown in his study of the young Corot, still very much a part of the academic system, and looked upon their outdoor studies as a private library of exercises and motifs, which in a few cases were intended for future use in paintings composed for exhibition. At the same time, by selecting their particular motifs and recording in paint their perceptions of a particular place in a particular light and atmosphere, they made objects that convey the power of feeling behind their search.

The painters were working in what might, borrowing from Simon Schama, be called the landscape of memory, in a very obvious sense. They were aware not only of Poussin and Claude, but were also sufficiently aware from their early education in Roman history and literature to be moved by the experience of walking where ancient heroes (and villains) had walked, and the glorious hills behind Tivoli were even further enhanced by the ghost of Horace. At the same time, the painters who studied the way that moss and wildflowers grow on tufa or on ancient stones, the way that the buildings of Civita Castellana seem to grow organically from its steep cliffs, or the way that the Sabine Hills frame the Roman Campagna, were discovering in terms of oil painting the truth of what Nicolas Vleughels, an earlier director of the French Academy in Rome, had told his students: drawing at the sites would "kindle their genius."[18] One has only to see how widespread the practice of open-air painting had become by the early nineteenth century — and how eager the young artists were to engage in it — to know that they were not entirely motivated by theory or by career needs, and that the studies had a more than utilitarian meaning for them. François-Marius Granet, for example, who survived in Rome — at least before his ecclesiastical

fig. 1. G. B. Nolli and G. B. Piranesi, *Small Map of Rome*, 1748, engraving on paper, 47 × 68.8 cm. The Arthur Ross Foundation, New York.

interiors became popular—on selling finished Roman views to visitors, possessed at the time of his final departure for Paris, in 1830, some one hundred oil studies done from nature, in Rome and its environs, most of them probably during his first decade there. In his memoirs he relates the harrowing tale of being detained and searched at the French border by surly customs officials, who ripped opened the package of studies and refused to allow him to carry them to Paris. The story ends well, with an official order from Paris to return the studies to their owner, for whom they provided "some consolation for being so far from my beautiful models."[19] They were both memories of the place he loved and a record of his own work; of no practical use to him this late in his life, they were embodiments of his own experience that it would have been terrible to lose.

Granet came to Rome in 1802 from his native city of Aix and from Paris where he was a student of David. In addition to the example of his fellow citizen of Aix, Jean-Antoine Constantin, it was the enthusiastic talk in Paris of other painters who had been to Rome that made him eager to go; but it was Rome itself that lured him to stay—with some interludes in Paris—for twenty-eight years. When he arrived in the city, Rome had an estimated 150,000 inhabitants, living in little more than the area of what is today called the *centro storico*.[20] The city was defined by the Aurelian Wall of the third century A.D.; but Nolli's 1748 map of Rome shows that the whole eastern half and southern quarter of the enclosed space, as well as part of Trastevere, was rural, parceled into small fields that were part of villas large and small (fig. 1). Lalande notes

in the 1760s that "Two thirds of the space enclosed by the walls is occupied by gardens and country houses, large and small."[21] Petit-Radel in 1812 reports the same, though indicating that some of the open land was at that time uncultivated. Thus the Roman Forum, the Palatine Hill, and the Colosseum lay at the edge of the city, beyond which were wooded hills and fields. It was these ancient monuments in their rustic settings, together with the great hilltop villas on the Pincio, Monte Mario, and the Janiculum, with their vast parks and views, that most often attracted the outdoor painters. The papal city of noble churches, palaces, fountains, and piazzas—the subjects of the "vedute di Roma," published by Giovanni Battista Piranesi and Giuseppe Vasi—was theirs to see and admire and learn from; but the subjects they chose to study did not lie in that direction.

Writing his own book of letters from Italy in 1797, the young painter and later critic Antoine-Laurent Castellan addressed one "letter" from Rome to a group of art students in Paris, "young artists who shiver at the very name of Rome." He tells them of his excitement at the prospect of going to see the Pantheon, the Column of Trajan, St. Peter's, and other basilicas; but when he speaks of the richness of motifs for the artist in Rome, he writes not of the baroque city with its incorporation of ancient monuments but of the

> ...banks of the Tiber, the hills of the city, the shape of its walls, the piling up of its immense ruins, the admirable variety of its gardens which bring the countryside inside the city walls, all will furnish the painter with motifs to study....There is not an out-of-the-way street, not an empty ground (*terrain vague*) that does not provide the occasion to exercise his brushes.[22]

These are the sources of motifs in Rome, not that he has personally chosen, but that have already been established as the most frequent among his artist acquaintances there. The emphasis is on the infinitely varied combinations of ancient structures with natural features that Rome provided, as well as on the power of the artist to create meaningful imagery from such unpromising subjects as out-of-the-way streets and *terrain vague.*

Castellan concludes this letter with a vignette of his chance meeting, while drawing in the Villa Borghese, with the German painter Johann Christian Reinhart, also at work on a drawing. He was flattered by the attention of the artist who was one of the earliest of the Germans to come to Rome, and who had since 1791 established himself both as a painter and engraver of landscape subjects, and as a guiding figure to young landscape painters. They walked together along the Pincian Hill, admiring the views of the Campagna and even, as it was possible to do then, the summit of Mount Soracte, rising from the plain some twenty-five miles up the Tiber valley to the north (fig. 2). We know very little about how often such casual encounters between painters might have taken place in Rome, but the potential for them was there, and not only because the artists were often attracted to work in the same sites. The part of the city where visitors of all kinds found lodgings was limited, consisting of the streets leading southeast into the city from the Porta del Popolo, where everyone entered from the north: the first part of the Corso; the Via Babuino with its adjoining streets; the area around the Piazza di Spagna; and from the height of Trinità dei Monti down the Via Gregoriana and the Via Sistina as far as the first part of the Via delle Quattro Fontane. It is not a large area, and within it were such places as the Caffè Greco and the Span-

fig. 2. Johann Christian Erhard, *Ponte Solario with Mount Soracte in the Distance* (detail), 1820, watercolor on paper, 14 × 20 cm. Kunstmuseum Düsseldorf.

ish Tavern, which provided sustenance and a place to meet. The French artists had their own institution, the Academy, which from 1725 until 1793 was located in the Palazzo Mancini in the Corso; by 1803, after suspension by the revolutionary government and reinstatement by Napoleon, Talleyrand had negotiated with the pope to acquire the Villa Medici on the Pincian Hill for the Academy. This outpost of the Académie des Beaux-Arts in Paris was established to receive the winners of the Prix de Rome, and its *pensionnaires* were primarily history painters, but it also served as a center for the French artists such as Granet, Corot, and many others who were not themselves members of the Academy. Even during the shutdown of the parent Academy in Paris in the 1790s, a skeleton group of students was maintained, and, of course, French artists continued to come to Rome on their own—some of them, like Madame Vigée-Lebrun, fleeing from the revolution because they had found patronage with the royal family. Vigée-Lebrun lodged with Simon Denis, a landscape painter who had come to Rome from Brussels in 1786 and who had married a Roman woman and settled there. He was ready to help her with practical problems and to take her on trips to Tivoli and the Alban Hills, where she made many landscape sketches.[23] This was the same M. Denis who gave useful advice to Granet when he first arrived in Rome in 1802.[24]

The German artistic presence was already well established by the 1780s when Goethe arrived to live in a house on the Corso: his good friend was Angelica Kauffmann, and he deliberately spent his time in Rome in the company of German painters, among them Johann Heinrich Wilhelm Tischbein and Jakob Philipp Hackert, both for what they had to teach him about drawing and seeing and because he wanted to avoid being trapped in the literary and social circles. There was no institutional center for the German-speaking painters, but as their numbers grew they made their own social group, the Ponte Molle Society, which held annual costume and drinking parties in the Campagna. By the 1820s the Caffè Greco had a large German contingent. Friedrich Wasmann, writing about his time there in the early 1830s, describes (naturally from a German perspective) the way in which each nationality

staked out a territory in the narrow suite of rooms: near the front door the French could be heard, chattering about politics "like a hedge of canaries"; the Germans had to sit very close to each other to hear above the din, and were always being asked to move a bit further back, at which point they came up against the English, who had reserved for themselves the farthest room at the back, where they talked in low and exclusive tones.[25] When the young Ludwig Richter woke up after his first night in a Roman inn, he went straightaway to the Caffè Greco, hoping to meet someone he knew, and there was his friend Carl Wagner, who immediately settled him in an apartment in his building.[26] Joseph Anton Koch and Reinhart were important members of the older generation, whose studios were essential first stops for the growing band of young landscape painters arriving in Rome (the distracted official who took Richter's passport at the Porta del Popolo listed his name as Signor Landschaft). The crown prince of Bavaria, Ludwig I, with his frequent presence at the Villa Malta on the Pincian Hill, was a major source of social life and patronage for the large number of German artists in his circle. Prince Ludwig, to whom Dillis was a mentor, was the contemporary of the German painters who came to Rome in the 1820s, and he made drawings with them as well as joining actively in their social life (fig. 3).

A social and artistic center for the Scandinavian painters, as well as for the Germans and others, was the studio of the renowned Danish sculptor Bertel Thorvaldsen, who made his career in Rome, living for much of that time in the Casa Buti, now no. 48 Via Sistina (see Eckersberg, cat. 54). Thorvaldsen was especially appreciated by the artists in Rome, both local and foreign, because he bought their work; his collection, now in the Thorvaldsen Museum in Copenhagen, included paintings of Italian subjects by Franz Catel, Johan Christian Dahl, Heinrich Reinhold, Pierre-Athanase

Chauvin, and Reinhart among others, as well as by such Italian artists as Giovanni Battista Bassi and Vincenzo Camuccini. The most famous, successful, and best connected of these artists before 1820 was another neoclassical sculptor, Antonio Canova, whose work and advice were sought by everyone, including Napoleon. He was, however, not so grand that he was not available to look at the work of beginners, such as Granet, to whom he gave professional advice.[27]

Artists like Granet and Catel, who settled in Rome early in the century, were able through such connections to come to the attention of one of the principal patrons of contemporary artists in Rome, Elizabeth, duchess of Devonshire. The duchess, residing in Rome from 1815 until her death in 1824, was active in supporting archaeological projects, initiating publications that involved the artists as illustrators, and buying their work. Her salon was a gathering place for everyone of interest in Rome, from artists and writers, to cardinals and visiting princes. Stendhal wrote that she was the only one of the English living in Rome who had been able to become part of Roman society.[28] This was not simply because of her title, but because she had a very sympathetic attitude toward art and artists, as well as a cosmopolitan outlook. At her salons people of all nationalities would meet. Other meeting points for the painters were the exhibitions organized for the most part in artists' studios, beginning in the late teens, and in the transactions between the more established painters and potential buyers. Stendhal, while criticizing the behavior of the English in Rome, provides a vignette of the painters' life in this connection. Normally, he writes, the painters sell directly to those who come to their studios; prices are well known and discussed in cafes and salons. Some English buyers, however, quiz the painter about how long it took to paint such and such a picture, and then offer a price-per-day amount well below the stated figure. As a result, many artists sell to English buyers only through agents, who charge much more than the studio price — and this amusing situation is also talked about in the salons and cafes.[29]

The part of Rome where, as Castellan put it, the ruins piled up and the countryside was to be found inside the city, existed in the most concentrated form on its southeast edge, where the Roman Forum stretches to the Colosseum in one direction and rises in another to the maze of ancient structures on the Palatine Hill. Since medieval times the Forum had been known as the Campo Vaccino — the cow field. The rough ground that had risen to cover all or parts of the remaining monuments and architectural fragments was used as a cattle market and pasture for grazing cows and sheep. Hackert's watercolor of the 1780s, showing a view from the edge of the Colosseum with a herd of cattle moving toward the eastern entrance of the Forum, makes clear the deserted, rustic character of the area (fig. 4). An engraving by Vasi, from his series of Roman sites in the 1750s, shows the two side arches of the Arch of Septimius Severus filled with earth to almost half their height, a condition that did not change until the end of the century (fig. 5). By the mid-1820s, when Louise-Joséphine Sarazin de Belmont was in Rome, a program to clear out the Forum for archaeological excavation had made considerable headway. A number of modern structures that cluttered the space had been removed, and the layers of dirt around the Arch of Septimius Severus had been carted away, revealing its full height and thus establishing the original level of the entire area. Initiated in 1802 by Pope Pius II in the wake of the first French inva-

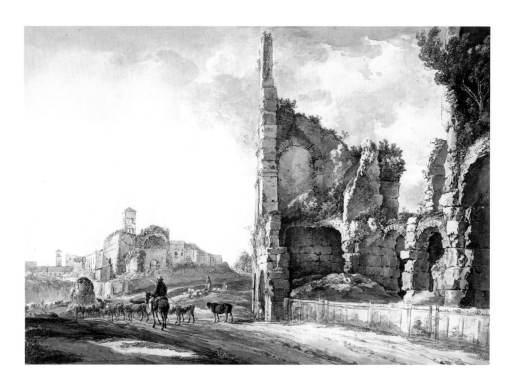

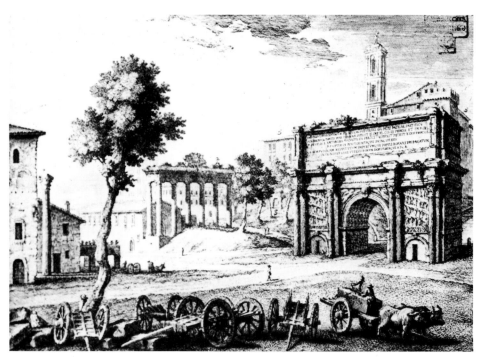

sion, this archaeological project was expanded throughout 1809–1814, when Rome was the prize of Napoleon's empire, and was continued after the restoration of papal rule. Professor Antonio Nibby, one of the leaders of the project and author of the most archaeologically up-to-date guide to Rome of the period, wrote in his 1824 edition that the "vile denomination" of Campo Vaccino had now disappeared, and the site was now known as the Forum Romanum.[30] That was somewhat wishful thinking, however; neither the name nor the cows went away immediately. The latter can be seen in Sarazin de Belmont's near-topographical painting, together with a by-then familiar figure of an artist, focusing on a study of the three surviving columns of the Temple of Vespasian (fig. 6).

TOP: fig. 4. Jakob Philipp Hackert, *The Colosseum with the Temple of Venus and Rome*, n.d., watercolor on paper, mounted on cardboard, 37 × 53 cm. Biblioteca Apostolica Vaticana, Rome, Thomas Ashby Collection.

BOTTOM: fig. 5. Giuseppe Vasi, *Parti di Campo Vaccino*, engraving on paper, from *Magnificenze di Roma Antica e Moderne* 1752, 2: pl. 31.

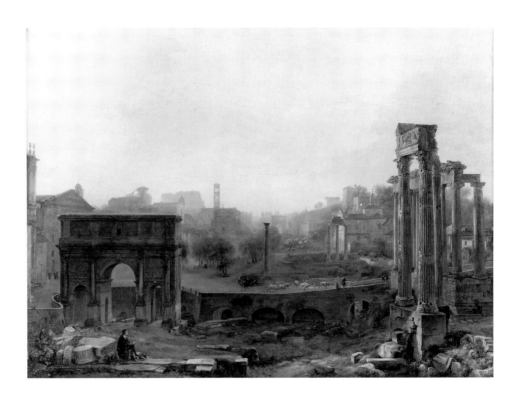

fig. 6. Louise-Joséphine Sarazin de Belmont, *View of the Forum in the Morning*, c. 1825, oil on canvas, 60 × 62 cm. Musée des Beaux-Arts, Tours.

If the Forum seems to have become a common motif for the outdoor painters only in the 1820s, the Colosseum had been an important subject as early as the late 1770s, when Granet's teacher Constantin was a young man working in Rome (cat. 26). Already in the 1760s, Lalande, whose primary concern is to provide an architectural and historical overview of the monument, notes the vegetation growing from the stones and the views onto the gardens and other ancient structures that suddenly appear through the arches to form "one of the most agreeable places for artists and people of taste."[31] Granet reports in his memoirs that after looking at all the monuments on his first tour around Rome in 1802, he chose the Colosseum as the place in which to begin painting.

> That monument had struck me as so handsome both for its remarkable form and for the vegetation that enveloped its ruins, and it produced such an enchanting effect against the sky! You find growing on it yellow wallflowers, acanthus with its handsome stems and its leaves so beautifully edged, honeysuckle, violets — in short, such a quantity of flowers you could put together a guide to the plants from them. Alongside this natural wealth, you have shadowy passageways, with a light so well contrived that no painter with a modicum of taste for color and effect could resist the urge to do studies of it.[32]

Granet's choice was also doubtless influenced by his knowledge of Constantin's work in the Colosseum, which he continued with his own oil studies made in different corners of the monument; in their idiosyncratic choices of viewpoints they may not have measured up fully to Lalande's classical idea of taste, but they were lively and original. They were also exemplary of the outdoor painters' approach to the phenomenon, so richly to be found in Rome and in special abundance in the Colosseum, of the interaction of vegetation with ancient brick and stone. It was an archetypal theme, and not to be understood solely as an aspect of the taste for the imagery of classical ruins that had been well established by the later eighteenth century, in the work of

Hubert Robert and others. For these open-air painters, attuned to the values of pure landscape, this theme did not have the primarily literary connotation of Nature overwhelming Culture, arousing sentiments of nostalgia for bygone grandeur. Their response was essentially visual, to the startling beauty of the intimate juxtaposition of vivid natural growth and architectural form, whose power remained undiminished by fragmentation. Nature was abundant life, springing from the cracks of ancient stones as testament to the ability of the past to endure and to create another form of magnificence. The Colosseum was experienced as a kind of amazing gigantic laboratory in which to explore this magnificence, providing as it did a multiplicity of viewpoints and ways of trapping the light in its complex of arcades. This campaign of visual discovery among the complex structures of the monument was taken up by Achille-Etna Michallon, Gilles Closson, Ernst Fries, Corot, and many others in addition to Granet. Granet's comment about the monument's providing the material for a guide to the plants was more accurate than he knew, for the Colosseum had its own ecosystem of three to four hundred specimens.[33] It is not surprising that Granet was shocked and horrified to find, on his return to Rome in 1829 after a four-year stay in Paris, that much of this vegetation had been removed for conservation purposes; to him, it was a profanation of a majestic monument.[34]

No such defoliation had taken place in the third and most "Romantic" of this triad of ancient grandeur: the Palatine Hill, with its extraordinary accumulation of ruins, at the top of which lay the remains of the enormous gardens built by Cardinal Alessandro Farnese in the late sixteenth century. The Farnese Gardens were terraced up from the Forum and built over the ruins of the palace of Tiberius and those of other emperors. More or less abandoned by the cardinal in favor of other projects, and left by his heirs to vegetable cultivation and some eighteenth-century excavations, the gardens and the large area of Roman architectural ruins surrounding it formed an impressive and haunting site. In the early 1780s it was one of Pierre-Henri de Valenciennes' favorite places to go and paint, providing a wealth of motifs among the maze of stone and terra-cotta brick walls and arches, hung with moss and laurel and standing among cypress, oak, and pine (see cats. 15, 16). It must have appeared to him as a kind of glossary of elements from a Poussin background, the very images that had shaped his eye and enabled him to frame his own studies. But it was the actual contact with the source, the love of the place and the knowledge gained through direct perception, that gave life to these studies and that allows them to convey the reality of the painter's experience.

Looking out from the hills of Rome to the east, from north to south, the viewer could see the ranges of the Sabine Mountains and the Alban Hills as they framed the low, open land of the Campagna. Whereas the city had long been an attraction and a source of imagery, this expanse of the Campagna, long uncultivated, frequented only by herdsmen and their flocks and punctuated occasionally by the ruins of aqueducts and tombs, had remained outside the visual vocabulary. The traveling writers of the eighteenth century, approaching Rome from the north, treated it as so much dreary, featureless space to be gotten through, down the Via Flaminia or the Via Cassia, before one arrived at the Ponte Molle, close to the gates of Rome (see map p. 70). For Dupaty, invoking the readily available "how are the mighty fallen" theme,

Detail, cat. 52, Knip, *Lake Albano with Palazzolo,* c. 1810-1812

the emptiness was mentally populated with visions of the caesars, the legions, and triumphal chariots that had filled the road in which now only the occasional pilgrim or beggar were to be seen.[35] Even Petit-Radel, with his eye for landscape views, could not make anything of the view along the Via Cassia: "From Nepi to Rome the view is very melancholy, the eye finding nothing on which to focus itself."[36]

Another kind of writer arrived in Rome in May of 1803. François René de Chateaubriand, temporarily on good terms with Napoleon, had been appointed by Talleyrand to the post of secretary to the French legation in Rome, soon to be headed by Napoleon's uncle, Cardinal Fesch. The highly independent Chateaubriand was at thirty-five already the veteran of an emigré voyage to America, active service with the royalist armies, and exile in England, and was newly celebrated for his controversial book, *Le Génie du Christianisme*. Lacking the temperament for a junior diplomatic position—he took the liberty of visiting the pope before the arrival of Fesch (whom he later privately characterized as "un sot") and of discussing theological points with the pontiff—he was dismissed by November and left Italy in January of the following year.[37] The result of this episode was an extensive series of essays on his travel in Italy, written with a clear eye for the qualities of the landscape. One of the best-known passages of the *Voyage en Italie* is the "Lettre à M. de Fontanes," which he begins with an extensive description of the Campagna: its vastness, its solitude, its unbroken silence, its dearth of growth and activity. But, he writes, it would be a mistake to think of this landscape as a frightful place; on the contrary, it has an "inconceivable grandeur": "Nothing is comparable in the way of beauty to the lines of the Roman horizon, to the gentle undulation of its planes, to the suave receding contours of the mountains that close it off."[38]

He describes how the hills at the horizon bound the Campagna, sometimes in such a way as to make the valleys seem like enclosed arenas; how the quality of the air defines objects, and how the light penetrates everywhere, with a harmonious tone. He writes of walking up the Tiber to the Ponte Molle at the end of the day to see the changing colors of the Sabine Mountains across the Campagna and to observe the changes in color and cloud formation above the land, empty except for a few semiwild cattle coming to drink from the river. Twenty-five years later, in his *Memoires d'outre-tombe*, he credits himself with discovering the beauty of the Campagna, now recognized by all the English and French travel writers who have followed him in their praise.[39]

But while Chateaubriand may have opened the eyes of these writers (the "Lettre à M. Fontanes" section of the *Voyage en Italie* was published as early as 1804), the open-air landscape painters had begun to look at the Campagna in a new way before he ever arrived in Rome. Valenciennes painted in the countryside near Rome, and both Granet and the German painter Johann Martin von Rohden worked extensively in the Campagna in the first years of the century. The remarkable Massimo d'Azeglio, the aristocrat from Turin who was a member of the landscape-painting community in Rome in the 1820s, before he became an important figure in the struggle for Italian unification, wrote in his memoirs:

> Although the antiquities and remains of Roman grandeur failed to attract me, I was enormously impressed by the still greater and more permanent grandeur of the Campagna...a region that will always be the love, poetry and desperation of artists.[40]

fig. 7. Jean-Baptiste-Camille-Corot, *La Promenade du Poussin*, 1826–1828, oil on paper, mounted on canvas, 33 × 51 cm. Musée du Louvre, Paris.

It was an area where the painters took a wide panoramic view in their small-scale studies, making images of the pure elements of land and sky, in which the structures of the Romans, the bridges and the aqueducts, were dwarfed by the unbroken space around them. Stendhal, traveling on a coach out of Rome toward Naples on the Via Appia, gives us a typically brief but vivid insight into the experience of the Campagna:

> Magnificent view of the Appian Way, marked by a suite of monuments in ruins; admirable solitude of the Roman Campagna. How to describe such a sensation? I went through three hours of the most singular emotion; respect was a large part of it.[41]

Stendahl recognizes the limitations of verbal description in the face of this particular landscape experience, which is the more complex for being at an early stage in the culture: it is more readily evoked in the oil studies made by Valenciennes, Granet, Corot, Blechen, and others who responded to the fascinating desolation of the Campagna.

This experience of silence and untrammeled space could be had just outside the walls of Rome, as well as further out toward the mountains. The French painters in particular had in mind the example of Poussin, whose traditionally favorite walk along the Tiber north toward the Ponte Molle, known as the "Promenade de Poussin," began less than a mile from the Porta del Popolo. In Corot's study of this site, he does not dwell on the potentially picturesque aspects of the place that might recall the background of a Poussin painting, but rather emphasizes its silence and emptiness (fig. 7). A mile or two northeast of the Porta del Popolo was the Acqua Acetosa, a spring with a baroque fountain structure that rose on the isolated riverbank (see Eckersberg,

cat. 57). In the hot July of 1887, Goethe would walk from his lodgings in the Corso in the early morning to drink its healthful mineral water.[42] Farther out toward the east, the Via Nomentana led to the river Aniene (then called the Teverone), flowing from the mountains behind Tivoli through the Campagna and joining the Tiber before it entered Rome. This was another favorite site of the outdoor painters, the Ponte Nomentano, which had a Roman arch over the river and a once-fortified medieval tower. Its sturdy, simple shape was always seen as isolated, either against its own stretch of the Campagna, as in Corot's painting in Rotterdam (cat. 101), or against the wider panoramic space of the Campagna with the Sabine Mountains at the horizon, as painted by Fries (cat. 82) and others.

To work in the Campagna at the edges of Rome required a day's walk out and back; any farther destinations involved a trip of days or weeks. It was possible by carriage to make a day's round trip to Frascati or Albani, the closest towns in the Alban Hills, but for the landscape painters this was highly impractical. The ancient volcanic hills that rose from the Campagna, surrounding the two crater lakes of Albano and Nemi and supporting a richly forested and cultivated land, were a regular feature of a traveler's visit by the eighteenth century. The history of the region went back to the son of Aeneas, legendary founder of Alba Longa, and Tarquinius Superbus, ruler of Tusculum—both settlements early absorbed into the structure of Rome. By Augustan times they were the site of country villas of such notables as Cato and Cicero. The appellation "Castelli Romani," by which the region is often known, refers to the medieval period when Roman patricians and papal officials built fortified castles in these hills, around which the towns later developed. By the sixteenth century, the hills were again home to country villas for the great Roman families. The town of Castel Gandolfo, with the dome of Bernini's St. Thomas silhouetted high above Lago Albano, was built in the seventeenth century as Pope Alessandro Chigi's country retreat. Frascati by the later eighteenth century had several large sixteenth- and seventeenth-century villas, some already in a neglected state, and most of them apparently easy for writers and painters to visit. Ariccia was the site of the Palazzo Chigi, a Renaissance structure modified by Agostini Chigi in the later seventeenth century and best known to painters for its large park, kept by its late eighteenth-century owner, Sigismondo Chigi, in a wild, semiforested style.[43] Ariccia was also known for its Locanda Martorelli, a small palazzo on the main square that in 1820 had been made into an inn especially hospitable to painters. D'Azeglio, staying there in 1826, gives us a rare if brief look at the painters' life:

> In the year 1826, Martorelli's inn, full from top to bottom, could have been called "Inn of the Four Nations," except that there were many more nationals than that in residence.
>
> One long table took us all at mealtimes. I got to know several at table who, young then, were starting their careers in art. Many of them were French and I got on well with them—really charming people.
>
> Every morning we each went off with our paraphernalia to find places to paint from nature. At dinner-time we all deposited our work in the common room, which thus served as a permanent exhibition. This was most useful as it encouraged competition.[44]

These hills with their two lakes, their villages perched on hilltops, their rich growth of oaks and chestnuts that often formed canopies over the roads leading from one town to the next, their multiple points of view over the Campagna and to the heights

from the lakeside or valley, were filled with motifs for the outdoor painters. If anything, there was a risk of succumbing to an excess of the picturesque. Valenciennes, the earliest artist known to have painted there in the open air, avoided this by studying a natural phenomenon of the region that travel writers and guides would normally ignore: the way in which the highest hill, Monte Cavo, with the medieval village of Rocca di Papa climbing up its northeast flank, holds a wide and seemingly permanent cap of mist on its summit between falls of rain (cat. 21).

Petit-Radel, with his eye for landscape qualities, wrote admiringly of the walk along the high road around Lago Albano, describing

> the lake and all the amenities of its verdant borders....It is surmounted by hills and knolls that give it a very attractive screen....the whole group of hills near and far provides at every step a variety of views which are bound to be of interest to lovers of beautiful natural scenery; but one should stay a long while to savor all of its charm, and return several times to its pleasures.[45]

This last remark provides a clue to the writer's seriousness about landscape. The views at Lago Albano are not dramatic or overwhelming or of the type commonly thought of as making up the usual tourist sites or the Romantic repertory; but Petit-Radel, shaped by the new perceptions of his time, shows that the deeper and quieter pleasures of landscape belong in that repertory as well, because they are part of a new way of connecting the human emotions to the shape and being of the land. The Dutch artist Joseph August Knip was in Rome during the same years as Petit-Radel, 1810–1812, though they were almost certainly unknown to each other. Knip made a magical painting of the view across Lago Albano from the west toward Monte Cavo (cat. 52), which provides an image of just that depth of observation and pleasure in landscape—and the intimate connection between the two—that the writer seems to be suggesting, but which can perhaps best be conveyed by the art of painting.

The other major site, only a few miles farther from Rome, that had long been established as a destination for travelers and artists alike was Tivoli. East of Rome at the edge of the southern ranges of the Sabine Mountains, Tivoli was beautifully sited on the first rise of the Monti Tiburtini, visible from Rome against the background of the dun-colored mountains. Like the towns of the Alban Hills, it had been an ancient Roman resort—known as Tibur—of fresh air and *villegiatura*, especially noted for the fact that the renowned poet Horace had lived nearby in the last quarter of the first century B.C. His independent life in the working countryside of Tivoli had been made possible by his patron Maecenas, whose proper name eventually became the common noun for a great and wise patron of art, and therefore attractive to artists. For centuries, before modern archaeologists found it to be part of a temple of Hercules, the arcaded ruin along the northeast slope of the town was called the Villa Maecaenae; perhaps it was the artists who helped to keep the name alive as long as possible. The most celebrated of the ruined villas in the region was, of course, the immense group of structures built on the plain to the southwest of Tivoli by the emperor Hadrian in the second century A.D. Lalande tells us that in the middle of the eighteenth century the vast ruins were still a source, as they had long been, for purloined sculptures and architectural ornaments. At the same time, attempts were being made, by Piranesi and others, to understand the nature of all the various structures—copied, at Hadrian's eerily postmodern behest, after existing monuments in the

fig. 8. Johann Christian Reinhart, *Ruins in the Villa Hadriana*, c. 1792–1798, watercolor and ink on paper, 33.8 × 48.5 cm. Private collection, Munich.

ancient world. It could not have been an easy task. When Chateaubriand visited Hadrian's villa in 1803, he found a farm in front of the amphitheater, complete with fruit trees, black pigs, and a well built with fragments of ancient columns.[46] The ruined structures of the villa encouraged a rich growth of vegetation, creating that juxtaposition of energetic botanical growth with decaying yet formally impressive stone that so stimulated the artists, as seen in the intensity of Reinhart's watercolor of the late 1790s (fig. 8).

From the plain of Hadrian's villa can be seen the nearby slopes of the hills in which Tivoli is set. A painting by Poussin in the Montreal Museum of Art, *Landscape with a Man Pursued by a Snake*, contains in the background a view to the Campagna that is unusually empty of the composed architectural features that normally structure the distances of his paintings. In this work, the distance is depicted with realism: the pale umber solitude of the Campagna is closed off by the dusty blues of the hills, on one of which there is a small patch of lighter color that could easily represent Tivoli; this is how it looks from the hills of Rome. Visitors had long been drawn to its antiquities, its greenery, and above all its waterfalls. In the sixteenth century, Cardinal Ippolite d'Este built a villa with an elaborate terraced park of fountains, sculptures, and descending waterways. Such a garden was popular with both tourists and artists, but from the mid-eighteenth century onward the greater attraction was the watercourses that had only been minimally engineered by mankind: the Grand Cascade and the Cascatelles of the river Aniene as it dropped tons of water over the mossy rocks into the valley on its way to Rome. Richard Wilson's *Tivoli: The Cascatelli Grandi and the Villa of Maecenas* (cat. 1) shows a painter at the site; the figure of artists drawing the cascade from various viewpoints is a regular feature of eighteenth-century imagery (fig. 9). No travel writer failed to go for a few days to Tivoli and to remark upon the spectacle and the sound of the rushing waters. Until the late 1820s the Grand Cascade began its fall within close view of another important feature of Tivoli, the ruin of the Temple of Vesta, known in the eighteenth and nineteenth centuries as the Temple of the Sibyl, its round columned form set at the edge of a high cliff just opposite the

fig. 9. Alexandre-Hyacinthe Dunouy, *View of the Villa Maecenas and the Cascatelles at Tivoli*, 1795, oil on canvas, 96 × 145 cm. Private collection (photo coutesy of Hazlitt, Gooden & Fox).

cascade. Very quickly in the early part of the nineteenth century, as Galassi has shown, the vertical motif of the temple atop the cliffs, with the waters pouring down from the left, became a staple of the painters.[47] The motif was so firmly established that it continued to be used even after the Grand Cascade was altered to circumvent flooding, and the falls were no longer visible in conjunction with the temple.

Tivoli and its near environs were well mapped out and described by eighteenth-century travel writers and guides, but when they left the town they tended to move not up into the higher hills behind it, but down to the southeast to Palestrina, site of a great Roman villa, celebrated for its mosaic floor, and thence to Frascati. The mostly forested and rocky hills behind Tivoli grow rapidly higher and less populated; at that time a journey into any part of the Apennines was difficult and potentially dangerous. Roads were poor, inns nearly nonexistent, and there was always the risk of *banditti*. Later in the century traffic did increase, up the valley of the Aniene to the northeast through Vicovaro, where the riverbed turned southeast to run through the town of Subiaco. Subiaco had been one of Nero's many country retreats, but had a history of violence in the intervening centuries that was remarkable even for this region of early medieval Saracen attacks and the territorial conflicts between the papacy and the noble families of Rome. Its fame lay in the fact that a young man called Benedict, who came there around A.D. 500 to devote himself to a life of solitary prayer and penance, was persuaded by his equally devout sister Scholastica to found an order of monks. After several years, local opposition led him to take some of his followers and settle at Monte Cassino; those Benedictines who stayed behind built impressive structures over the centuries on a hill above the town. But what began to draw people to it in the later eighteenth century was not so much the Benedictine monasteries as the cool air, the forested hills, and the mountain views. Jean-Joseph-Xavier Bidauld painted there in the late 1780s, making outdoor studies of the mountain from above the town; Denis painted in the mountains near Vicovaro around 1800 (cat. 34), and doubtless went on to Subiaco as well. Granet, with his love for ecclesiastical architecture, helped develop the motif of the monastery set against the steep hill (see Boisselier, cat. 51), which was well established by the time of Blechen's visit there in 1829.

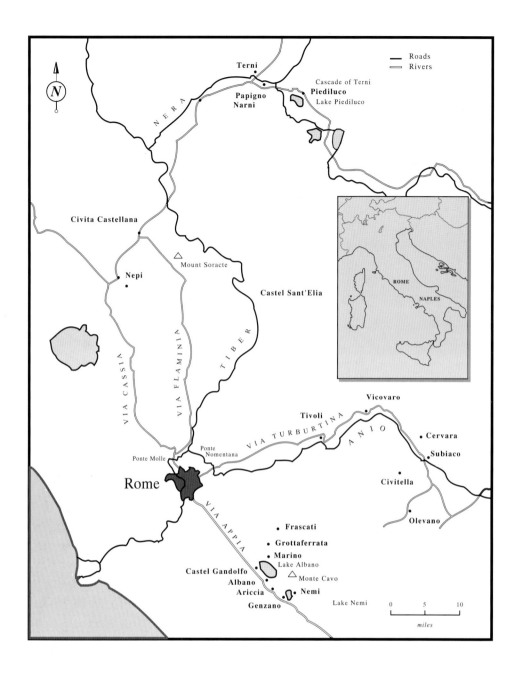

When Granet stayed in Subiaco, the monks gave him a place to sleep.[48] Other artists were put up in the town at a private hostel, run by a family which in the early 1830s included one daughter married to a man from Bohemia, and one to a French artist named Flachéron.[49] The mix was appropriate, as the French painters of the turn of the century were joined by more and more of the Germans. The French were the first to paint outdoors around Subiaco, the largest town in the area, with historical connections to ancient and papal Rome. The Germans, on the other hand, had by the 1820s fully "colonized" another, smaller town and its environs, not very far away but even more remote, and with no previous history of significance to outsiders.[50] This was the hill town of Olevano, only about fifteen kilometers to the southwest of Subiaco, but less accessible by road. Young German painters, especially in the years after 1815, followed the lead of Koch, who had begun to visit Olevano around 1804, and who eventually married a local woman and returned there every summer. Like Koch, they went there to make drawings, studies for the "heroic" landscape that was their goal. The rugged character of the region, with its rocky peaks, eagles' nest

hamlets, and barren slopes punctuated by patches of forest, began to become familiar in the paintings of Koch and his followers. The first of these artists to not only draw but to paint in the open air around Olevano was Reinhold (cat. 72). He arrived in 1820 with J. J. Faber, and was followed later in the decade by Fries, Wagner, Corot, and others. The "colonizing" power was that of the artists, who brought their aesthetic perceptions to a region that was innocent of representation, and proceeded to establish significant motifs. As the imagery of the region became known, the area, in turn, took its place in the travel writers' lists of places to visit. Certain favored motifs began to appear in the guides: the town of Olevano built up against a steep slope; the tiny village of Civitella on its high peak a short way to the north (fig. 10); the stand of ancient oak trees in between, known as "La Serpentara"; and the mountain views all around from the high point of Civitella. The following excerpt from the 1828 edition of Maria Starke's very successful travel guide tells the story:

> After sleeping in Subiaco, those Travelers who delight in fine Forest Scenery, usually go, through a Rocky narrow path, *to Civitella*; and thence to Palestrina. This path is only fit for mules; the ascents being uncommonly steep and slippery. *Near Civitella the Forest Scenery* commences; and *the Valley, to the east of Olevano*, is picturesque beyond description; and much frequented by Painters.[51]

Tivoli had an established visual tradition, shared by artists and travelers alike, long before the word picturesque was invented. At Olevano or Civitella on the other hand, a visual tradition was created, eventually becoming part of the traveler's itinerary. The younger painters were helped to find their way in Olevano by Koch, and also by the German art critic Baron von Rumohr, who in 1819 arranged to rent a villa above the town (called "Casa Baldi" after the local inn-keeping family who owned it and who were very friendly to the foreign painters), which he made available for several years to his artist protégés and their friends. By the late 1820s there was a steady traffic in landscape painters, most but not all of them German (see Corot, cat. 98). The poet Wilhelm Waiblinger, whose travel essays from Italy in the late 1820s were published regularly in fashionable newspapers in Dresden and Leipzig, was par-

ticularly fond of the Sabine region and especially of Olevano. He writes admiringly of the landscape and amusingly of the landscape painters, who were coming in ever greater numbers at the end of the decade. He is pleased with the unusual degree of hospitality to be found among the citizens of the town, and notes (or invents?) a curious question that they put to visiting painters: whether one is "a Paesista (landscape painter) or a Figurista (history painter)."[52] In 1830 he went so far as to write a draft of a guidebook of Rome and its surroundings to the east, as far as the as yet little penetrated mountains of the Abruzzi.[53] But in one of his letters to the Leipzig *Zeitung für die eleganten Welt,* in November 1828, he wrote:

> I am happy that we are now at a place where the usual riffraff of travelers, coaches high as houses filled with English families, all sorts of landscape painters painting on the way, boring antiquarians or South German masters, do not annoy me....But if the foolishness of travel lasts like this, and people after me celebrate and proclaim to the world the Lago Fucino, there will in a hundred years be a "Hotel d'Angleterre" in Avezzano and a steamer on the Lago Celano.[54]

Only eleven years earlier, in 1817, the young German painter Franz Horny, writing to his mother about his recent stay in Olevano with Rumohr and Peter Cornelius, calls it a beautiful place that is visited by almost none of the crowds of foreigners who travel to Italy.[55] It is worth noting that in this letter Horny calls the Olevano countryside "ein wahres Zauberland"—a real magic land, the same phrase used forty years earlier by Thomas Jones to describe the Alban Hills on his first visit in 1776.[56]

By the 1830s, when Friedrich Nerly, Wasmann, and Johann Wilhelm Schirmer went there, Olevano was thoroughly identified with the German community of painters in Rome, and La Serpentara was its best-known motif. German artists continued to paint there throughout the century, and it was among their ranks that the money was raised in 1873 to buy the oak grove to prevent its being cut down. Before the end of the century it had been incorporated into the Academy of Fine Arts in Berlin, with its outpost, the German Academy in Rome. Casa Baldi was added in 1939, and in 1955 both were restored to the West German government.[57] It is interesting to see this relatively obscure information turn up in Schama's book *Landscape and Memory,* where the "discovery" and eventual acquisition of this isolated stand of oak trees is seen in the context of the ancient, modern, and very complex history of German forest mythology.[58] In the light of that history, the fact that it was the German painters who initially found their way to this particular part of the Sabine Hills and made it their own seems eminently logical, if not preordained. The oak tree had long been a national symbol of ancient Druid/Gallic/Saxon fortitude in France and in England as well as in Germany; but as Schama shows, during this period in Germany it took on a more vivid force because of the need to assert the power of German culture in opposition to the force of Napoleon and the Enlightenment missionary zeal of the French. Herder versus Winckelmann, the medieval forests and Gothic traditions of Germany against universal rationalism and the classical ideal: such an opposition casts light on the situation of the German painters—in particular the landscape painters—in Italy in the early nineteenth century. By seeking out the heart of classical Mediterranean culture they became implicated to some extent in a conflict with strong currents of cultural feeling at home. It is interesting in this context to contemplate the number of German painters who chose to make their life in Italy—such as Koch, Reinhart, von Rohden,

Nerly—as well as the numbers who developed only limited careers, or none at all, because of early death—among them Fries, Reinhold, Blechen, and their contemporaries in Rome, Horny, Carl Philipp Fohr, and Johann Christian Erhard.

Two other regions providing sites of particular interest to open-air painters were to the north of Rome, up the Via Flaminia, the most ancient of the two routes through the Campagna to and from Rome. The farthest of these areas, in the valley of the Nera River which comes in from the northeast to join the Tiber, was also the better known and most mentioned by the travel writers. Travelers to Rome via Spoleto and Foligno were guided to stop at Terni, chiefly to experience the Cascate delle Marmore, a splendidly high waterfall created in ancient times to drain the Velino River and prevent flooding in the high plain of Rieti. Cochin, in his *Voyage d'Italie* of 1758, devotes a single paragraph of perfectly Enlightenment description to the cascade:

> ...This cascade is one of those great spectacles of nature, which produce astonishment and admiration. One sees a river, two or three hundred feet high, falling on rocks where this fall has worn by its continual force a hole of very great depth. The water falls there with such violence that a good part of it rises in mist or rain nearly as far as the place from which it has fallen. The rest forms a second cascade, which is scarcely less than the first.[59]

In the 1820s, many years and many descriptions later—including Byron's in Canto IV of *Childe Harold* in 1818—the young Mrs. Jameson writes, in the first of her many books of cultural adventure, about her visit to the site:

> As I stood close to the edge of the precipice, immediately under the great fall, I felt my respiration gone: I turned giddy, almost faint, and was obliged to lean against the rock for support. The mad plunge of the waters, the deafening roar, the presence of a power which no earthly force could resist or control, struck me with an awe, almost amounting to terror.[60]

This Romantic rhetoric with its emphasis on the physiological effects of natural phenomena has its origins in Romantic writing about the Alps; it was not at all the style of Stendhal, who journeyed from Rome to see the falls. He climbed to the belvedere, halfway up, where the falling water could be seen from very near at hand, and then on to the top. He says little more than "It is the most beautiful waterfall I have ever seen in my life"; he returned to Terni "fatigued with admiration."[61] Indeed, he has more to say about his irritation at the fact that the papal government maintained a high-priced monopoly on the transportation service from Terni to the Cascade, which made him lose his temper and walk the whole way, occasionally getting lost. Stendhal's focus in writing was never on landscape description—he was too well aware of its limitations in comparison with pictures—but he makes his love of the Italian landscape clear nonetheless. Making a list for his sister of the reasons why she should come to Italy, he puts, in second place between "respirer un air doux et pur" and "to have a bit of a lover," "voir de superbes paysages."[62] When it comes to Romantic rhetoric, the outdoor painters are on Stendhal's side. Admire they do; but they know the limits of the representation of observed reality when it comes to great heights and clouds of light-shot vapor. Unlike the *vedutisti* of the mid-eighteenth century, they do not paint inside the Grotto of Neptune behind the cascade at Tivoli, and they do

fig. 11. Jean-Baptiste-Camille-Corot, *The Augustan Bridge at Narni*, 1826, oil on paper, mounted on canvas, 34 × 48 cm. Musée du Louvre, Paris.

not emphasize the drama of the Cascate delle Marmore. Corot's masterful study of the latter (cat. 92) shows a minimum of Romantic intensity and a maximum of deeply felt attention to light and structure. While in the region of Terni in the summer of 1826, he spent less time working at the falls than he did in sites little mentioned in the guides, around the nearby hill village of Papigno and the mirror lake of Piediluco, in the hills above the cascade.

A few miles down the valley of the Nera River to the southwest from Terni is the medieval town of Narni, set on a cliff above the river. Here the painters' main interest was in the powerful forms of the ruins of the Augustan Bridge, built in the first century A.D. to carry the Via Flaminia over the river and up toward Spoleto. The great height of the remaining arch and the size of the remaining bases, set between high banks and seen against a line of distant hills, provided one of those landscapes that led contemporary writers to describe Italy as a place where pictures simply exist in nature, waiting to be painted. Such sites usually consist, as this one does, of a particular combination of a naturally sculptural terrain and the formal geometries of human construction. When Corot chose the viewpoint from which to make his study of the Narni bridge, what resulted was a painting as classically structured as anything he could have composed in the studio (fig. 11).

The town of Civita Castellana rises from its peninsula of tufa cliffs at the northern edge of the Campagna, less than twenty miles south and east from Narni along the winding Via Flaminia. Unlike the valley of the Nera, this region has no striking natural feature like the Cascate delle Marmore or monumental ruin like the Augustan Bridge. It is noted by Lalande for its historical role as a local defender of the Etruscan tribes against the incursions of the ancient Romans, and for the inaccessible, fortress-like character of its natural setting. In medieval times it was used again as a fortress, and an imposing castle was built during the Renaissance. By the eighteenth century the town was largely a center of traffic to and from Rome, and the castle had become a prison. Some travelers from the north tended to dismiss it as a grim place, very different from the picturesque and cultivated valley of the Nera from which they had

fig. 12. Massimo Taparelli d'Azeglio, *View of Mount Soracte*, 1824, oil on canvas, 19.2 × 45 cm. Galleria Civica d'Arte Moderna e Contemporanea, Turin.

Mount Soracte from the West, photograph, 1994

come. Petit-Radel, however, with his eye for landscape, describes the town as "built upon a rock in an isolated and very romantic way" and calls its site "one of the most picturesque."[63] As a Frenchman, Petit-Radel was not put off by the presence of Napoleonic soldiery in the castle; on the contrary, they took him around and showed him the wonderful view from the top of the fortress, where one could see long distances, from the mountains rising all along the eastern horizon down to the south and the open Campagna, with the great shoulder of Mount Soracte rising above it. Already in the late 1780s, Bidauld with his love of mountain landscape had worked in the environs of Civita Castellana. His picture from Stockholm (cat. 29) shows, despite its different manner of painting, the same fascination with the high reddish rocks with their heavy vegetation and the way the buildings seem to grow out of the cliffs, as in the studies that Corot made in 1826 and 1827 (cats. 93–97). The painters were drawn to the site by the motif of the interrelationship between natural rock, the shaped stone of buildings, and the many variants of vegetation. In and around Rome this motif played itself out largely in terms of the juxtaposition of live growth and ancient ruins; but its independence from the theme of the nostalgia of ruins is shown by the related motifs, without ruins, that were seized upon by the painters in the region of Civita Castellana, as they were in the hills around Olevano and Civitella.

Corot also worked in the similar terrain around Nepi, a smaller town some five miles southwest of Civita Castellana. Nepi and the even smaller clifftop settlement of Castel Sant'Elia were not on the tourist route; as in the case of Civita Castellana, their attraction lay in their terrain of tufa ravines and gorges, their flourishing growth of hardy trees and shrubberies, and their mountain views. In 1821 d'Azeglio was one of the first open-air painters to work there. He followed his teacher in Rome, the Flemish landscape painter Martin Verstappen, who spent the summer there that year. He wrote in his memoirs:

> One of the most beautiful and picturesque parts of the Roman Campagna is that which begins at Nepi and, in width, stretches as far [east] as the Tiber; in length [north], it reaches Otricoli and even Narni. It is unknown to foreign tourists even today; it was still less known in 1821.[64]

Thus Nepi and Sant'Elia came late to the repertory of the open-air painters. Like the painters of Olevano in the early 1820s, they were drawn by pure landscape values, of light and space and terrain. When they looked south and east from this northern edge of the Campagna, they saw only a few miles away the isolated silhouette of Mount Soracte, that remarkable self-contained spur of the Apennines that rises up from the western side of the Tiber valley (fig. 12), its profile so well pictured by Byron:

> ...the lone Soracte's height...
> Heaves like a long-swept wave about to break,
> And on the curl hangs pausing.[65]

In the following stanzas Byron reminds us of Horace's brief reference to Mount Soracte covered with snow (*Ode* I, ix), which every schoolboy knew and which is so often cited as a kind of identity tag when the travel writers speak of the mountain. For the painters, the connection of every site with a still familiar classical culture was enriching, but in the end not essential. What they perceived in the landscape of Italy was possessed of a natural significance that could stand on its own terms. Mount Soracte loomed as a form that demanded representation by these students of the terrain of the Roman region; Mont Sainte-Victoire would command the same response from Cézanne toward the end of a century in which the representation of landscape as a means of grasping our relation to the world would achieve a significance only glimpsed and intimated by these young men busy traveling the roads leading in and out of Rome.

Notes

Except where otherwise noted, translations from the French and Italian are by the author; translations from the German are by Sylvain Bauhofer, research intern at the Brooklyn Museum, 1994.

1. Goethe 1962, 209.
2. Goethe 1962 (introduction), 14.
3. Goethe 1962, 148.
4. Galassi 1991, 239, n. 19.
5. Dupaty, *Lettres sur l'Italie,* in Hersault 1988, 66.
6. Dupaty in Hersault 1988, 71.
7. Petit-Radel 1815, 1:xiii.
8. Petit-Radel 1815, 1:xiv.
9. Petit-Radel 1815, 1:xv.
10. Petit-Radel 1815, 2:410.
11. See Klenze 1907; Schudt 1959; and Galassi 1991, bibliography and notes.
12. Lalande 1790, 6:170.
13. de Staël 1985, 140–142: "On voit de là, [the Villa Mellini] dans l'éloignment, la châine des Apennines; la transparence de l'air colore ces montagnes, les rapproche et les dessine d'une manière singulièrement pittoresque. Oswald et Corinne restèrent dans ce lieu quelque temps pour goûter le charme du ciel et la tranquillité de la nature. On ne peut avoir l'idée de cette tranquillité singulière quand on n'a pas vécu dans les contrées méridionales....Ne trouvez-vous pas, dit Corinne en contemplant avec Oswald la campagne dont ils étaient environnés, qu la nature en Italie fait plus rêver que partout ailleurs? On dirait qu'elle est ici plus en relation avec l'homme, et que le créateur s'en sert comme d'un langage entre la créature et lui."
"Tout est là pour la pensée, pour l'imagination, pour la rêverie. Les sensations les plus purs se confondent avec les plaisirs de l'âme, et donne l'idée d'un bonheur parfait."
14. de Staël 1985 (introduction), 11–12.
15. Letter of 22 October 1803, in Haufe 1987, 133.
16. Schuster 1990, 15–17.
17. Roland Michel 1990, 107.
18. Roland Michel 1990, 106.
19. Granet 1988, 53–54.

20. *Guida d'Italia* 1993, 23.

21. Lalande 1790, 6:105.

22. Castellan 1819, 2:49–51.

23. Vigée-Lebrun 1869, 173, 179.

24. Granet 1988, 21.

25. Wasmann 1915, 107–108.

26. Richter 1891, 117–118.

27. Granet 1988, 31.

28. Stendhal 1973, 1215. See also Kuyvenhoven 1985, 145–154.

29. Stendhal 1973, 1215–1216.

30. Nibby 1824, 1:105. Nibby took over the guidebooks established in the 1760s by Giusseppe Vasi, and continued by his sons, who also made translations of it. In 1827 Nibby was made a director of the excavations in the Forum. One of his contributions, already argued in the 1824 Itinerary, was to prove that the great vaulted ruin near the Arch of Titus was not, as it had long been called, the Temple of Peace, but was the remains of the great Basilica of Maxentius, later named for his victor Constantine (1:126).

31. Lalande 1790, 4:285.

32. Granet 1988, 21.

33. Moatti 1992, 77.

34. Granet 1988, 48.

35. Dupaty in Hersault 1988, 65.

36. Petit-Radel 1815, 1:344.

37. Paris 1969, cat. 173, 163.

38. Chateaubriand 1968, 126–127: "Rien n'est comparable pour la beauté aux lignes de l'horizon romain, à la douce inclinaison des plans, aux contours suaves et fuyants des montagnes qui les terminent."

39. Chateaubriand, *Memoires d'outre-tombe* [Paris, 1849–1850], in Hersault 1988, 550.

40. d'Azeglio 1966, 76. The memoir was first published in 1867. I am grateful to Prof. Stefano Sussini for the introduction to d'Azeglio.

41. Stendahl 1973, 507: "Vue magnifique de la Voie Appienne, marquée par une suite de monuments en ruine; admirable solitude de la campagne de Rome; effet étrange des ruines au milieu de ce silence immense. Comment décrire une telle sensation? J'ai eu trois heures de l'émotion la plus singulière: le respect y entrait pour beaucoup."

42. Goethe 1962, 358.

43. Petrucci 1984, the first detailed historical study of the palazzo, which is undergoing renovation based on his research. The property was acquired in 1661 from the Savelli family by the Chigi family, whose most important member at the time was Pope Alessandro VII. He commissioned the work on Castel Gandolfo and—from Bernini—both the Church of St. Thomas in the town square of Castel Gandolfo and the Church of the Assumption on the main square of Ariccia.

44. d'Azeglio 1966, 275.

45. Petit-Radel 1815, 2:451.

46. Chateaubriand 1968, 81–82.

47. Galassi 1991, 109.

48. Granet 1988, 51.

49. Wasmann 1915, 98.

50. Galassi 1991, 123.

51. Starke 1828, 222–223. This was the sixth updated edition of this intrepid travel writer's guide, published by the well-known John Murray of London. Starke had begun in 1798 with a memoir of her life in Italy during the French campaigns; from there she was taken up by Murray and became a prolific author in his series of travel guides.

52. Waiblinger 1980–1982, 4:422.

53. Waiblinger 1980–1982, 4:429–441.

54. Waiblinger 1980–1982, 4:371.

55. Letter of 31 July 1817, in Haufe 1987, 210.

56. Jones 1946–1948, 55.

57. Belloni 1970, 16–19, 22.

58. Schama 1995, 116.

59. Cochin 1991, 110.

60. Jameson 1860, 124.

61. Stendhal 1973, 1226.

62. Crouzat 1990, 261.

63. Petit-Radel 1815, 1:342.

64. d'Azeglio 1966, 157.

65. *Childe Harold's Pilgrimage*, Canto IV, in *Byron*, ed. Jerome J. McGann (Oxford, 1986), stanza 75, 169. The subject of Canto IV is based on Byron's first and only trip to Rome, in the spring of 1817.

Nature Studied and Nature Remembered: The Oil Sketch in the Theory of Pierre-Henri de Valenciennes

JEREMY STRICK

fig. 1. Jean-Baptiste-Camille-Corot, *The Artist's Studio*, c. 1855/1860, oil on wood, 61.9 × 40 cm. National Gallery of Art, Washington, Widener Collection, 1942.9.11.

Detail, cat. 21, Valenciennes, *Rocca di Papa in the Mist*

Many of the artists in this exhibition would have been surprised to find their modest and informal oil studies hanging on the walls of a grand institution. Although they entertained the highest ambitions for their larger, finished compositions, the oil study was, by and large, a private affair, conceived by the artist for personal use.

Nevertheless, it is probable that many of these works were exhibited soon after they were made, and in some instances for years thereafter. The venue, however, was neither the museum nor the annual exhibition, the art gallery or the collector's home. It was, of course, the artist's private room or studio.

Nineteenth-century images of painters' studios frequently show small oil studies tacked to the walls (fig. 1). Artists often shared their outdoor studies with colleagues, comparing approaches and eliciting suggestions and praise. Such seems to have been an important aspect of the social life of landscape painters in Italy. During the winter months, when painters confined themselves to the studio, these studies could stimulate ideas and provide inspiration, and serve as points of reference for use in composed landscapes. Even years after they were painted, these open-air studies could be found on studio walls in Paris, Munich, Düsseldorf, or Copenhagen.

It might be supposed that these open-air studies later served as essential sources in the construction of more detailed, finished paintings. That, at least, was the idea expressed by contemporary theoreticians. Pierre-Henri de Valenciennes, for example, author of the most extensive and influential treatise on landscape painting published in the early nineteenth century, noted that even studies of trees or of foliage might be kept in portfolios for later consultation.[1] What is surprising, then, is how infrequently elements from such a study are transposed into a composed landscape. This is especially true for oil studies produced at the end of the eighteenth century and the first decade of the nineteenth, those years during which the tradition of the Italian oil study was established. Only rarely, it seems, did landscape painters use their open-air studies as sources.

Even the briefest survey of the works produced by Valenciennes, his contemporaries, and his followers, however, reveals a wide chasm separating the oil studies from the historical landscape paintings they were supposed to inform. The high finish and carefully calibrated, elaborated composition central to the aesthetic of the composed landscape were distinct from the free handling and informal pictorial structure permissible in the oil study. The composed landscapes usually show little interest in the transient effects of light and atmosphere, indeed, with the appearance of a real sky or of objects seen in actual daylight. At their best, they appear as marvelous abstractions,

crystallized visions of an imaginary world impossible to penetrate except by imagination. At their worst, they seem dull decorations, paintings-by-formula lacking conviction and surprise.

Yet if the oil study served neither as direct source, nor, it seems, as inspiration for composed landscapes, why, then, did painters keep their studies, and why did they display them in their studios? Once completed, what purpose did these studies serve? The answer lies in the fact that the landscape oil study satisfied two imperatives: that of understanding nature and that of recalling the experience of nature. Together, these imperatives came to define a new purpose for landscape, which was first expressed in the Italian oil study.

Understanding Nature

Arguably the most famous foreign visitor to Italy in the late eighteenth century was Johann Wolfgang von Goethe. His Italian journey, begun at the relatively advanced age of thirty-seven, lasted from 1786 to 1788. Goethe kept a journal of his trip, and it provides at once a wonderfully detailed account of a Grand Tourist making his way down the Italian peninsula, and an extraordinary insight into the range and depth of the poet's interests.

From the first entry in his journal Goethe reveals himself to be an assiduous observer not only of art and architecture, people and customs, but also of natural history. He comments frequently and at length upon such matters as meteorology and mineralogy, botany and geology. Just before reaching Rome, for example, he enters the following notation from Città [Civita] Castellana:

> Otricoli lies on an alluvial mound, formed in an early epoch, and is built of lava taken from the other side of the river. As soon as one crosses the bridge, one is on volcanic terrain, either lava or an earlier metamorphic rock. We climbed a hill which I am inclined to define as grey lava. It contains many white crystals with the shape of garnets. The high road to Città Castellana is built of it and worn wonderfully smooth by the carriages. This town is built upon a volcanic tufa in which I thought I could recognize ashes, pumice stone, and lava fragments. The view from the castle is magnificent. Soracte stands out by itself in picturesque solitude. Probably this mountain is made of limestone and belongs to the Apennines. The volcanic areas lie much lower, and it is only the water tearing across them which has carved them into extremely picturesque shapes, overhanging cliffs and other accidental features.[2]

For Goethe, observation of the landscape, and appreciation of magnificent views and picturesque forms, goes hand in hand with a scientific understanding of the elements that constitute those shapes and the natural forces that have created them. His journals reflect an enormous and wide-ranging curiosity about natural phenomena and an equally wide foundation of knowledge.

Goethe was not unusual in this regard. The Enlightenment ideal called for men to be educated in letters and science, and to be close observers of the natural world. Travel literature, a genre which blossomed in the eighteenth century, was frequently filled with just the kind of observations made by Goethe.[3] The excitement of discovery led to an age of scientific exploration, with expeditions to remote areas of the world. Voyagers brought back detailed accounts of the marvels they had witnessed, geological

samples, and specimens of exotic flora and fauna. Artists were frequently included on such voyages, and mezzotints and engravings produced after their drawings found an avid market throughout Europe.

This fashion for scientific observation of the natural world also appears in contemporary landscape painting. In the late eighteenth century, for example, numerous paintings depicted volcanos, testaments to a nascent Romantic taste for an apocalyptic sublime, as well as to a fascination for this most dramatic of geological phenomena. Certain landscape painters, moreover, produced works which had as their subject the natural history of a particular site or terrain. Carl Gustav Carus, for one, a disciple of the German Romantic painter Caspar David Friedrich, as well as an eminent doctor and scientist, portrayed mountains that suggested in precise fashion the processes of geological time. In his *Nine Letters on Landscape Painting*, published in 1831 but written a decade earlier, Carus argued that scientific understanding of nature was a primary goal of landscape painting.[4]

The importance of observing a landscape with the benefit of scientific understanding was emphasized by no less a figure than Valenciennes. His two-part treatise, *Elémens de perspective pratique à l'usage des artistes*, first published in 1800, contains extensive discussions of the causes of numerous natural phenomena. Those discussions take place, for the most part, in the first book of his treatise, which offers a detailed description of the rules and procedures of perspective. It follows a lengthy discussion of the properties of natural phenomena, from rivers and mountains, to trees, clouds, and fog. Typical of that discussion is his treatment of mountains:

> One must first know the nature of the different substances that compose the seams
> or the veins of mountains. Each one of these substances has its particular fractures and
> manner of decomposition; and as the highest eminences of the Earth tend each day toward their destruction, their form and their decomposition vary following their nature,
> and according to whether they are more or less distant from the causes of their degradation, which it is very important to study and to study deeply.[5]

Valenciennes is advocating, of course, the same kind of study of which Goethe gives such ample evidence. The landscape painter must become an expert observer of nature, one familiar with its various manifestations and effects, and one who understands their causes.

Valenciennes gives fullest expression to that notion in his long chapter on aerial perspective, which he defines as "....the effect of vaporous or ambient air interposed between different objects....This science is one of the principal bases of painting, without which it is impossible to make a picture that is the just imitation of nature."[6] His discussion of aerial perspective involves the causes and appearance of various atmospheric effects, as well as the appearance of certain landscape forms seen through those effects:

> We have just noted that, when mist is drawn up into the atmosphere, it forms clouds
> which sail about at the mercy of the winds. However, when the water out of which
> those clouds are formed acquires a weight which exceeds the density of the air that supports it, that water falls in drops that can be more or less large, and that can fall with
> greater or lesser frequency. Thus is made rain. Therefore, rain is a fluid water, distilled by
> nature. When it is fine, it does not fall from a great height; but during a storm its drops

are large and heavy, and fall with vehemence. Rain purges the air of atmospheric vapors, and renders the atmosphere infinitely more clear, and purer than it was previously.[7]

The connection of this discussion to Valenciennes' interest in the landscape oil study should be apparent. Valenciennes has chosen to describe at length those subjects that pertain most closely to the possibilities and the technique of outdoor painting. Whereas the structure of trees or mountains can be effectively rendered by drawings and engravings, the oil study is uniquely suited to portray effects of light and atmosphere. To master aerial perspective, Valenciennes insists, the artist must thoroughly understand the appearance and causes of numerous meteorological conditions. That understanding can come from study (from reading, for example, the *Elémens de perspective pratique*) but it must also come from the practice of painting oil sketches.

The primary purpose of the oil study, then, is didactic. Studies offer a means through which the student may become familiar with nature, and by which he may acquire a repertoire of techniques to render nature. Valenciennes' suggestion that an artist consult his studies well after they are made also fits in with this didactic function. The physical presence of the study in the artist's studio supplements the lessons incorporated in the memory of its creation.

A second function for the oil study is suggested by the very nature of Valenciennes' project in writing the *Eleméns de perspective pratique* and the *Réflexions et conseils à un élève*. Like virtually every treatise on art since Alberti's *Della Pittura*, Valenciennes' text serves to demonstrate the elevated status of art. Specifically, Valenciennes makes a plea for the status of landscape painting. He argues, in effect, that the landscape painter should be regarded as the equal of the history painter, by reason of his ability to treat the elevated themes of history, allegory, and religion. The knowledge required of the historical landscape painter, moreover, exceeds that of the history painter. In addition to a sound knowledge of and facility with the techniques of painting, as well as a familiarity with history and literature, both of which qualities are required of the history painter, the landscape painter must also have the knowledge of a naturalist.[8]

Focusing on the various aspects and conditions of nature that the landscape painter must learn to represent, Valenciennes adopts a language of scientific description that is not far distant from that employed by Goethe. His familiarity with this language serves to demonstrate his erudition. But the tool of scientific description most readily available to the painter is not language, but visual representation. Here the oil study can play a role in demonstrating the landscape painter's unique competence.

Natural science of the eighteenth century comprised, in good measure, observation and collection. Scientific exploration was undertaken to observe new phenomena and to collect samples, or specimens. Closer to home, the amateur naturalist might collect specimens that could be ordered to reflect a systematic view of the natural world. Valenciennes, who belonged to two scientific societies,[9] was one such collector of specimens, which he organized following the principles of the French naturalist Lamarck.[10]

The oil study could also be regarded as a kind of specimen, demonstrating scientific observation and reflecting the artist's understanding of a specific phenomenon. It also provided a lasting record of that phenomenon. Indeed, in the case of effects of light and atmosphere, where no actual sample could be taken, the oil study offered the closest thing to a specimen.

Despite the urging and example of the *Eleméns de perspective pratique*, there is little

fig. 2. André Giroux, *Androcles Rescues the Child Pyrrhus*, 1824, oil on canvas, 38 × 46 cm. Ecole nationale supérieure des beaux-arts, Paris.

evidence that many of the landscape painters who painted outdoor studies in Italy came to share the extensive scientific interests evidenced by Valenciennes. Nonetheless, the landscape subjects these painters so frequently explored — whether water-worn ravines or rocky outcroppings, mountains isolated or in ranges, rushing water or a cloud-filled sky — all served to demonstrate an understanding of nature that only the landscape painter was capable of expressing.[11] The matter-of-fact quality that most oil studies evince, the manner in which they exclude narrative and emotional effect, speaks to an attitude of detached scrutiny closely akin to that required for scientific observation. By keeping open-air studies in their possession, landscape painters maintained not so much a repertoire of motifs to be recopied piecemeal as a fund of knowledge that might continually be demonstrated.

Recalling Nature

In 1817, the French Academy instituted a competition for a Prix de Rome for historical landscape painting, divided into three stages. In the first stage, the competitors executed, in the studio, a study of a tree. In the second, they were to produce a painted study for a finished composition, the subject of which they were assigned. In the third stage they were to produce a finished landscape painting based on their initial study. In none of these stages was the competitor allowed to leave the studio: the painting was to be executed from memory and imagination. Nature was not to be consulted.

That divorce between the production of landscape paintings and the observation of nature speaks to the *retardataire* quality of the Prix de Rome competition, and helps to explain its negligible impact upon landscape painting in nineteenth-century France. Even a brief comparison of a typical Prix de Rome entry (fig. 2) with an outdoor oil

study (e.g., André Giroux's *Civitella*, cat. 106) reveals the enormous impact the presence of nature could effect upon an artistic sensibility.

The exclusion of nature from the competition also indicates a profound ambivalence at the core of neoclassical landscape theory. That ambivalence is most clearly expressed by Valenciennes, although it is also present in the writings of such later theorists as C. J. F. Lecarpentier and Jean Baptiste Deperthes. Neoclassical theory privileged the selection and combination of perfect elements. According to that theory, no single person could combine the ideal of perfection in all of its aspects. The neoclassical figure painter would therefore seek out the finest forms, combine them first into single figures and then into compositions. For the neoclassical landscape painter, the procedure was analogous. Nature was regarded as imperfect. The task of the landscape painter was to seek out instances of perfect form from unsatisfactory ensembles, and bring those elements together into composed landscapes, every portion of which would equally express the ideal.[12]

Finding nature wanting, the neoclassical landscape painter would manage to perfect nature through selection and combination. But whereas the neoclassical figure painter sought inspiration and models from ancient painting and sculpture, classical texts, and even the most highly esteemed modern masters, the landscape painter found inspiration above all in nature. On the one hand, then, Valenciennes could say of nature:

> When the man of genius wishes to refresh his imagination, he reopens his eyes upon nature: he contemplates it, he observes it; he searches on all sides for models which might help him to paint that which his enthusiasm had made him perceive. Alas! He finds almost nothing. He sees this nature as it is: he admires it, but he is not satisfied. The boulders appear paltry, the mountains sunken, the precipices without depth.[13]

On the other hand, as he states in his preface to the *Elémens de perspective pratique*:

> It is the love of the countryside, the desire to contemplate nature at one's leisure, and above all the ardent desire to represent nature with precision and truth that have determined our profession....[14]

For all his descriptions of ideal landscapes and mythical subjects, the inspiration offered by nature is more strongly felt in the *Elémens de perspective pratique* than is the insufficiency of nature. Throughout his book Valenciennes lingers over the descriptions of various natural scenes and effects, his prose emphasizing the intense feelings that these scenes occasion. Landscape painting offers a means by which the artist can communicate those feelings to a viewer. To be communicated, however, they must be directly felt. Here the landscape oil study serves not only as a transcription of a specific view but, as a corollary, as a record of the artist's presence within that view.

Valenciennes advises his readers to finish their oil studies quickly, taking no more than two hours and, in the case of sunrises or sunsets, no more than a half-hour.[15] The emphasis he places upon producing oil studies quickly, and his urging of the reader to put aside the finish of details in favor of the unity of the ensemble, speaks to his concern that the oil study capture the experience of a specific and contingent moment rather than the precise details of a determined form. Lack of finish makes possible the rendering of fleeting moments, but also serves as an index of instantaneity, to guarantee, in effect, that that which the study purports to represent was, in fact, experienced

Detail, cat. 106, Giroux, *Civitella*, 1825–1830

by the painter. The issue is important to Valenciennes: he calls studies that do not reflect a brief and specific moment "lies against nature...the apex of deceit...."[16]

As accurate records of authentic experience, oil studies serve to remind the landscape painter of that experience. Their authenticity allows the artist imaginatively to re-enter an experience that might otherwise be lost. In a long passage, Valenciennes details the process whereby oil studies serve to rekindle the artist's memory and imagination:

> The artist brings back the result of his observations, and the studies that he has made in the countryside....In looking at his work, he remembers perfectly the sites that he has copied; all the phenomena that he has admired retrace themselves in his memory....He recalls with pleasure the flowers of spring, the lovely summer evenings, and the rich harvests of autumn: he believes that he still has before his eyes those beautiful bunches of grapes, adorned with their vines, which tightly embrace the trunks of elms, the apple trees heavy with vermillion fruit, the country chores, the dance of the shepherds, the march of the animals, all the pleasures of the grape gathering. Finally, he feels regret for having been forced to leave such pure and healthy amusements, such joys without remorse, such tranquil and productive studies, and above all the image of a happiness that one can only appreciate far from the great cities, where joy is almost always false, and where pleasure is mixed with bitterness.[17]

The oil study triggers memory and emotion, out of which pictures form in the artist's mind. They can accomplish that end because they demonstrate that the artist was in a particular place at a particular time. Their emotional power, as the foregoing passage makes clear, derives from the fact that the artist is in that place no longer.

To the extent that oil studies insist upon the effect of instantaneity, the recording of a specific moment, they necessarily emphasize that the moment is past. They point to the passing of time, rather than to an eternal present. In this sense, they are inscribed with a kind of nostalgia central to the experience of the community of foreign artists in Italy among whom the landscape oil study first flourished. Most of those artists visited Italy in their youth, and they were quite aware that their time there would constitute a special and distinct moment in their lives. Those artists were freed of the strict schedules of students, and those who had received stipends for their travels were temporarily freed of financial responsibilities, too. Oil studies offered records of moments spent tramping through mountain passes or along seacoasts, setting up easels in the midst of monuments or in a cool forest glade.

Nostalgia, too, was inscribed within the monuments and the countryside that these painters depicted. Italy was venerated for its ancient past rather than for its present. Ruins evoked thoughts of the passing of time and empire, and humble vernacular architecture contrasted with noble monuments to ancient glory. Oil studies, with their matter-of-fact handling, did not stress such themes. Their attitude generally was one more of cool, even scientific, observation than of emotional engagement. That detachment, however, gave to the oil study a kind of emotional transparency that may have allowed memory to work more freely.

The outdoor oil study evolved as an independent artistic activity, a distinct genre, in Italy, among the artists whose works are seen in this exhibition. The aesthetic of the open-air study came to influence, and ultimately transform, that of the studio-composed landscape. But the Italian open-air studies, which by their freshness and immediacy, oftentimes humble subjects, and informal compositions appear so different

from composed neoclassical landscapes, also seem distant in spirit from the emotionally high-keyed productions of such painters as Théodore Rousseau or even from the late work of the ultimate master of the Italian open-air oil study, Camille Corot.

The Italian oil studies of Corot, so clear, concise, and ordered, have often been contrasted with the softly focused, evocative style of the artist's late work. It is worth noting, however, that this preeminent master of the outdoor oil study came eventually to be the master of the "souvenir," those paintings which have as their explicit subject memory, paintings which gently embody a sense of loss which memory at once exposes and assuages. Without the conspicuous emotional devices of the "souvenir," the Italian oil study contrived, too, to address that subject.

Notes

1. Valenciennes 1800, 410.
2. Goethe 1982, 113–114.
3. See Stafford 1984.
4. Carus 1831.
5. Valenciennes 1800, 223.
6. Valenciennes 1800, 243.
7. Valenciennes 1800, 267.
8. Valenciennes 1800, 390–391.
9. Radisich 1977, 234.
10. Radisich 1977, 235.
11. An interest in the detailed examination of clouds was not limited to artists who worked in Italy. Indeed, none of the artists surveyed in this exhibition produced an extensive body of cloud studies to match that of John Constable—who never traveled to Italy. See Badt 1950.
12. For an extensive discussion of the theory of selection and combination, see Lebensztejn 1990.
13. Valenciennes 1800, 384–385.
14. Valenciennes 1800, xxiv.
15. Valenciennes 1800, 407.
16. Valenciennes 1800, 406.
17. Valenciennes 1800, 472.

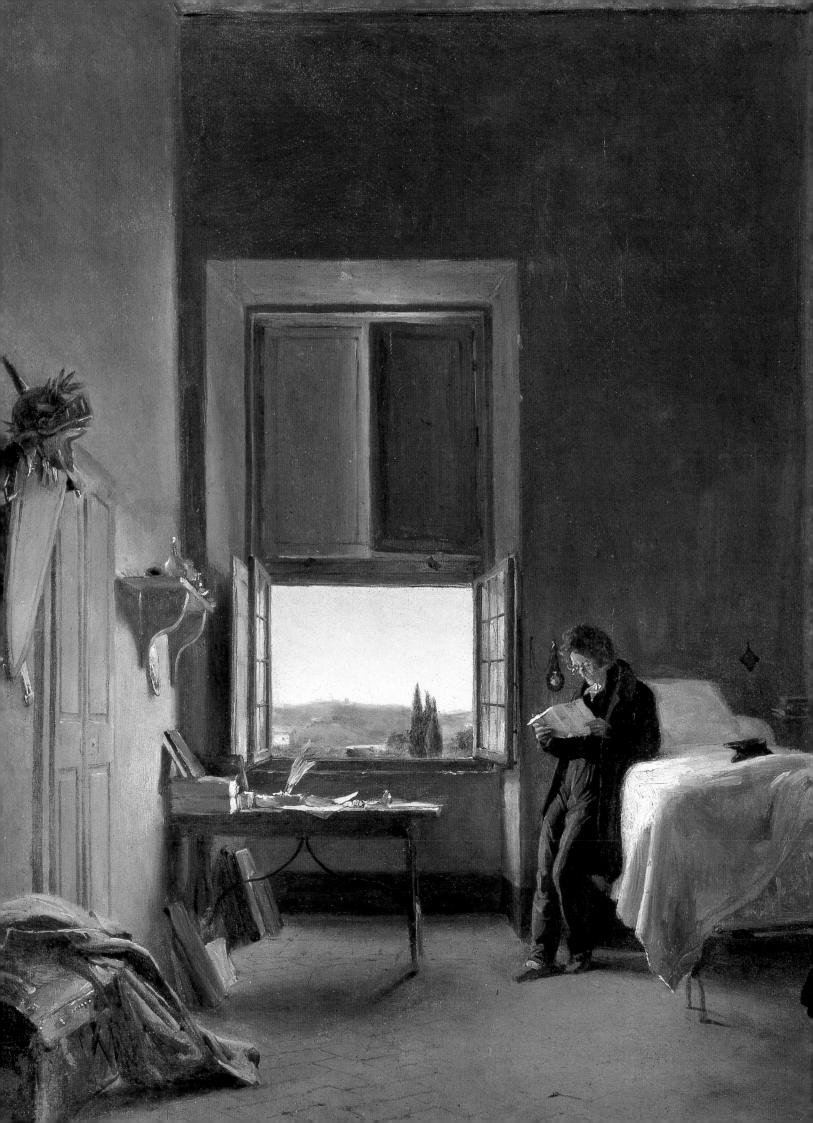

VINCENT POMARÈDE

An analysis of classical doctrine and its consequences for the evolution of landscape painting in Europe confirms that the very clear distinction between realistic landscape and ideal landscape (a distinction firmly established since the end of the seventeenth century) was not questioned until about 1800. Before the nineteenth century, the landscape painter primarily worked in the studio, seeking to reinvent nature through imagination. There was no need to work in the open air, except to draw or paint realistic landscapes for didactic purposes or visual exercise.

The Tyranny of the Imagination
Roger de Piles (1635–1709), whose writings marked the triumph of the "Rubenists" over the "Poussinists,"[1] of color and expression over line and intellectualism, clearly associated the practice of landscape, developed in his famous *Cours de peinture par principes,*[2] with his definition of "truth" in painting. Thus, he distinguished *simple truth*, "the simple and faithful imitation of expressive movements of nature and objects," in which the painter must seek "a sensitive and animated imitation of nature, so that the figures seem, as it were, to be able to detach themselves from the picture and enter into conversation with those who look at them"; *ideal truth*, "the choice of diverse perfections which could never exist in a single model, but which can be drawn from several and usually from the antique"; and *composite truth*, "composed of simple truth and ideal truth," and representing "credible beauty which often appears more true than truth itself."[3] Each of these notions constitutes a further step toward perfection: the realism of simple truth permitted the mental construction of ideal truth, which ultimately led to the perfect beauty of composite truth. Born of this quest for "composite truth," the various degrees of this hierarchy resulted in landscapes created in the studio and ennobled by the artist's imagination.

The obvious consequences of this theory were that the two categories of landscape introduced by de Piles (the rustic style, in which nature "shows itself simply, plainly, and without artifice," and the heroic style, "the composition of objects which in their type draw from art and from nature all that one or the other has to offer, which is great and extraordinary")[4] could be created only in the studio, because the artist had to compose his pictures around these truths reassembled from nature. The open-air study most certainly was recommended during the apprenticeship period, and afterwards for the day-to-day maintenance of the artist's familiarity with natural forms and to reinforce his sense of visual fidelity. However, the creation of composite landscapes,

Detail, cat. 59, Cogniet, *The Artist in His Room at the Villa Medici, Rome,* 1817

even when representing topographically accurate sites, remained the ultimate aim of the landscape painter, requiring the mental concentration and the technical means offered by the studio. In such a case, the quality of the landscape created by the painter relied above all else upon the superiority of his imagination and his ability to synthesize the forms of nature in a conceptual manner.

Imagination and Topographical Truth

Things would evolve considerably during the Enlightenment with the expanding practice of *veduta* painting. Even if these meticulous urban landscapes had been prepared from numerous graphic sketches after nature as well as some studies painted in oil, in fact such paintings were realized within the tranquility and unified lighting of the studio. Painters such as Viviano Codazzi, the precursor of this genre; Gaspar Van Wittel, called Vanvitelli; Canaletto; Bernardo Bellotto; and Francesco Guardi, all of whom were active in Italy; and Joseph Vernet or Hubert Robert, who were active in France, created works of a rare topographic fidelity in which they rediscovered the luminous, highly colored, and sensual universe of the site represented after long sessions in the studio, interrupted with some on-site verifications. The etymological origin of the term *veduta*, "the point where the view falls," moreover leads directly back to the strict rules of linear perspective expounded since the Renaissance, a technique permitting the imitation of nature in a conceptual manner and one entirely tied to work in the studio.[5]

The *veduta* painters, therefore, developed a technical elaboration of a decidedly classical character in their landscapes, one which was centered upon the maturation of the work in the studio. At the same time, they painted subjects whose very goal was, by definition, absolute fidelity to the topography of an existing site, remaining at the stage of "simple truth" as defined by de Piles. It thus seems evident that this persistent quest for topographic accuracy on the part of the *veduta* painters, which is removed from the labor of creative imagination extolled by classical theories of landscape, would inevitably necessitate an increasingly systematic recourse to the study of a motif, to work in the open air, in order to improve the fidelity to nature. Having begun as a fashion, tied to the development of tourism and the desire to bring home a memento of voyages in Italy, the practice of the *veduta* rapidly found equivalents in all the capitals of Europe, where it soon became an entirely separate genre of landscape.

From this point of view, the perusal of the *Dictionnaire de peinture, sculpture et gravure* of Watelet and Lévesque is particularly instructive, as it presents three definitions of types of landscapes — new versions of the three definitions of "truth," as expounded by de Piles — and introduces the *veduta* as an entirely distinct genre. Thus, the "view" was to represent "aspects of the countryside as they present themselves to the gaze"; the mixed or composite landscape was to take "for its basis real aspects, but to which one is permitted to make some changes so that these representations are in part imitations of nature and in part idealized"; and the ideal representation of rustic nature was to show "landscapes created with no other aide but memory and imagination."[6] The description of this last category of landscape, "the ideal representation of rustic nature," directly concerns our discussion, because Watelet and Lévesque specifically state that the painter may "without leaving the studio, paint the countryside," proving by contrast that the first two categories involve a more substantial recourse to

the study of nature and that by inference, the execution of landscapes in the open air clearly had been expanding during the preceding years.

Alongside the tyranny of imagination that had been imposed during the seventeenth and eighteenth centuries, the desire to paint nature and reality for their own sake was increasingly a new dimension in the execution of landscape, for which visual observation was indeed more important.

The New Status of the Study of Nature

In this regard, an examination of the themes and titles of landscapes shown at the Salon between 1780 and 1800 seems particularly significant. In fact, even while proving the continuity of the general principle whereby only pictures painted in the studio could be shown to the public as distinct works of art, we are witness to the progressive development over the course of the final Salons of the eighteenth century of a growing number of exceptions to this rule. Artists who no longer accepted the imagination as the sole criterion of aesthetic reference embraced the consequences of this evolution.

The adoption of the *veduta* genre by French landscape painters produced a taste for direct references, made within the title of the work itself, to the topography of the site represented. In the Salon of 1781, for example, Pierre-Antoine de Machy, one of the most influential landscape painters of the Royal Academy of Painting and Sculpture, exhibited a *View of Paris* which he specified was "taken from the Pont-Neuf,"[7] while Hubert Robert showed "two pictures, one representing *The Burning of the Opera* viewed from a window of the Academy of Painting and Sculpture, Place du Louvre, and the other *The Interior of the Opera House* the day after the fire."[8] These two artists, who adapted the technical principles of the *veduta* to their urban views of Paris, much as Canaletto or Guardi would have practiced them in Venice, attribute a primary importance to this precision—the orientation chosen, indeed the very moment at which the landscape was executed is included within the very titles of their works. In the Salon that same year, Jean Houel sent a view of Etna representing the configuration of the terrain as it had been formed by the eruption of a volcano "which began March 9 and which lasted until the end of May of the year 1769."[9] The landscape painters thus added a temporal exactitude to the topographic truth, reinforcing the potential interest for works representing a specific site at a given moment, just as the spectator would have found it at the very instant at that exact place. The frequency of landscape titles commencing with "View taken from...," which is characteristic of the absolute fidelity to the sites represented and the precision of the moment chosen for the execution of these works, becomes indicative of this new dependence of the landscape genre upon reality.

Hubert Robert was among the first to carry this practice to its logical conclusion by presenting works painted in the open air at the Salon. Thus, in 1783, he exhibited "two pictures painted from nature in the gardens at Marly," specifying in their very titles the circumstances surrounding the execution of these views.[10] This title, moreover, reveals the artist's desire to apologize to the spectator for the possibly unsteady technique of these works, which had not benefited from the convenience of studio execution, as well as the desire to express his own pride in the virtuosity of their achievement. The end of the century witnessed the increasing frequency with which views painted rapidly out-of-doors were exhibited next to works completed at length

in the studio. In 1798, Jean-Joseph-Xavier Bidauld, who in the 1830s would become one of the fiercest opponents of Théodore Rousseau's search for a more radical naturalism, exhibited a "Landscape painted from nature in the environs of Montmorency,"[11] which he clearly differentiated from another of his submissions to the Salon, which had been executed in his studio "from studies made at Civita Castellana."[12] Another landscape painter, Louis-Philippe Crépin, showed a *View of the Port of Brest*, which, according to him, "belonged to the artist who, having been called to service and having spent four years in the navy at Brest, painted [it] from nature."[13] Likewise, in the Salon of 1812, certain "southern" painters, admirers of the great Italian landscape painters or Poussin, exhibited their studio landscapes side by side with their landscapes from nature, as did some of the "northern" painters, who were passionate about Dutch and Flemish landscapes. Bidauld exhibited a *View Painted from Nature at Ermenonville*,[14] while Jean-Louis Demarne sent *A Landscape from Nature Representing a Gothic Monument along the Highway of Saint-Denis*.[15] That same year, the young Achille-Etna Michallon, who had just begun his career—he was only sixteen at this time—likewise showed a view painted out-of-doors, *A Wash House; Study from Nature at Annay*.[16]

This search for topographical exactitude and realism thus led certain artists first to execute, and then to exhibit, views from nature concurrently with their studio compositions. They seemed to wish to impose, though still in an informal way, the idea of a spatial division between the creative activity of the landscape painter, working out-of-doors when he was painting nature for its own sake, and in the studio when executing imaginary landscapes from memory.

The Appearance of the Notion of "Souvenir"

It is, moreover, at this period that Pierre-Henri de Valenciennes elucidated the meaning of the two views that could be cast upon nature, theories that sprang directly from the classical doctrine:

> There are two ways in which to envision Nature, and each of the two offers an infinite number of nuances which form and determine the ability. The first is that which shows us Nature as it is, and represents it as faithfully as possible....The second is that which shows us Nature as it could be and as the embellished imagination represents it.[17]

Bearing in mind the evolution of the preceding fifty years, Valenciennes introduced into his work a new genre, the landscape portrait. The goal of this genre was absolute fidelity to nature, as it had "no other distinctive characteristic than that of resemblance."[18] While he is describing this new dimension of landscape painting, Valenciennes was advising artists to work from memory, "to make studies based on recollection, after those you make on a daily basis, by imitating the masters, or by copying Nature."[19] The artist, therefore, must observe natural forms attentively and be penetrated by the "very idea" of the tree or the rock. But he must preserve its memory exactly in order to use it later in a landscape composed in the studio, without having to return to the original motif.

Valenciennes also attempted a synthesis of the various elements of this evolution in landscape painting, seeking to unite the need for observation with the nobility of working from memory. So in the final event, he judged the landscape portrait in

Detail, cat. 15, Valenciennes, *Ruins at the Villa Farnese*

a rather pejorative manner: "The genre of landscape portrait does not require, strictly speaking, a great deal of talent. It is only the eyes and the hand which work," he declared. Devoted to the return to the grand notions of the past, above all Valenciennes admired works representative of the "Beau idéal":

> When a man of genius wishes to refresh his imagination, he reopens his eyes to Nature: he contemplates it, he observes it; he looks for models on all sides which may help him to paint that which his enthusiasm has led him to perceive. Alas! he finds almost nothing; he sees this nature as it is: he admires it, but he is not content.[20]

Nevertheless, the status conferred by painters on the numerous studies from nature which they brought back from the trip to Italy or from long sessions of work around Paris would become particularly complex during the first quarter of the nineteenth century, and their relation to studio work was far from resolved. Did not the fact that the painter used his studies while working them up, or while copying them from memory, dictate that he preserve them, show them; in short, give them a veritable status and a place within his studio?

Instructors frequently turned away from the practice of studying in the open air by having their students copy their own studies from nature directly in the studio, to impress upon their minds the principal effects that one could draw from a site. Valenciennes, Bertin, and Michallon, all three able instructors in the practice of landscape, made their Italian oil studies available for their students to copy. The contents of the Valenciennes studio, part of which was purchased at the auction after his death in 1819 by Pierre-Charles de l'Espine, and now in the Musée du Louvre,[21] reveal several studio replicas of nature studies painted during Valenciennes' various excursions to Italy—replicas or copies, which moreover are difficult to distinguish from the original.[22] Michallon's studio, which was dispersed on 25–27 December 1822,[23] likewise contained studies from nature that represented the same site twice, taken from the same angle and with the same lighting, testimony to the copy exercises executed by his students—or even himself—during 1822. Some of these works, acquired at the time of the posthumous auction of Alexandre-Emile de l'Espine, are now in the collection of the Musée du Louvre. Moreover, Corot copied certain oil studies painted in Italy or Paris by his teacher Michallon: "On rainy days, Corot copied with an extreme conscientiousness Michallon's studies chosen from among the simplest: views of roofs and chimneys captured at Montmartre, of plants and factories," Emile Michel recounted in 1905.[24] And, in fact, at the posthumous auction of Corot's studio in 1875, studies of plants and architecture, as well as some "views of the Alps in sunlight," which he had copied at Michallon's studio, were found, testifying to these sessions of his apprenticeship.[25]

In this same spirit, studies—painted in the open air in oil or drawn in pencil— would be hung on all the walls of his studio so that the landscape painter could refer constantly to this or that form that he spotted in nature, but also to show them to visitors and students. The open-air study, formerly executed as a simple training technique or to distinguish visual landmarks, thus became a reference in the realistic representation of nature. Evidence of this progressive change in the attitude of instructors and artists relative to studies from nature resides in their systematic mounting on canvas backings, which reveals a desire to show them rather than merely keep them stockpiled in a portfolio, as Valenciennes had recommended. The pursuit of a heightened facility in execution had always led artists to use prepared paper as the most

common support for work produced on site, due to its convenience and relative ease in arrangement. From this time forward, the new usage ascribed to their studies required artists to strengthen them by mounting on cardboard or canvas. Thus, most of the small landscapes that Valenciennes painted on paper during his visits to Italy were glued to cardboard. Similarly, the posthumous inventory of Michallon's studio reveals that numerous studies from nature that he had executed in Italy had already been mounted on canvas during his lifetime, proof of the frequency with which he used them.

At the same time, the study from nature, which was omnipresent in the studio of the landscape painter, became an object for collection, sought after by amateurs and professionals alike, who recognized in them the foremost qualities of the painter, namely, his skill in the realistic portrayal of nature and his spontaneity in the transcription of natural forms. After 1800, posthumous auctions of landscape painters experienced a genuine success, precisely as a result of the number of people acquiring these nature studies. The exceptional effects from Valenciennes' studio, upon which all his students worked, were put up for sale in 1819, and professionals snapped up his studies, just as they would later do in 1822 at the posthumous Michallon sale. Certain collectors, such as Pierre-Charles de l'Espine and his son Alexandre-Emile, benefited from this occasion to form veritable collections specializing exclusively in nature studies, generally those inspired by sites painted in Italy. A number of artists, including history painters such as Anne-Louis Girodet-Trioson, Guillaume Guillon-Lethière, François-Xavier Fabre, and Jean-Dominique Ingres likewise collected studies from nature executed by their landscape-painter colleagues.

During the eighteenth century, the study from nature was considered a mysterious element in the creative evolution of the artist, interesting as a simple phase in the creation of a studio landscape. Around 1800 it became an independent phenomenon, a genuine point of departure for the visual reference of the artist, which one could study, copy, collect, and exhibit.

The Transformation of the Composition of Studio Landscapes
through Recourse to Memory

The place of studies from nature in the formation of an artist and the increase in this practice evidently weighed heavily upon work in the studio and on an artist's conception of landscape, not to mention the greater frequency with which such works were collected and exhibited. Indissolubly bound to a realistic vision of nature, the open-air study became in and of itself one of the sources of inspiration most frequently utilized by the artist during his hours of studio work.

The first characteristic sign of this important evolution was the practice adopted by some landscape painters of deliberately retouching their open-air studies in the studio to render them more marketable, exhibitable, or at least presentable. An examination of two landscapes painted by Bidauld in Italy in 1789, *View Taken at Subiaco* (fig. 1) and *View of the Town of Avezzano, on the Edge of Lake Cellano, near Naples* (fig. 2), which have often been considered to be studies from nature, are fascinating in this regard. They diverge in the nature of their supports, permitting one to consider the former work, painted on paper, as a study from nature and the other to be a studio work. However, their execution presents troubling contradictions between areas that are very finished,

very polished, as in works painted indoors, and other passages which are much more spontaneous, more loosely handled, that are consistent with the conditions of open-air painting. In the two works, the treatment of the skies and mountains are admirable, painted with an absolute realism, proving that the painter had observed nature at great length. But as in all such cases, it is particularly difficult to know whether these two views were painted exclusively in the open air or if their creator carefully reworked them in the studio. The result suggests a truly mixed technique with the execution begun out-of-doors followed by long sessions of retouching in the studio.

TOP: fig. 1. Jean-Joseph-Xavier Bidauld, *View Taken at Subiaco*, 1789, oil on paper, mounted on canvas, 26 × 45 cm. Musée du Louvre, Paris.

BOTTOM: fig. 2. Jean-Joseph-Xavier Bidauld, *View of the Town of Avezzano, on the Edge of Lake Cellano, near Naples*, 1789, oil on canvas, 37 × 49 cm. Musée du Louvre, Paris.

LEFT: fig. 3. Achille-Etna Michallon, *The Torrent*, c. 1817–1820, oil on canvas, 48 × 60 cm. Musée du Louvre, Paris.

RIGHT: fig. 4. Achille-Etna Michallon, *The Waterfall of Tivoli*, c. 1817–1820, oil on canvas, 62.5 × 56 cm. Musée du Louvre, Paris.

Likewise, the series of waterfalls painted by Michallon during his voyage in Italy is truly vexing.[26] One of them, in oil on paper mounted on canvas, is likely to be an open-air study (fig. 3) — or at least partly worked in the open air. The others are painted on canvas and of relatively large dimensions, some of them with a refined execution which removes them from open-air painting, as do the small figures that occasionally were added. *The Waterfall of Tivoli* (fig. 4), a painting which exceeds acceptable dimensions — and what is possible technically, besides — for an open-air work, underwent several stages of execution, including replicas and at least one variation with figures,[27] demonstrating how Michallon slowly brought this work to its successful completion, moving away from the spontaneity of the open-air work to render the recollections of these visual impressions with greater precision. Once again, we may legitimately pose the question in regard to the execution of these works: where did the open-air study end and the studio work begin?

The practice of systematically retouching open-air studies in the studio became widespread around 1810 by reason of the evolution in the status of these studies. Destined to be shown, copied, and even exhibited, the artist could not allow the technical defects nor the stylistic awkwardnesses associated with work done out-of-doors to remain. Therefore, he completed them in his studio, preserving the spontaneity of the original work, while correcting errors due to the inevitable haste of their initial execution. In other respects, for the elaboration necessary for his large historical compositions, the painter could prepare at length, through replicas and successive variations, this or that part of his future picture.

After 1810, the conditions of studio work seem to have been influenced distinctly by the development of the practice of open-air painting and by the new status that had been conferred upon studies from nature. It thus appears undeniable that the

exaltation of the creative imagination of the artist as it had been conceived by the neo-classical doctrine, and restored to fashion by Valenciennes, would be amended by the execution of the view after nature. The organization of the exams for the Prix de Rome for historical landscape, held for the first time in 1817, was particularly significant in this regard. Relying upon the classical doctrine as well as the candidate's aptitude for imagining scenery and composition suitable to the subjects assigned by the jury, the very conception of the exams nevertheless depended more upon the facilities of memory than imagination. The most dreaded task was the "tree exam," which involved the execution of a picture originating with a particular species of tree, chosen by the jury, and which the young landscape painter was to represent as faithfully as possible from memory. For this first competition in 1817, the winner, Michallon, incorporated an exact portrayal of a chestnut tree into his painting *Woman Struck by Lightning*.[28] Thus, memory and realism were the fundamental criteria used by the judges in awarding the Prix de Rome.

The style of historical landscape during the 1820s also reflected the evolution of the genre toward a greater realism and a strengthening of the visual ties with nature. This is apparent in the commission in 1818 by the government of Louis XVIII of an ambitious series of historical landscapes for the Galerie de Diane in the Chateau of Fontainebleau. The involvement of Michallon in this decoration, with a particularly somber and tormented landscape in the manner of Salvator Rosa, *The Death of Roland*,[29] is not coincidental, any more than the commissions awarded to painters as diverse as François-Marius Granet, Nicolas-Antoine Taunay, and Alexandre-Hyacinthe Dunouy, all of whom were united by a similar passion for the precise description of Dutch landscape painters. The genre of historical landscape had succeeded in extricating itself from neoclassical considerations, finding a much-needed regeneration through a more realistic gaze directed at nature.

In fact, realism remained a genuine obsession for neoclassical landscape painters, and studies from nature frequently appeared—simple copies or souvenirs of nature—in works which theoretically should only have come from the realm of the imagination. Neoclassical landscape painters often introduced fragments of nature from the open air into their pictures, drawing ever closer, even in these imaginary landscapes, to the topographical reality of the sites before which they worked. In his *View of the Ancient City of Agrigentum*,[30] exhibited in the Salon of 1787, Valenciennes indulged in this spirit for skillful visual montages realized from studies—drawn or painted—executed after a motif during his travels in Italy. To faithfully represent Agrigentum, a city in Sicily renowned for its ancient monuments, Valenciennes made use of his own recollections and specific studies that he brought back from one of his voyages. In 1779 he had worked in Sicily for some time, and returned with a notebook filled with drawings.[31] As Geneviève Lacambre has rightly emphasized, folio 34 of this notebook shows the Temple of Concord, which is located on a hill in the background of the picture, while another drawing—this one in folio 132—is a study of the same site in its entirety. Both sketches were taken from exactly the same angle that was later used in the picture for the Salon of 1787. Working from these studies drawn from nature, Valenciennes recomposed his landscape in the studio, with both the considerable freedom permitted by the mythological subject that he chose, as well as the apparent constraint to represent as accurately as possible these ruins, the evidence of which was preserved in his notebooks.

In the same vein, a few years later Michallon introduced the souvenir of a study that he painted on site at the Temple of Segesta — once again in Sicily — as well as elements from some of his studies of waterfalls of which we have already spoken, in a large mythological picture that he sent from Rome in 1821, *Theseus pursuing the Centaurs*.[32] The connection with reality which gives the picture its credibility was now becoming an obligation for the artist, even in such large mythological, religious, and literary compositions.

In purely quantitative terms, the historical landscape, which was the resurgence of the heroic landscape of de Piles, no longer superseded that of the "view" in the Salons, in exhibitions, and in sales. Freed from intellectual, historical, and anecdotal references, the practice of such "views," which were themselves the heirs of the rustic landscape and of the *veduta*, continued to adapt unceasingly and more faithfully studies from nature. A single view of a site painted in the open air could in turn inspire entire series of works recomposed in the studio after it. When Bidauld went to Italy, he returned with numerous views of the Isola di Sora: a watercolor dated 1787 (Musée des Beaux-Arts, Angers), which made possible the execution of a small picture painted in 1789 (private collection); two studies done in wash (Musée des Beaux-Arts, Grenoble, and Musée Calvet, Avignon) portrayed the same site from a different angle. The culmination of all these studies came in 1793 with the creation of a large painting, *Landscape in Italy*.[33] In this painting, which the artist exhibited in the Salon of 1793, he reinvented the landscape entirely in the studio, working from these various sketches. Michallon practiced a similar approach when he titled his submission to the Salon of 1822 *Landscape Inspired by a View of Frascati*,[34] defining with perfect clarity the powerful bond between the souvenir of an Italian site, the work executed in the studio after an open-air study, and the absence of recourse to the imagination.

Numerous artists worked in this vein, painting and exhibiting accurate views, realistically and skillfully constructed and composed in the studio after actual sites before which they had initially worked from nature. All of the neoclassical artists who made the voyage to Italy brought back with them the kinds of studies from nature that could be recycled in the diverse works they would later execute in the studio. From Louis Gauffier with his variations based on a view of Vallombrosa and Pierre-Athanase Chauvin with his views of Naples, to Jean-Victor Bertin with his austere landscape paintings of the Roman Campagna and Granet with his views of Trinità dei Monti, all these painters brought back with them from Italy material which afterwards would allow for long years of studio exploitation. But ultimately, was it not an identical approach that at this very time motivated Georges Michel, who tirelessly painted pictures in his studio recomposed after studies painted on site around Paris: pictures which were equally inspired by the works of Dutch painters which he cherished, restored, sold, and copied in abundance? Was it not the same idea and even the same technique that led John Constable to work in a systematic manner, alternating between work in the studio and work in the open air before Salisbury Cathedral?

This approach of enriching the landscape composed in the studio with the realism of studies produced outdoors was certainly the common denominator among all landscape painters of this period. At this stage the classical ideal, which still ran deep in certain artists, appeared as if transformed. Occupied with painting numerous replicas, variations, or enlargements after their open-air studies, the landscape painters of this period were more interested in the technical elements, the imitation of the subject or

particular light effects, and with duplication of real nature, rather than competency in creating an entire piece from the imagination, the idealized landscape, as would have been the goal of the landscape painter working in the neoclassical spirit. The narrative of a picture was thus having to compete more and more with the demands for realism which the neoclassicists themselves, and later the Romantics, mandated for all landscape paintings regardless of type. Whereas in classical doctrine, and for Valenciennes, the study from nature was an exercise that allowed the landscape painter to "practice his scales," around 1810 it became the direct source for work in the studio, enabling the landscape painter to develop his recollection of a site. Since the goal of these landscapes was becoming the representation of nature for its own sake, the role of imagination was diminished while that of study from nature became preponderant. A simple "view" painted from nature thus became the point of departure for an abundance of studio work: replicas, transpositions with figures, utilization within a historical landscape composition, the realization of a topographical view. The obvious question which could be put to these artists, of course, is why did the landscape painter continue to work in the studio, when working from nature had become his central activity?

Between Realism and Recollection

This question—with an absence of answers—would be posed by the younger generation of neoclassical painters who were just beginning their careers about 1820, primarily in the studio of Jean-Victor Bertin, who at that time was the authority in the instruction of landscape. It is at the heart of the aesthetic and the conception of landscape of this "new wave" of landscape painters, who, from Corot and Rousseau to Edouard Bertin and Paul Huet, occupied the forefront between the years 1830 to 1840. The Barbizon school would form itself from this heritage.

If we take the very significant example of Corot, who applied the example of his predecessors conscientiously and intelligently, we are confronted with a landscape painter who would carry this relationship between open-air study and studio work to an exceptional level.

First of all, he succeeded in reconciling the two practices, which had been opposed for two centuries, the latter previously being entirely dependent upon the former. One way that he accomplished this, for example, was by utilizing improvised studios which allowed him to paint from nature and to preserve an absolute fidelity to topographical reality, all the while remaining in an interior and thus benefiting from the technical advantages and the concentration of working in the studio. Thus in Rome in 1826 he took as a motif the rooftops of the city as viewed from the window of his room (private collection), an exercise that he would take up again on several occasions at Lormes (private collection) and Orléans (Musée des Beaux-Arts, Strasbourg). Likewise, in 1833, he established a makeshift studio on the second floor of a factory in Soissons belonging to Monsieur Henry so that he might paint a superb view of the city (Rijksmuseum Kröller-Müller, Otterlo). In 1851, he similarly obtained permission from one of his merchant friends to paint the port of La Rochelle from the first floor of the man's house (Yale University Art Gallery, New Haven):

Detail, cat. 29, Bidauld, *Gorge at Civita Castellana*, 1787

One of his views required no less than ten to twelve sessions of between three and four hours each. The artist, quietly installed on the first floor of a house alongside the banks of the quay, avoided the obtrusiveness of the curious. Thanks be given for the prudent solicitude of the one who procured for him this marvelous belvedere. It was the merchant and friend of the arts, Monlun, who lodged him in his home on the rue Ponte-Neuve during his stay at La Rochelle and who keeps eloquent testimonials of his passage on the walls of his home.[35]

Is it not possible that he painted his celebrated view of *Chartres Cathedral* (Musée du Louvre, Paris) under similar conditions? And in 1871 he would once again repeat this procedure by painting *The Belfry of Douai* from a window in a house of that city (Musée du Louvre, Paris).

Elsewhere, the recourse to views from nature in the neoclassical manner was evidently quite common for Corot in the composition of his studio pictures, as he did beginning with the study of the *Bridge of Narni* (Musée du Louvre, Paris), which he then adapted in the *View taken at Narni* (National Gallery of Canada, Ottawa), exhibited in the Salon of 1827; or *La Cervara* (the study is in the Musée du Louvre, while the picture exhibited in the Salon of 1827 is in the Kunsthaus Zürich); or the *View of Riva* (Kunstmuseum, Saint-Gall), an open-air study painted in 1834 on Lake Garda, which would allow for numerous variations inspired in the studio by this site (Neue Pinakotek, Munich; Musée des Beaux-Arts, Marseille; and Taft Museum, Cincinnati). Another example is illustrated by a small sketch of *Lake Piediluco* (Ashmolean Museum, Oxford), which was reprised years later in a number of large studio compositions (J. Paul Getty Museum, Malibu; The Corcoran Gallery, Washington). Once systematized after 1860, this practice became one of the characteristics of his oeuvre with the recurrent theme of the "souvenir."

All of these studies from nature were reworked at length in Corot's studio, particularly after 1840. Thus *The Colosseum Viewed from the Farnese Gardens* (fig. 5), *Chartres Cathedral*, *The Belfry of Douai*, and *The Church of Marissel* (all Musée du Louvre, Paris) are examples of masterpieces that were both executed out-of-doors and carefully completed in the studio.

At this stage, Corot, who had sufficiently developed his visual memory and his experience of nature, was capable of painting masterpieces in the open air, but he could also literally create major pictures without referring to his studies or to nature. As his first biographer, Théophile Sylvestre recorded: "This memory served me better at times than did nature itself."

I will extract...a picture from this study; but, if absolutely necessary, I can at present dispense with having it in front of me. When an amateur wants a repetition of one of my subjects, it is easy for me to give it to him without looking at the original again; I keep within my heart and within my eyes the copy of all my works.

Thus, his process of creation, the result of this neoclassical method in which the study from nature was a beginning and the exercise of the memory an end unto itself, was characterized by a prolonged period of maturation interrupted by long intervals of incubation:

fig. 5. Jean-Baptiste-Camille Corot, *The Colosseum Viewed from the Farnese Gardens*, 1826, oil on paper, mounted on canvas, 30 × 49 cm. Musée du Louvre, Paris.

Then, seizing a white pencil, he traced, after a moment of meditation, with an extraordinary fullness and suppleness, the principal outlines of a composition, which became immediately comprehensible, and from which he scarcely strayed except in order to embellish some of its details. From this first stroke, he himself predicted its fate: "There is one which will be famous," he said and, leaving this canvas, he went on to continue or to complete some others. These first ones that he sketched were not resumed until after having undergone an incubation period. They would then be brought back to his easel in order to be sketched in. Supplied with a fairly somber and rather poorly organized palette composed of pure tones, armed with strong and pliable brushes, the master would establish, using umber, black and white, heightened with Sienna and ocher, the arrangement of his picture in terms of its values and lighting effects, by first fixing everything in the two extremes: the greatest light and the greatest strengths. He thus asserted the principal forms with an almost violent firmness, which he moderated afterwards with the aid of some light scumbling. A new abandon followed this principal effort. Then when the rough sketch was quite solid, the master would try to obtain the color and harmony of his work with the help of colored paints, both pure and thinned.[36]

Thus is expressed the conclusion of a long evolution which, by means of the open-air view, had led landscape painters from the end of the eighteenth century and the beginning of the nineteenth to regenerate the landscape genre, abandoning the primacy of imagination for the benefit of visual memory and realism which did not exclude the power of expression. Corot was surely one of the most representative artists of this evolution, which was shared by Théodore Caruelle d'Aligny, Edouard Bertin,

François-Louis Français, Auguste Lapito, Nicolas-Louis Cabat, but also Huet, Narcisse Diaz de la Peña, and Constant Troyon. While the final aim of the traditional classical landscape was the re-creation, through the imagination of the landscape painter, of an ideal pictorial universe inspired by nature, the neoclassical landscape, with the increased practice of open-air study and the complex relationship with studio work which sprang from it, gradually imposed a new, more realistic conception of landscape: it should be, above all, respectful of nature, a truly existent nature, and the artist's imagination was to be limited to a series of variations stemming from visual souvenirs. The following generation — that of Corot, but also of Rousseau and the Barbizon painters — treated open-air study and studio work as two parallel, rather than successive, practices which could thus enrich one another.

But with the personality of Rousseau, the last aesthetic battle could be waged at last: that of the exhibition at the Salon of open-air studies, works which by definition were unfinished, and which did not necessarily refer to a topographically identifiable site, where they were placed on the same aesthetic level as studio pictures. Not only did narrative and anecdote disappear from landscape, but nature, as perceived through the more or less objective eye of the painter, was now sufficient in and of itself to engender a work of art.

Notes

The essay was translated from the French by Kimberly Jones.

1. At the end of the seventeenth century, a violent feud erupted within the Royal Academy of Painting and Sculpture, which opposed the partisans of Poussin, who defended the preeminence of line, drawing, and structure, to those of Rubens, who, according to them, sought to establish the superiority of color, the vibration of visible brushstrokes, and expression. Roger de Piles, a great admirer of Rubens, sided with the "Rubenists" completely, and concluded by imposing his theories over the course of various conferences and publications, as in his *Dialogue sur le coloris* (Paris, 1673), *Conversations sur la connaissance de la peinture* (Paris, 1677), and *Dissertation sur les ouvrages des plus fameux peintres* (Paris, 1681).
2. de Piles 1989.
3. de Piles 1989, 20–22.
4. de Piles 1989, 99–100.
5. Briganti 1971, in his magisterial work dedicated to Italian *veduta* painters, perfectly explained this origin of the *veduta* genre deriving from the application of the rules of perspective to landscape.
6. Watelet and Lévesque 1792, 4:8–9.
7. Salon of 1781, no. 60.
8. Salon of 1781, no. 94.
9. Salon of 1781, no. 172.
10. Salon of 1783, no. 10.
11. Salon of 1798, no. 35.
12. Salon of 1798, no. 36.
13. Salon of 1798, no. 99.
14. Salon of 1812, no. 89.
15. Salon of 1812, no. 287.
16. Salon of 1812, no. 15.
17. Valenciennes 1973, 380–381.
18. Valenciennes 1973, 479.
19. Valenciennes 1973, 417.
20. Valenciennes 1973, 382–383.
21. Pierre-Charles de l'Espine, director of the factory of the Mint of Paris, between 1810 and 1820 amassed a collection of studies from nature that was inherited by his son Alexandre-Emile, who, in turn, would enrich it substantially. Since 1930, the Musée du Louvre has held this important ensemble of studies composed of works by Valenciennes and Michallon, among others, and which was given to the museum by a direct descendant of the l'Espine family, the princess Louise de Croÿ.
22. A few examples of these strange "doubles" found among the series of studies by Valenciennes in the Musée du Louvre will suffice to recall the frequency of these replicas executed by the students in the studio

of Valenciennes in the course of their apprenticeships: *Ruins on a Plain* (RF 2898 and RF 2940), *Lake Nemi in the Rain* (RF 2901 and RF 3015), *On the Shores of Lake Nemi* (RF 2902 and RF 2924), *Entrance to a Grotto among Foliage* (RF 2907 and RF 2932), *Roman Landscape* (RF 2936 and RF 2942).

23. The posthumous inventory of Michallon, even more so than the auction catalogue itself, supplies useful information on this subject (Archives Nationales, ET XLIV 865). Thus, the Musée du Louvre possesses a *Study of a Roman* (RF 2893), of which a replica exists in a private collection, and a *Seascape, Effect of a Wave in the Region of Naples* (RF 2870) and a *View of the Ravines of Sorrento* (RF 2890), of which two copies are in the Musée des Beaux-Arts, Orléans, as part of the Léon Cogniet bequest.

24. Michel 1905, 10.

25. These studies appeared at the posthumous Corot auction in 1875 as lot number 505.

26. The Musée du Louvre has the majority of works from this series: *The Waterfall (Tivoli)* (RF 2881), *The Torrent (Tivoli)* (RF 2883), *Waves at the Base of Some Rocks* (RF 2869), *Landscape with Mountains Traversed by a Torrent* (RF 2867), while the Musée des Beaux-Arts in Orléans possesses a beautiful example, *The Waterfall of Terni* (inv. 644), which belonged to Léon Cogniet.

27. These two variations are in private collections.

28. *Woman Struck by Lightning,* Paris, Musée du Louvre (RF 3731).

29. Paris, Musée du Louvre (inv. 6632). This work was exhibited in the Salon of 1819, no. 826, not far from Théodore Géricault's *Raft of the Medusa.*

30. Paris, Musée du Louvre (M.N.R. 48).

31. This notebook, entitled *Voyage in Sicily and Naples,* is presently housed in the Cabinet des dessins of the Musée du Louvre.

32. Paris, Musée du Louvre (inv. 6631).

33. Paris, Musée du Louvre (inv. 2588).

34. Salon of 1822, no. 940. Paris, Musée du Louvre (inv. 6633).

35. Moreau-Nélaton 1924, 1:77.

36. Burty 1875, preface.

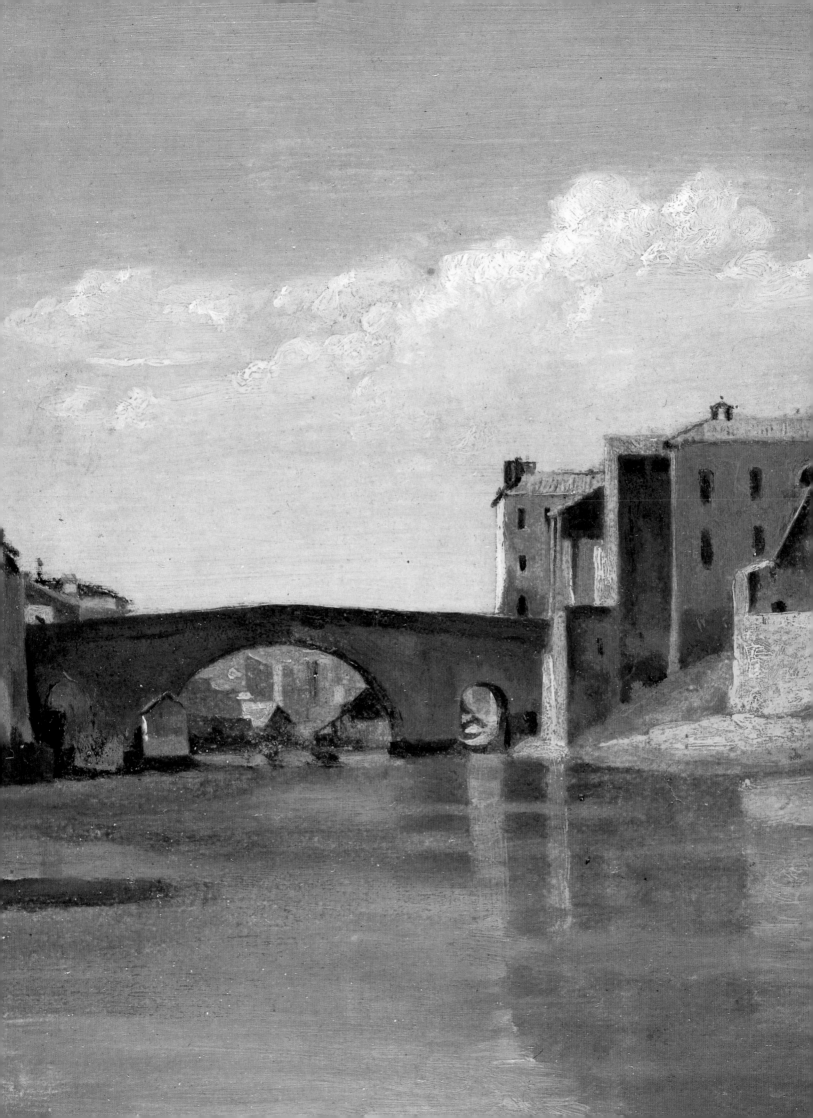

Note to the Reader

The catalogue section was written by Philip Conisbee, Sarah Faunce, and Jeremy Strick. The author's initials appear at the end of each artist's biography.

The artists are arranged in chronological order of their visits to Italy, with a few minor variations. Each artist's works are arranged chronologically, when the dates are known.

The works by Corot carry a reference, on the dimension line, to R and a number, following the standard catalogue of Corot's works, Robaut and Moreau-Nélaton 1905 and supplements.

Dimensions are given in centimeters, followed by inches in parentheses; height precedes width.

PRECEDING PAGES: Detail, cat. 91, Corot, *Island of San Bartolommeo*, 1826–1828

RICHARD WILSON
British, 1713–1782

Wilson was born in Wales, but went to London in 1729 under the sponsorship of Sir George Wynne. There he trained as a portrait painter and also painted topographical landscapes—the two staples for British artists at the time. He began a continental tour in 1750, stopping in Venice where he won a commission from Joseph Smith, the British consul and patron of Canaletto and other Venetian artists. In Venice, Wilson studied the landscapes of Marco Ricci and Francesco Zuccarelli. The British art dealer and cicerone Thomas Jenkins accompanied Wilson from Venice to Rome in 1751 and introduced him to the international art world there, notably the British community. It was in Rome that Wilson decided to devote himself to landscape painting, following the advice and the example of Claude-Joseph Vernet, who was at the peak of his career there. Vernet was preparing to leave Rome for his native France in 1752, and Wilson probably saw the opportunity to pick up some of the Frenchman's lucrative business with British Grand Tourists. In Lord Dartmouth and Ralph Howard, later Lord Wicklow, and Joseph Leeson, later Lord Milltown, Vernet and Wilson shared patrons at this time.

In Rome, Wilson not only found patrons for a lifetime but also the personal style that engaged their interest. His landscapes, whether topographical, adjusted from nature to varying degrees, or more-or-less fanciful, are richly evocative of Italy, antiquity, and the great landscape painters of the seventeenth century. The sites are usually familiar from the works of Claude Lorrain or Gaspard Dughet, but the sources of Wilson's style are found in the work of his contemporaries in Italy: Ricci and Zuccarelli in Venice; Jan Frans van Bloemen and Vernet in Rome. Wilson favored a warm light and a softly atmospheric focus, which imbue his work with an evocative, even elegiac air, enhanced by the presence of some ancient ruins or fragments. As such, his paintings proved to be perfect souvenirs of the Grand Tour. After his return to Britain in 1758, Wilson enjoyed considerable success by continuing to produce poetic evocations of the Italian scene and by painting views of country houses and

fig. 1. Richard Wilson, *The House of Pompey at Albano*, c. 1752, chalk on paper, 21.9 × 38.1. Metropolitan Museum of Art, New York, Rogers Fund, 1906.

British landscapes, often cast in a somewhat Romantic Italianate light. Later in life he fell victim to excessive drinking and died destitute.

With Wilson, British landscape came of age, and he is rightly regarded as the founder of the school. He was an example and an inspiration to the Romantic generation of John Constable and J. M. W. Turner. There is no evidence that Wilson painted in oils out-of-doors—his preferred medium was drawing (fig. 1)—but he was the key figure in establishing Italy and the Italian landscape as major subjects of British art in the second half of the eighteenth century. When his pupil Thomas Jones made his first excursions into the Campagna and the hills around Rome in the 1770s, he saw with Wilson's eyes wherever he went:

> Every scene seemed anticipated in some dream—It appeared Magick Land—In fact I had copied so many Studies of that great Man, & my Old Master, Richard Wilson, which he had made here as in Other parts of Italy, that I insensibly became familiarized with Italian Scenes and enamoured of Italian forms, and, I suppose, *injoyed pleasures unfelt by my Companions*.[1]

PC

Notes

1. Jones 1951, 55 (December 1776).

Literature

Constable 1953; Solkin 1982.

1

Tivoli: The Cascatelli Grandi and the Villa of Maecenas

1752
oil on canvas
49.5 × 64 (19½ × 25³⁄₁₆)

National Gallery of Ireland, Dublin

This painting and its pendant, *Tivoli: The Temple of the Sibyl and the Campagna* (see Conisbee essay, fig. 15), were painted for Joseph Henry of Straffan, County Kildare, who was in Rome in 1752 with his uncle Joseph Leeson, later Lord Milltown (whose descendants gave the two pictures to the National Gallery of Ireland in 1902). An artist is seated approximately at the belvedere on the Via delle Cascatelle looking across the Cascatelli Grandi (large waterfalls) toward the substructure of the so-called Villa of Maecenas (in fact, the foundations of an ancient temple complex). By

contrast with this picturesque hillside, the flat Campagna stretches out into the distance, where the dome of St. Peter's, about twenty miles away, is visible.

Tivoli had rich associations for the eighteenth-century visitor, not only because Claude Lorrain, Gaspard Dughet, and others had worked there in the seventeenth century, but even more so because of its reputation since ancient times. Maecenas, the most famous patron of writers such as Horace and Virgil, had lived there. These poets, along with Catullus and Propertius, had extolled the beauty of Tivoli and the surrounding Sabine Hills, country retreats from the political intrigues and summer heat of Rome.

It was not Wilson's usual practice to paint out-of-doors, but probably Vernet encouraged him to do so. The presence of an artist painting the view, with his portable easel and folding stool, implies an endorsement of the practice.[1] The

middle and far distances likely were painted, at least in part, in front of the motif. In the companion picture, an artist and his assistant, carrying a large canvas and a folding easel, are departing Tivoli at the approach of a storm. Both paintings appear quite freely and rapidly executed for Wilson. In the pendant, the flat panorama of the Campagna has been scored through the wet paint with horizontal lines to reveal the dark ground, giving a sense of texture and depth.

Notes

1. Constable 1953, 225, under no. 117a lists several versions of this composition, including the present one; Constable points out that the version in the Dulwich College Picture Gallery, London, was mentioned by the diarist Joseph Farington, who was a pupil of Wilson, when he saw it in the collection of Sir Francis Bourgeois on 3 May 1809: "He shewed me a beautiful picture of Tivoli by Wilson....In it he represented himself with an Easel painting."

CLAUDE-JOSEPH VERNET
French, 1714–1789

The son of an artisan in Avignon, Vernet showed promise at an early age and was sponsored by members of the local nobility to make a study trip to Italy in 1734. He quickly became absorbed into the international art world of Rome, where he established his reputation as one of the leading view painters. He was patronized by the Roman nobility, the French diplomatic community in Rome and Naples, and above all by the British on the Grand Tour.

In 1746 Vernet began to send works for exhibition at the Salon in Paris, which made his reputation there. He finally returned to France in 1753, where he continued a highly successful career of international renown, working chiefly for French, British, and Russian patrons. The esteem in which Vernet's work was held marked the coming of age of landscape painting in France. His example and his teaching had a considerable effect in Rome, especially on British artists such as Alexander Cozens and Richard Wilson; there and in Paris Vernet set an encouraging example for French landscape artists.

Vernet was a strong advocate of painting from nature. His ideas on landscape painting are set forth in a didactic "Letter on landscape painting," probably written after he settled in Paris in 1765. In it he recommends the constant close study of nature and the steady observation of the overall tonal harmony provided by the atmosphere.[1]

> The shortest and surest method is to paint and draw from nature. Above all you must paint, because you have drawing and color at the same time. First of all you must choose carefully what you want to paint from nature; everything must compose well, as much for the form as for the color, light and shade....Once you are in position you must take as the subject of your drawing or your painting what can be encompassed in one glance, without moving or turning your head....When you have selected what you want to paint, you must copy it as exactly as possible, both in form and color, and do not think you can do better by adding or subtracting....You must do exactly what you see in nature; if one object is confused with another, be it in form or in color, you must render it as you see it; for, if it is good in nature it will be good in painting....The time of day that you choose to paint a picture must be apparent throughout, and each object must partake of the general tone of nature....The further away you are from an object, the more vapors there are between the eye and the object. That is why we see fewer details and why the color of the object appears weaker....Whatever the object represented in a picture, it will only be beautiful in proportion to the general harmony spread throughout; that is why you must frequently quickly look over all the objects offered you by nature, and never lose sight of this general harmony, which is so seductive, but which you cannot achieve except by comparing the tones assumed by the objects in your picture, by reason of their distance.

PC

Notes

1. The letter is reproduced in full, in French, in Conisbee 1976, appendix, n.p. It was first published in Jay 1817, 622–625.

Literature

Ingersoll-Smouse 1926.

2

View at Tivoli

c. 1745
oil on canvas
35.6 × 46.4 (14 × 18¼)

Mr. John Lishawa

The sale of Vernet's estate after his death in 1789 included "33 Tableaux & Etudes, peints d'après nature, tant à Rome qu'à Naples, de différentes grandeurs, sur toile sans cadre."[1] *View at Tivoli* is the first of this type of open-air painting by Vernet to reappear. In style it can be compared with the backgrounds of any number of his landscapes of the 1740s, but particularly good comparisons are the two small view paintings of *Rome: The Castel Sant'Angelo* (Louvre, Paris) and *Rome: The Ponte Rotto* (see Conisbee essay, fig. 13), which can be dated to 1745.[2]

Tivoli had been one of the most popular sites for artists since the early

seventeenth century, on account of its natural beauty and rich historical associations (see Wilson, cat. 1). Vernet was clearly attracted by the picturesque combination of the overgrown hillside and the ancient architecture of the Temple of Vesta (known as the Temple of the Sibyl in his day) and its adjacent vernacular buildings. He made a drawing of this

site (fig. 1), taken from lower down and to the left of the oil study.

fig. 1. Claude-Joseph Vernet, *The Temple of Vesta, Tivoli*, c. 1745, ink and pencil on paper, 26.2 × 37.9 cm. Ecole nationale des beaux-arts, Paris.

Notes

1. *Notice des Tableaux* 1790.
2. Ingersoll-Smouse 1926, 1:47, nos. 155–156, and pl. XIV, figs. 30–31; on *Rome: The Ponte Rotto* see Conisbee 1976, n.p., no. 11.

ALEXANDRE-HYACINTHE DUNOUY

French, 1757–1841

One of the so-called little masters who painted views of the region around Paris in the late eighteenth and early nineteenth centuries, Dunouy was born in Paris and exhibited at the Salon for the first time in 1791. Throughout the 1790s he exhibited views made in and around Rome and Naples. Apart from a few absences, he showed regularly until 1833. He was awarded medals in 1819 and 1827. Under the patronage of the Napoleonic general Joachim Murat, whom Napoleon had made king of Naples, Dunouy traveled to Italy in 1810. There is evidence that he was there in the 1780s.

In France, Dunouy worked in the region around Paris, as well as in the Auvergne, Savoy, and around Lyons. His paintings, most frequently small and decorative, are full of the spirit of the late eighteenth century: they feature highly finished classical compositions, a clear atmosphere and precise detail, and even, undramatic lighting. Certain of Dunouy's works include figures painted in by Jean-Louis Demarne or by Nicolas Antoine Taunay. Achille-Etna Michallon may have received early lessons from Dunouy. JS

Literature

Bellier de la Chevignerie and Auvray 1979, 2: 482–483; Hans Vollmer in Thieme-Becker 10: 147–148.

3

3

The Palazzo Reale and the Harbor, Naples

c. 1780?
oil on paper, mounted on canvas
21 × 29.2 (8¼ × 11½)
inscribed on stretcher: "Vue du Château de l'Oeuf à Naples par Dunouy vers 1805"

Private Collection, New York

Like *Hill Town in Italy* (cat. 4), this oil study offers a painstakingly detailed representation of contemporary architecture. That approach is surprisingly combined with a cropped, asymmetrical composition that brings to mind the approach of Thomas Jones, who worked in Naples in the early 1780s. Still, despite its evident asymmetry, it is worth noting how carefully the artist has calibrated the composition. A round tower stands in the middle of the painting, with its single window at the exact center between left and right.

The inscription (probably not by the artist himself) has provided the basis for the attribution of this and the following work to Dunouy, but relatively little has yet been published about him. Another inscribed work, which recently came to light, is clearly by the same hand.[1] Dunouy was certainly in Italy in the 1780s,[2] and at the Salon throughout the 1790s he exhibited views made in and around Rome and Naples. In spite of the inscribed date, on stylistic grounds the present work and cat. 4, which was acquired at the same time, could well have been executed in the 1780s. Their affinity with certain Italian oil sudies by Jones has suggested their juxtaposition in this catalogue, but we cannot rule out the possibility that Dunouy painted these studies on a later visit to Naples.

Notes

1. New York 1994, no. 4, illus.
2. See Clarke 1986, no. 1, a *View of Sora* signed and dated by Dunouy in Rome, 1789.

4

Hill Town in Italy

c. 1780?
oil on paper, mounted on canvas
17.1 × 25.4 (6¾ × 10)

Private Collection, New York

This remarkable small painting suggests the range of possibilities open to the genre of the landscape oil study soon after its adoption in Italy by Pierre-Henri de Valenciennes and Jones. The composition, a solidly structured pyramid of buildings, appears in its order and stability like an element from a classical landscape by Poussin. The architecture is modern, however, and the painting seems entirely self-contained: it does not appear as an incomplete component of, or a study for, a larger composition. Unlike paintings by Valenciennes and Jones, or, later, François-Marius Granet, the level of detail here is extraordinary. Nothing suggests a speedy execution. The atmos-

4

5

Attributed to Dunouy

Rooftops in Naples

c. 1780
oil on paper
29.2 × 44.5 (11½ × 17½)

Private Collection

The attribution to Dunouy of this radiant view looking southeast across rooftops to the hills near Sorrento is tentative and can be tested during the exhibition. The execution of the trees, clouds, buildings, windows, and wall textures is comparable with Dunouy's *The Palazzo Reale and the Harbor, Naples* (cat. 3), as are the overall feeling of light, the disposition of the architecture, and choice of an unusual viewpoint. The same sensibility is found in Dunouy's *View of the Ruins of the Town of Stabiae, near Castellamare,* recently on the art market.[1]

phere is limpid and the fall of light is observed with great care. For this artist, then, the landscape oil study had as its purpose the close observation of form, and the precise description of detail.

This is far from the project of Valenciennes, closer, perhaps, to that of Dunouy's near-contemporary, Jean-Joseph-Xavier Bidauld.

5

Rooftops in Naples provides an interesting view of the characteristic Neapolitan *lastriche,* or roof terraces, from which Jones liked to paint in the early 1780s (cats. 7–13). Jones had a studio in this neighborhood next to the Castel Nuovo, whose northeast side is bathed in light at the right. In the center is a lighthouse, often featured in eighteenth-century scenes of Naples harbor, but long since removed in modernization. This view is in some respects a reverse of Jones' *Buildings in Naples* (cat. 9): the small dome near the center is probably that of the no longer extant church of Santa Maria Poveri, while the church at the left edge of the painting may be San Diego (formerly called San Giuseppe Maggiore dell'Ospedaletto). PC

Notes

1. New York 1994, no. 4.

6

Unknown artist

Villa and Fortifications on a Hill

c. 1780?
oil on paper
20.3 × 38.1 (8 × 15)

Private Collection

It has proved impossible to identify the site of this sketch, but it could have been made in or around Naples. The type of arcaded substructure supporting the hillside is found there and is visible in works by Jones, such as the exhibited *Ruined Buildings, Naples* (cat. 7). In the eighteenth century, villas of the kind seen in the present painting dotted the hills around Naples, commanding views of the famously beautiful bay. (Similar buildings were also depicted by Jones, as in cats. 11, 13.)

John Gere felt that *Villa and Fortifications on a Hill* could be by a British painter and suggested (orally) an artist in the circle of Richard Wilson, which implies a date in the early 1750s.

The low viewpoint, the grouping of the buildings, and the willful deployment of an empty foreground are indeed similar to certain Italian drawings by Wilson, such as his *House of Pompey at Albano* (see Wilson biography). But the touch of this sketch does not have the painterly, picturesque quality of Wilson in Italy, and there is a tight, precise, even neoclassical sense of observation in the lighting and depiction of the architecture that suggests the later generation of Jones and Dunouy, in the 1780s and 1790s. The exhibition may help to resolve the problem of dating, if not of attributing, this exquisitely observed oil sketch. PC

THOMAS JONES
British, 1742–1803

Jones came from a landowning family in Radnorshire, Wales. Destined for the church, he attended Oxford University from 1759 to 1761, but persuaded his father to allow him to study art in London, which he did at Shipley's School and the Academy in St. Martin's Lane. He was apprenticed to Richard Wilson from 1763 to 1765, a determining experience for his career as a landscape painter. Although Wilson encouraged his students to draw rather than to paint in oils from nature, Jones must have absorbed the latter idea in this milieu. In 1770 he recorded that he "painted in oil some Studies of Trees &c after nature" at Gadbridge, Hertfordshire; during a visit to Pencerrig, his family home in Wales, in July 1772, he "Made a good many Studies in oil on paper." On another visit before his departure for Italy in October 1776, Jones painted "a number of Studies in oil on thick primed paper – after Nature."[1] A number of these fresh and unpicturesque oil studies of his native landscape survive and are unique in British art at the time.

In 1776 Jones went to Italy, where he stayed until 1783. He was in Rome from December 1776 to September 1778. He made a visit to Naples, September 1778 to January 1779. He was back in Rome until May 1780, when he returned to Naples, remaining there until August 1783. On his return to London Jones lived on the income from an inherited estate and continued to paint Italianate landscapes in the tradition of Wilson. After the death of his father he returned to Radnorshire in 1789 to manage the family properties. He became a magistrate, high sheriff of the county in 1791, and led the life of a country gentleman, continuing to paint occasionally for amusement.

Tantalizing references in Jones' *Memoirs* suggest that he had a variety of international contacts in Rome and Naples. He once recorded a festive dinner in Rome with "Danes, Swedes, Russians, Poles, Germans, all Artists," while other foreign visitors occasionally crossed his path. In Naples he knew the two famous landscape artists of the day, the German Jacob Philipp Hackert and the Frenchman Pierre-Jacques Volaire. In September 1781, "Monsieur *Mingot*, a French Landscape painter, with another Artist, a Country man of his, and myself took a boat for Puzzuoli." He developed a friendship with the topographical painter Giovanni Battista Lusieri, who had a large international clientele for his topographical views of Naples and Pompeii. Jones, too, made a sufficient living painting landscapes mainly for British visitors, but also for Russians and Germans. They are finished and somewhat idealized views of Rome, the surrounding Campagna and hill towns, and Naples with its famous bay. Since their "rediscovery" in the early 1950s, Jones' oil studies have attracted interest and admiration, but his works painted for sale still await study and a catalogue. Jones worked very much in the tradition of his teacher Wilson, but his manner of painting is drier, as was noted by contemporary critics, and he lacks Wilson's richly evocative mood.

Jones' contribution to the history of art and his importance for the present exhibition is in the oil studies he made from nature, particularly in Italy. During the first week of June 1778, he stayed at the villa belonging to a certain Martinelli on a hill along the Via Nomentana, beyond the Porta Pia near Sant'Agnese fuori le Mura, with a view southwest to the city, while to the north and east were the Campagna and the Alban Hills. There, in the company of the British watercolorist John Robert Cozens, "I made some Studies in oil of the surrounding Scenery."[2] It had taken him four years

in Italy to discover the type of motif that twentieth-century viewers most admire —
for the originality of his vision and the compelling beauty of his execution — when in
April 1782 he went onto the rooftop of his studio and looked at the building across
the street. The subsequent views of walls and rooftops from his several Neapolitan
studios have no surviving precedents in the history of art. Like the oil studies by other
painters in this exhibition, those of Jones were made for his own instruction and
amusement. As far as is known, none was sold in his lifetime; they became public
knowledge only because a descendant sent a portfolio for auction in London in 1954.
Yet at the end of Jones' life the interested visitor to his remote house in Radnorshire
could indeed have seen them, according to James Baker, author of *A Picturesque
Guide through Wales and the Marches*:

> Trevorren, in this neighbourhood, is the paternal dwelling of Thomas Jones, Esq., the
> possessor of Penkerrig before named, and other ample estates in this neighbourhood; for
> the trust of which the school of painting lost a powerful assistant: his numerous lessons
> from views in Italy, highly finished coloured drawings, are at the last named house open
> to the inspection of the amateur and the friend, and are perhaps equal to the best
> specimens of the sort that have been brought to this country.[3]

PC

Notes

1. Jones 1951, 22, 27, 38; for surviving oil studies done at Pencerrig see Edwards 1970, nos. 4, 5, 13, 14.
2. Jones 1951, 73; one of these studies, inscribed "Porta Pia," has survived: see Gowing 1985, 40, fig. 33.
3. Baker 1795, 3:224–227.

7

7

Ruined Buildings, Naples

c. 1782
oil on paper
24.4 × 39.7 (9⅝ × 15⅝)

Glynn Vivian Art Gallery, Swansea

The site, a picturesque mixture of embankment, trees, and architecture, has not been identified for certain, but Anthony Blunt convincingly suggested "the substructures to the terrace of one of the religious houses on the slopes of Capodimonte, almost certainly the Sagra Famiglia di Gesu."[1] Lawrence Gowing suggested "the substructure of the Pizzofalcone hill."[2] The site can be compared with a drawing in a sketchbook by Jones' friend John Robert Cozens, dated November 1782, and annotated "a Range of Convents near Capo di Monte,"[3] whence Blunt suggested the two artists may have gone on a sketching trip together at that time. If so, Jones did not record it in his *Memoirs*.

Notes

1. Blunt 1973, 500.
2. Gowing 1985, 50, 63.
3. *Seven Sketchbooks* 1973, 47 (vol. 5, fols. 3v and 4r) and unpaginated illus.

8

Rooftops, Naples

1782
oil on paper
14.3 × 35 (5⅝ × 13¾)

Ashmolean Museum, Oxford

Washington and Brooklyn only

Dated April 1782, this view was certainly made from the same roof terrace of Jones' residence in Naples as cat. 9. He wrote in his *Memoirs*, based on a journal entry of May 1780, that he had taken rooms in

> a large new built house or Palace if you please, that took up the greatest part of one side of the little Piazza, on the opposite side of which was situated the *Dogana del Sale* or Custom house for Salt—The ground Appartments were all appropriated to Warehouses.... As nobody now lived in the house, I had my choice and took Part of the second floor nearest the Sea, being by far the pleasantest, with the use of the *Lastricia* or Terras Roof.[1]

8

It seems, however, that he did not take advantage of the views from his residence until just before his lease was up in May 1782.

Notes

1. Jones 1951, 95–96 (20 May 1780).

9

Buildings in Naples

1782
oil on paper
14 × 21.5 (5½ × 8⁷⁄₁₆)

National Museum and Gallery, Cardiff

The present painting was presumably made from the *lastrica* or roof terrace

of the building in which Jones rented rooms and a "*Study* or painting Room" in the warehouse and customs-house area near the Castel Nuovo in Naples for two years from May 1780.[1] Jones depicted this same building, but turning more to the right and taking in its entire length, in another oil study on paper in the Ashmolean Museum, Oxford (cat. 8). Dated April 1782, these remarkably

9

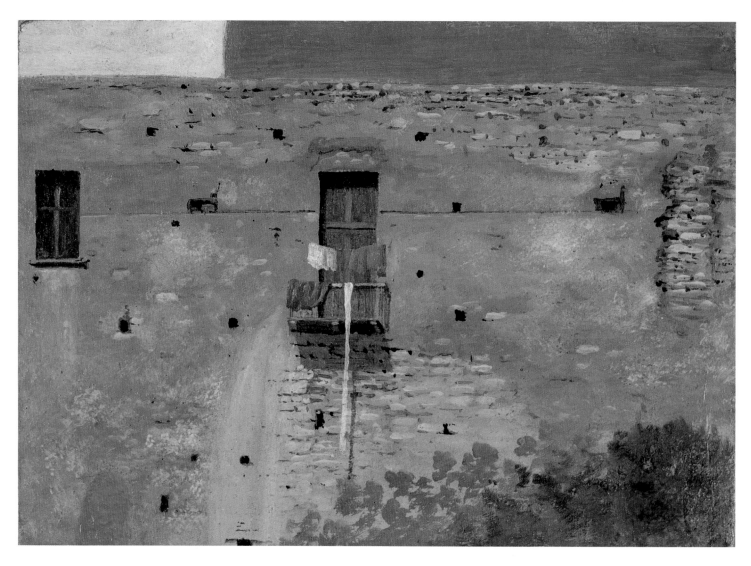

direct studies of a nondescript facade are among the most original paintings of the eighteenth century. It was only a few weeks before he had to move house that Jones seems to have discovered this novel manner of depicting his daily surroundings of the past two years. The low cupola immediately to the left of the sunlit wall is probably that of Santa Maria Visita Poveri (destroyed in the nineteenth century); the middle dome is that of Santa Maria Nova, while that to the left belongs to San Giuseppe (in Jones' day called San Diego dell'Ospedaletto).[2]

Notes

1. Jones 1951, 95–96 (20 May 1780).
2. See Blunt 1973, 498–500. Blunt, however, confused the names San Diego and San Giuseppe (p. 500).

10

Wall in Naples

1782
oil on paper, mounted on canvas
11.4 × 16 (4½ × 6⁵⁄₁₆)

The Trustees of the National Gallery, London

There is no way of telling which of the three studios used by Jones in 1782 and 1783 had the window from which he painted this remarkable work: was he in the Convent of the Capella Vecchia (May 1782), the house on the road to Capodimonte (June 1782–May 1783), or the studio in Chiaia (from December 1782 to May 1783)? Lawrence Gowing characteristically found the right words: "It is one of the great microcosms of painting, less than five inches by hardly more than six, yet built grandly out of the very stuff of illusion, that stuff of quite infinite, yet endless potential."[1]

Notes

1. Gowing 1985, 47.

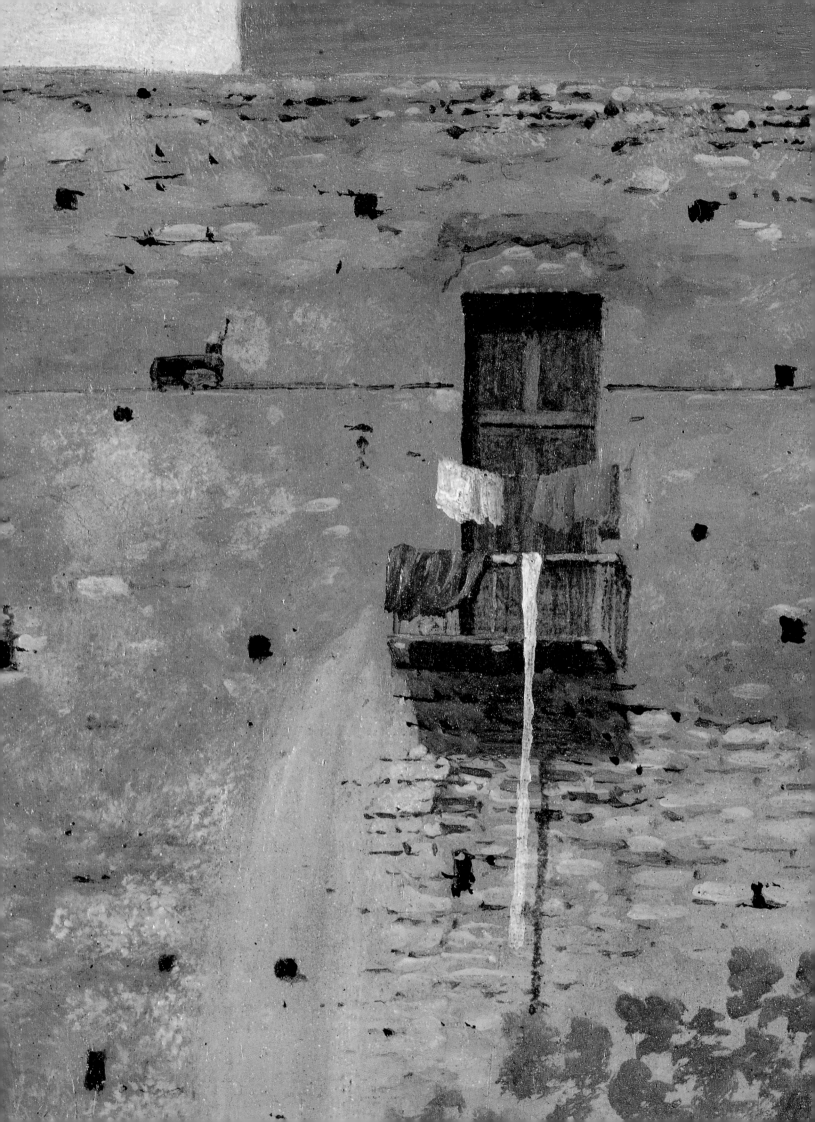

11

12

The Grotto at Posillipo

1782
oil on paper
20.3 × 27.3 (8 × 10¾)

Private Collection

The tunnel whose entrance is depicted
by Jones lies just beyond the western
end of the Riviera di Chiaia in Naples.
No longer in use, it was originally cut
in Roman times to link Naples with
Pozzuoli, to the west. Like the nearby
Tomb of Virgil, it was a considerable
tourist attraction in the eighteenth cen-
tury. It was also depicted by Jones'
friends Francis Towne, William Pars,
and John Robert Cozens, as well as by
French artists such as Claude-Joseph
Vernet, Hubert Robert, and the Swiss
Louis Ducros, to name only six of the
many artists who joined the tourist
throng there.

The tunnel was admired for the
drama of its tall, narrow, dark space, and
as a feat of Roman engineering. Jones'
interest is rather more purely pictorial,
however, in a quite remarkable painting
that is not so much about the famous

11

A Hilltop, Naples

1782
oil on paper
14 × 21.6 (5½ × 8½)

Birmingham Museums and Art Gallery

Washington only

The painting is inscribed on the reverse
"Naples 1782 T.J." It was probably one
of the sketches done from his window
in a cell in the Convent of Santa Maria
a Capella Vecchia, in May 1782, as
described in the *Memoirs*:

> As for a room to paint in, I procured
> one in a little Convent adjoining,
> called the Cappella Vecchia, situated
> in the Borgo of the Chaja & very
> near Sr W'm Hamilton's palace....The
> only window it had, looked into a
> Small Garden, and over a part of the
> Suburbs, particularly the *Capella
> nuova*, another convent, the *Porta di
> Chaja*, Palace of Villa Franca, and part
> of the hill of *Pusilippo*, with Castle of
> S. Elmo & convent of S. Martini &c.
> all of which Objects, I did not omit
> making finished Studies of in oil upon
> primed paper.[1]

The gable at the left belongs to the
complex of buildings of the Capella

Nuova next door to the convent in
which Jones had his studio; it appears
again in the oil study now in the Tate
Gallery, London, which is a view
of the dome and adjoining buildings
of the Capella Nuova taken by turning
just a few degrees left of the scene in the
present painting.

Notes

1. Jones 1951, 110–111 (3 and 12 May 1782).

12

site as a study of sunlight and shadow. He concentrates on the play of reflected lights in the shadows which contrast with the intense blue of the sky and the sunlit ocher of the cliff face at the right. In his *Memoirs*, Jones notes passing through this grotto to and fro between Naples and Pozzuoli on several occasions in September and October 1778, but an inscription on the reverse of the paper, now laid down, "TJ Naples August 1782," indicates that it was painted on a later visit, not recorded in his journal.

13

Scene near Naples

1783
oil on paper
24.1 × 34.2 (9½ × 13⁷⁄₁₆)

Lent by the Syndics of the Fitzwilliam Museum, Cambridge

The painting is inscribed on the back, "Naples Aprile 1783 TJ," and must be among the last oil studies Jones made

before "leaving, with *Regret*, my favorite little house near *Capo di Monte*."[1] Jones had moved to a top-floor apartment there in June 1782, attracted by the flat roof to which he had exclusive access:

> From this *Lastrica*, by which Term the flat roofs of the houses in Naples, surrounded by parapet Walls, are called; I say from this *Lastrica* you Commanded a view over great part of the City, with the Bay, Mountains of Sorrento & Island of Caproea—on the other Side, the Rocks, Buildings, & Vineyards about Capo de Monte—and where I spent many a happy hour in painting from Nature.[2]

The building depicted on the rocky hill above the terraced vineyards in *Scene near Naples* has sometimes been identified as the Monastery of San Martino,[3] but it is more modest in scale—more like a villa—than the famous monastery. To be nearer to fashionable society, Jones moved his painting room (but not his residence) across the city to Chiaia in December

1782, continuing to work there until the following May. He did not have a rooftop there, but

> The Windows on each side looked over fruitful Gardens, and commanded a View of many Churches, Convents, Villas and the greatest Part of the hill of Pusilippo....I began several Studies of the different Scenes & Objects seen from the Windows on both Sides, some of which were painted in oil.[4]

Scene near Naples could be a view up one of the hillsides above the neighborhood of Chiaia. Early in May 1783 Jones moved his paintings and equipment to the billiard room in the palace of British Envoy Sir William Hamilton, who made it available as a temporary studio while the artist awaited the next ship to Britain.

Notes

1. Jones 1951, 122 (29 April 1783).
2. Jones 1951, 112 (8 June 1782).
3. Edwards 1970, no. 73; Gowing 1985, 51.
4. Jones 1951, 118–119 (6 and 28 December 1782).

PIERRE-HENRI DE VALENCIENNES
French, 1750–1819

In 1930, the princess Louise de Croÿ presented the Louvre with a large group of paintings and drawings from the collection of her grandfather, Prince Charles de l'Espine, which she had inherited. Included in the donation were 124 landscape oil studies by a then-obscure academic artist of the late eighteenth century, Pierre-Henri de Valenciennes. These studies proved a revelation: they antedated Corot's Italian oil studies by nearly half a century, and they preceded the open-air paintings of the impressionists, to which they were compared, by almost a full century. This rediscovery set in motion a reevaluation of the history of late eighteenth and early nineteenth-century landscape painting, which has come to place Valenciennes at the head of a crucial and distinguished artistic tradition.

Born in Toulouse, Valenciennes trained first at the Academy in his native city, studying with the history painter Jean-Baptiste Despax and with the miniaturist Guillaume-Gabriel Bouton. Taken up by a patron, Mathias du Bourg, a member of the Toulouse parliament, Valenciennes traveled to Rome in 1769. In 1771 he arrived in Paris, entering the studio of the history painter Gabriel-François Doyen in 1773.

In 1777, Valenciennes traveled again to Rome, where he remained until 1781. By his own account, he devoted much of his time there to the study of perspective, instructed by an Italian mathematician. Returning briefly to Paris in 1781, he made the acquaintance of Claude-Joseph Vernet, who in one lesson transformed his understanding of perspective, and of the role of sky and clouds in landscape. Vernet may have also taught Valenciennes the technique of the outdoor oil study, for upon his return to Rome in 1782 Valenciennes began the series of paintings that eventually found their way to the Louvre.

Although Valenciennes did not invent the landscape oil study, in his hands the technique, which had been practiced fitfully since the seventeenth century, became firmly wedded to a set of subjects and artistic concerns. Working in Rome, Valenciennes all but ignored the major monuments and eschewed broad, descriptive panoramas. He favored humble, nondescript architecture or anonymous corners of ruins that suggest the passage of time, but not history. As Peter Galassi has pointed out, these subjects were part of an artistic repertoire that French artists in Rome had been *drawing* since the mid-eighteenth century. In the medium of the oil study, however, this repertoire was transformed by an overriding artistic interest: the appearance of these subjects under different, and often changing, conditions of light and atmosphere. Not only might Valenciennes paint the same subject twice, at different times of day, but in a number of studies he took as his subject the sky itself, anchoring it only by a small strip of land at the bottom of his sheet. To capture the effect of his subjects at a specific moment, Valenciennes painted his studies quickly. Their technique is relatively free, the brushwork often loose or open. And yet in none of Valenciennes' oil studies does the artist give himself over to bravura, to the conspicuous display of his mastery. Instead, the studies retain a modest quality, a simple delight in the accurate transcription of visual experience.

There is little evidence of Valenciennes' artistic contacts in Rome — whom he met, and to whom he may have shown his studies. There is little doubt, however, that it was in considerable measure through Valenciennes' agency that the practice of making

oil studies spread. Having returned to Paris by 1785, Valenciennes was made a member of the Academy in 1787, that same year making the first of his regular submissions of historical landscape paintings to the Salon. At about this time he opened a studio, and his pupils came to include both amateurs and aspiring professionals. He taught perspective at the Ecole des Beaux-Arts from 1796 to 1800, and in 1812 received an official appointment as professor of perspective. Regarded as the most distinguished landscape painter of his time, he was called "the David of landscape." Among those trained by Valenciennes were Jean-Victor Bertin and Achille-Etna Michallon—both of whom would eventually teach Corot; Pierre-Athanase Chauvin, who passed most of his career in Rome; and Jean-Baptiste Deperthes, a theorist of landscape and an amateur landscape painter. As a teacher, Valenciennes placed a premium upon the outdoor oil study, encouraging his students to work outdoors frequently and under all possible conditions of light, season, and weather. In addition, he made available his own studies for his students to copy, thereby familiarizing them with a repertoire of motifs and a range of effects and techniques. He no doubt played an important role in the conception and establishment of the Prix de Rome for historical landscape painting, the first of which was awarded to Michallon in 1817.

In 1800 Valenciennes published *Elémens de perspective pratique à l'usage des artistes, suivis de réflexions et conseils à un élève sur la peinture*. This was, in effect, two books published in a single volume, the first a detailed manual of perspective, the second a lengthy essay on the theory and practice of landscape painting. The second book offers the fullest and most complete account of the neoclassical theory of landscape painting ever written. In it he describes the various types and styles of landscape painting, and asserts that idealized historical landscape—the most elevated of the landscape genres—is equal in status to history painting. At the same time, he argues passionately for the experience of nature, and urges his reader to record that experience by means of the oil study. His prescriptions for the landscape oil study are quite detailed and extensive, and are evidently based on his own practice. Far from a minor, isolated activity, the landscape oil study takes its place at the very center of Valenciennes' theory and pedagogy as the essential means by which the landscape painter comes to understand and represent nature. By his pioneering of the oil-study technique, and by his placement of that technique at the very center of prescribed academic practice, Valenciennes initiated a series of profound changes in the course of European art, changes of which he was certainly unaware, and for which he has only lately received proper credit. JS

Literature

Lacambre 1976; Radisich 1977.

14

14

View of the Colosseum

oil on paper, mounted on cardboard
25.5 × 38.1 (10 1/16 × 15)

Musée du Louvre, Paris

Taking his viewpoint from the area of
the Palatine Hill, Valenciennes looks
down toward the Colosseum and east-
ward to the distant Sabine Hills. The
painting is a tour-de-force of his oil-
study technique, with its contrast of
foliage seen close up and in silhouette,
at right, with the summary treatment
of architecture and landscape in the
middleground and distance. Even more
dramatic is the dark, sweeping diagonal
that cuts across the painting at its right
edge, abruptly pushing the remainder
of the composition back in space.
A similar view (cat. 63) was painted
approximately thirty-five years later by
Valenciennes' student Michallon, in a
finely detailed manner which throws into
sharp relief the exceptional verve and
energy of Valenciennes' treatment.

15

Ruins at the Villa Farnese

oil on paper, mounted on cardboard
25.8 × 39.7 (10 3/16 × 15 5/8)

Musée du Louvre, Paris

The combination of ancient ruins and
verdant foliage became a favored *topos*
for open-air landscape painters, begin-
ning with the studies that Valenciennes
executed in the Farnese Gardens. Adja-
cent to the Palatine Hill and the Forum,
the gardens offered masses of overgrown
foliage and a jumble of ruins for those
painters who wished to try their hands at
such unruly motifs. Valenciennes' view-
point for this painting exemplifies the
artist's departure from the norms of clas-
sical landscape composition. Alternating
masses of ruins and vegetation seem
piled atop one another, improbably sur-
mounted by thin trees cropped by the
picture's edge. Studies such as these are
among Valenciennes' most painterly, as
the artist attends to a multitude of colors
and forms, and contrasts of light and
dark, describing them with fluent, fluid
brushwork.

Writing about ruins in his *Réflexions
sur la peinture*, Valenciennes noted:

A ruin being only the remains of an
artificial object which once existed in
its entirety, it represents for us only
the sad and cold skeleton of that
edifice which has been more or less
degraded according to the period of
time that has passed since its con-
struction, and according to the events
which have hastened or progressively
caused its destruction. The painful
sensations that one feels in considering
them as ruins; the reflexions relative to
our own existence, menaced by this
distressing image; the memories that
are retraced in our imagination and
which carry us back to the time when
these constructions were an integral
part of monuments which were
masterpieces of architecture and of
sculpture in those centuries most
renowned for the arts; these works of
famous men mutilated by the treach-
ery of time or overturned by igno-
rance; finally the ideas which are
involuntarily suggested to us by this
gradual decomposition and this con-
tinuous destruction, carry into our

15

16

Roman Ruins at the Villa Farnese

oil on paper, mounted on cardboard
26.3 × 40.4 (10⅜ × 15⅞)

Musée du Louvre, Paris

spirit a wound of sadness and of a painful and sorrowful melancholy.[1]

The mood of this oil study seems far removed from those sentimental reflections, and more in keeping with the investigative spirit expressed in the following passage, which comes only three pages later:

It is very useful to draw ruins when they can serve for the discovery of an historical fact of interest to the sciences and the arts. The ruins of a land, compared with those of another, may clarify interesting points concerning the customs and the manner of living of their ancient inhabitants, and even concerning certain objects relating to natural history.[2]

Notes

1. Valenciennes 1800, 413–414.
2. Valenciennes 1800, 416.

Valenciennes' oil studies vary from close-up views to distant panoramas. Here he is concerned not with the depiction of a single landscape element, such as the form of a plant or leaf, but rather the profusion of elements found even under the most restricted focus. That detached, microcosmic vision can be tied to the artist's fascination with the collection of botanical specimens, but also suggests a link between the world Valenciennes uncovered in his oil studies and the concept of the fragment, so crucial to later Romantic thought and artistic practice.

16

17

17

Buildings at the Southwest End of the Palatine

oil on paper
23 × 38 (9¹⁄₁₆ × 14¹⁵⁄₁₆)

Private Collection

At the end of the second century, the area of the Palatine Hill was increased by the emperor Septimius Severus, who added a series of arcades at its southern end. The ruins of those arcades are seen in this oil study behind a low, modern structure — perhaps a row of cow sheds — that leads to a small modern house, at left.

18

At the Villa Farnese: Houses on a Hill

oil on paper, mounted on cardboard
25.5 × 38 (10¹⁄₁₆ × 14¹⁵⁄₁₆)

Musée du Louvre, Paris

Not only did Valenciennes eschew in his oil studies the standard views of Roman monuments favored by the so-called

vedutisti, but frequently he avoided those monuments altogether, turning his attention to relatively humble, vernacular architecture. As is typical of many of his oil studies, Valenciennes is concerned here to describe the interplay between architecture and vegetation. These oil studies frequently convey the sense of the Roman landscape as a living entity, brimming with a verdant energy.

18

tuted the northern boundary of the city, beyond which stretched the empty, even desolate Campagna. For Valenciennes, the park and its vista furnished an anchor for this magnificent sky study, in which subtle, fluid brushwork melds creamy whites with darker earth tones to create a convincing image of a shifting, almost living atmosphere.

19

At the Villa Borghese:
White Clouds

oil on paper, mounted on cardboard
26.7 × 42.2 (10½ × 16⅝)

Musée du Louvre, Paris

Immediately north of central Rome, just outside the Aurelian Wall, lies the Villa Borghese, a large park established in the seventeenth century by Cardinal Scipione Borghese. Nearly four miles in circumference, the park covers more than 1,700 acres. Although the area around the park is now built up beyond recognition, at the time Valenciennes painted this oil study the villa consti-

20

Villa near Rome

oil on paper, mounted on cardboard
25.8 × 38 (10³⁄₁₆ × 14¹⁵⁄₁₆)

Musée du Louvre, Paris

Intrigued as he was by effects of mist and dense clouds, Valenciennes also took care to execute many oil studies under conditions of bright, clear daylight. Not surprisingly, landscape forms seem clear and solid under these conditions, lacking the evanescent appearance that other atmospheric conditions may impart to them. Set in the Roman Campagna, the precise location of this study has not been identified.

21

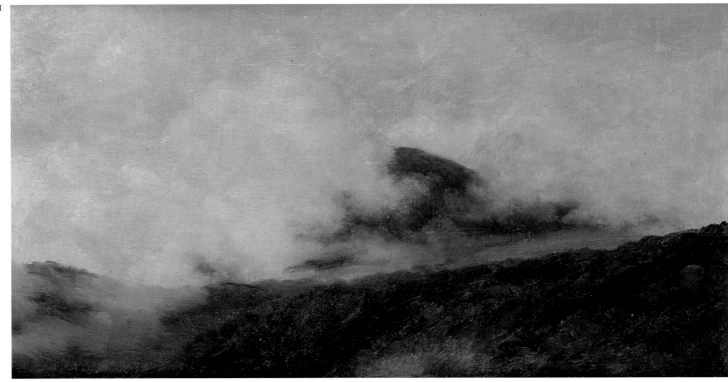

21

Rocca di Papa in the Mist

oil on paper, mounted on cardboard
15.1 × 28.5 (5⁵⁄₁₆ × 11¼)

Musée du Louvre, Paris

22

Rocca di Papa under Clouds

oil on paper, mounted on cardboard
14.4 × 29.7 (5¹¹⁄₁₆ × 11¹¹⁄₁₆)

Musée du Louvre, Paris

Arguably the most remarkable of all of
Valenciennes' oil studies are the two sets
of paintings in which the artist depicts
the same site under different conditions
of light and atmosphere. One such set of
studies (not in this exhibition) takes
as its motif a view of Roman rooftops.
The second set shows the conical moun-

22

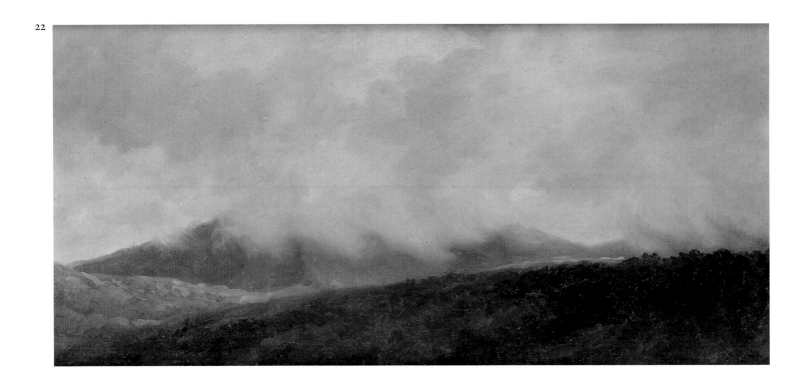

taintop of Monte Cavo, on whose
northern slope climbs the village of
Rocca di Papa. These two studies, *Rocca
di Papa in the Mist* and *Rocca di Papa
under Clouds*, appear to have been exe-
cuted within minutes of one another.
The fall of light across the landscape is
virtually identical; only the position
of cloud and mist have changed.

The two studies demonstrate not
only Valenciennes' speed and facility
with the paintbrush (evidently excep-
tional), but also his deep understanding
of the nature and causes of atmospheric
effects. The clouds in these paintings do
not appear simply as a mask, covering
over the solid form of the mountain, but
rather as entities possessed of density
and gravity, evanescing with changes in
temperature and atmospheric pressure,
shifting with changes in the wind.

23

Ruins on a Plain at Twilight

oil on paper, mounted on cardboard
16.6 × 39.7 (6⁹⁄₁₆ × 15⅝)

Musée du Louvre, Paris

This dark and brooding oil study is
anomalous in Valenciennes' oeuvre.
The motif at right (a building? a land-
scape element?) is difficult, at the least,
to identify, and the study as a whole is
unusually free and even expressive in
treatment. Certain studies by Granet
(cat. 48) and by Blechen (cat. 115a–d)
similarly approach the expressive
capacities of the landscape oil study, as
did other practitioners of the genre
such as Constable and, later, the French
painter Paul Huet and certain members
of the so-called Barbizon School.

JACQUES SABLET

Swiss, 1749–1803

Son of a decorator and gilder in Lausanne, Sablet learned the rudiments of his art from his father. In 1772 he moved to Paris, where he studied with the neoclassical history painter Joseph-Marie Vien for three years. In 1775, Vien was named director of the French Academy in Rome, and Sablet, supported financially by his father, accompanied Vien to Rome. However, with the competition of artists such as Jacques-Louis David and Pierre Peyron in Rome, Sablet eventually abandoned his aspirations to become a history painter. His lack of solid academic training meant that he did not win any of the significant commissions available in Rome, such as the decorations of the Villa Borghese, where an international team of artists was employed. Instead, he concentrated on genre, portraiture, and landscape. Sablet's genre scenes focused especially on the everyday life of Rome and the manners and costumes of Romans and of country folk in the Campagna, which became subjects of fashionable interest in the 1780s.

Sablet was closely involved with the Swiss, French, and German communities in Rome. He shared a studio with the French history painter Hubert Drouais and was a close friend of the Belgian landscape painter Simon Denis. In 1793, public and official opinion in the papal states turned violently against the French, as a result of the Revolution that was reaching a climax in France that year. The French-speaking Sablet fled to Florence. Perhaps because Louis Gauffier already had an established practice painting small open-air portraits in Florence, Sablet did not remain there for long, but returned to Paris. There he continued a successful career painting small portraits and scenes from modern life.

In 1800 Lucien Bonaparte was named ambassador to Madrid, and during his brief tour of duty Sablet accompanied him as an adviser on his art collection. Sablet is not known to have painted landscape sketches outdoors, although his highly finished portraits, with the sitters normally seen in the open air, often have beautifully observed landscape backgrounds. PC

Literature

Van de Sandt 1985.

24

Conrad Gessner in a Landscape

1788
oil on canvas
39 × 31 (15⅜ × 12³⁄₁₆)

Kunsthaus Zürich, Gift of G. Lory

Conrad Gessner (1764–1826), a painter
of landscapes and animals, was born in
Zürich. His father was the famous
Salomon Gessner, known as the "Swiss
Theocritus" for his bucolic idylls in
verse and prose, and who was also a
landscape painter and author of a widely
read essay, *On Landscape Painting,* which
advocated naturalism and the study of
nature out-of-doors.[1] After studying
with his father, and for a time in
Dresden with the landscape and battle
painter Casanova, Conrad Gessner
arrived in Rome in June 1787. He soon
established contact with his fellow Swiss
Sablet and their neighbor the Belgian
landscape painter Simon Denis, and was
off into the Campagna on painting
trips, as he wrote to his father on 27
October 1787:

> It is already nearly a month since I
> have visited the most beautiful coun-
> tryside around Rome with a group
> of young artists. You carry an easel
> folded like a stick in one hand; on
> your back a haversack, which contains
> a three-legged seat which can easily be
> folded, and a sort of box the size and
> shape of a surveyor's board, which
> contains brushes, colors and other
> necessities, that's all our equipment.
> Thus we make our way up hill and
> down dale, like a caravan, halting
> wherever there is a fine point of view,
> some picturesque object, on a whim,
> or at an inn that invites us to stop.
> With this easy way of painting from
> nature, your portfolio is filled without
> noticing. Mine is already very rich in
> studies of which I have painted the
> greater part in oil.[2]

Sablet's portrait of his friend Gessner
was no doubt intended as a record of
such expeditions. Gessner wrote a letter
to his mother on 18 July 1788 to say he
was happy with it.

Notes

1. Salomon Gessner, *Brief über die Landschafts-
malerei an Herrn Fuesslin* (Zürich, 1787); English
translation, Salomon Gessner, *Idyls, or; Pastoral
Poems; to Which is Annexed, a Letter to M. Fuesslin,
on Landscape painting* (Edinburgh, 1798).
2. Van de Sandt 1985, 55, no. 14.

25

An Artist in the Campagna

1789
oil on canvas
39.5 × 30.5 (15⁹⁄₁₆ × 12)

Musée des Beaux-Arts, Nantes

Painted in Rome in 1789, this work has
sometimes been called a self-portrait,
an identification not accepted in the
modern literature.[1] It could represent
any one of Sablet's artist friends in
Rome, seated in the shade of a tree to
avoid the glare of the sun. Sablet special-
ized in small portraits showing the
sitters in the open air. Their modest scale
was a good deal more practical than the
famous life-size portrait of *Goethe in
the Roman Campagna* (Städelsches
Kunstinstitut, Frankfurt) painted by
Tischbein in Rome in 1786–1787, about
which the sitter remarked, "It is going
to be a fine painting, but it will be too
large for our northern houses."[2]

Notes

1. Van de Sandt 1985, 56–57, no. 15.
2. Goethe 1962, 141 (29 December 1786).

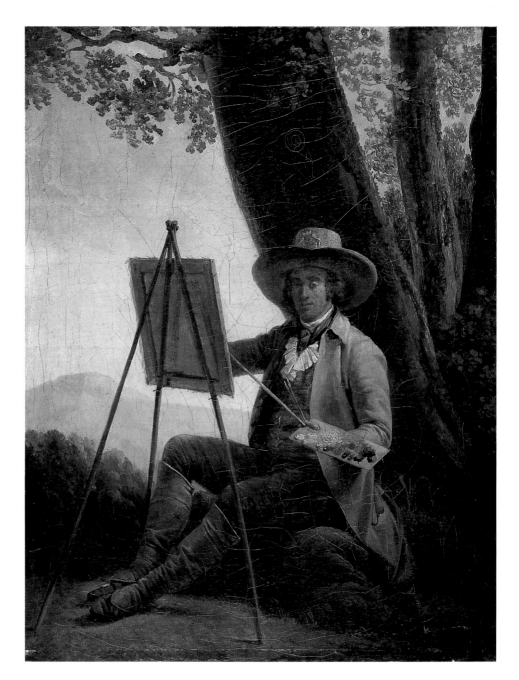

JEAN-ANTOINE CONSTANTIN
French, 1756–1844

Born in Marseille of a peasant family, Jean-Antoine Constantin entered at eleven years of age into apprenticeship as a decorator of faience. In 1771, even while he continued his apprenticeship, he entered the Academy of Painting and Sculpture of Marseille. Constantin won awards at the Academy in 1772 and 1773, and his talents were recognized by a wealthy merchant in Aix, who in 1777 arranged with several friends to send him to Rome for six years to pursue his artistic training. Although his stay in Rome was cut short after three years by illness, Constantin remained there long enough to confirm his interest in landscape painting and to amass a considerable body of drawings and oil studies. Little is known of his contacts in Rome, although he went to the Eternal City in the same year that Pierre-Henri de Valenciennes arrived for his second trip, and it may have been from him that Constantin learned the technique of the open-air oil study.

In 1786 Constantin was appointed director of the School of Drawing in Aix, a position he maintained until 1794, when it was dissolved in the wake of the French Revolution. Those eight years were the most prosperous of Constantin's life, and were equally important for the relationships he forged with two of his pupils: François-Marius Granet and Auguste de Forbin. Following the closure of the school, Constantin taught for several years at the municipal school in Digne, then returned to Aix where he seems to have supported himself by giving private lessons. Finally, in 1813, he was appointed adjunct professor of landscape at the reopened School of Drawing that he had formerly directed. He exhibited at the Paris Salon for the first time in 1817 (perhaps with the encouragement of Forbin) and for his four views of Provence was awarded a gold medal. Thereafter he exhibited regularly at the Salon until 1831, attaining a respectable reputation as a painter of landscape. He was awarded the Legion of Honor in 1833. Despite that distinction, he passed the remaining eleven years of his life in increasing poverty, supported in good measure by the largess of his friends, including Granet.

Constantin was among the earliest of French painters to produce a significant body of open-air oil studies in Rome. His influence is apparent in the oil studies of Granet, particularly in the depiction of architecture and the dramatic spatial effects of ruins. The experience of Rome was clearly crucial to Constantin. In a letter to Granet he wrote:

> I was so content when I lived in that country. Those were the happiest years of my life. I would like to be there still and be able to walk with you in those lovely ruins, to examine that nature which is so beautiful in its colors and which is grander than one can find elsewhere....how happy you are to live in that magnificent Italy, where nature and monuments bring everywhere the character of the Beautiful.[1]

JS

Notes

1. Vidal-Naquet 1986, 11.

Literature

Vidal-Naquet 1986.

26

26

Inside the Colosseum

1777–1784
oil on canvas, mounted on wood
35 × 47.5 (13¾ × 18¹¹⁄₁₆)

Musée Granet, Aix-en-Provence

The interior of the Colosseum, with its worn stones and fallen arches covered in vegetation, proved to be one of Constantin's favorite subjects. He executed numerous drawings and oil studies at the site. This unfinished oil study is of particular interest for its demonstration of Constantin's technique. The composition was blocked out first in pencil, and then painted. Evidently Constantin originally intended to include a shepherd and sheep in this picturesque scene; he has carefully painted around their drawn forms at the bottom of the study.

27

Inside the Colosseum: Chapel and Terrace

1777–1784
oil on canvas, mounted on wood
34.8 × 49 (13¹¹⁄₁₆ × 19⁵⁄₁₆)

Musée Granet, Aix-en-Provence

Far from the standard tourist images of the grand Colosseum, this study focuses in more intimate fashion on the experience of being inside the ruins. Above all, it offers a dramatic study in formal contrasts, as Constantin plays dark against light, mass against void, and straight line against curve. Some art historians have sought to link Paul Cézanne to a tradition of Provençal landscape that stretches back from Paul Guigou, through Granet, to Constantin. While the influence of that lineage is slight at best, this study nevertheless offers a striking example of nature seen in terms of geometric form.

27

28

*Rocky Cliff with Shepherd
and Sheep*

c. 1780
oil on canvas, mounted on wood
35 × 49 (13¾ × 19⁵⁄₁₆)

Musée Granet, Aix-en-Provence

The cliff face takes on an almost
architectural quality as it recedes into
the distance at left, its hard, light-toned
forms punctuated by softening, dark
vegetation. This close-up view is
characteristic of many early outdoor
studies, which typically prefer the detail
to the overview. The site of this study
has not been identified.

JEAN-JOSEPH-XAVIER BIDAULD
French, 1758–1846

Born in the Provençal city of Carpentras, Bidauld received his initial training from his elder brother Jean-Pierre-Xavier, a painter of flower and genre pictures in Lyons. Bidauld arrived in Paris in 1783, where he was taken up by the art dealer and perfume-seller Dulac. Subsidized by Dulac, Bidauld began a five-year sojourn in Italy in 1785. He resided in Rome but traveled widely, executing numerous landscape oil studies, many of which he kept throughout his career. His contacts among the colony of French artists in Rome, however, were mostly with history painters.

Bidauld returned to Paris in 1790 and entered the Salon for the first time in 1791, participating regularly thereafter. Prizes and official commissions began in 1792, and in 1823 he became the first landscape painter elected to the Institut de France. In 1825 he received the Legion of Honor. Although Bidauld maintained his official station for the remainder of his life, his reputation began to decline in the later 1820s and 1830s. As a member of the Institut de France, Bidauld served on the Salon jury, and he was held singularly responsible for the systematic exclusion of a new generation of landscape painters, Théodore Rousseau above all. He was attacked in the press in the most bitter terms, and as his work fell from fashion commissions and purchases nearly ceased; by the end of his life, Bidauld was reduced to near penury.

Although Bidauld painted Italian subjects throughout his career, he returned to Italy only once after his initial trip, in 1817. Some elements from his oil studies can be found in his finished paintings, but overall he seems to have relied far more upon his memory and imagination to produce the latter, which may explain their dry and formulaic character. Called upon to uphold the classical landscape tradition, Bidauld was neither a true academic, nor a theoretician. His finished compositions appear considerably less ambitious than those of his near-contemporary Pierre-Henri de Valenciennes, and they seem more decorative in intent. Nevertheless, Bidauld was not without his influence. At the mention of his name, Corot is reported to exclaim:

> Bidauld! Ah! But gently, now, he wasn't just anybody, he was at times truly a
> master, and one of the finest. Certain of his small canvases are masterpieces, and full
> of fine example and sound counsel for all of us, young and old alike. I admire him
> and I respect him, since, you see, I owe him a great deal, if not my very best.[1]

JS

Notes

1. Laurens 1901, 288.

Literature

Gutwirth 1978.

29

Gorge at Civita Castellana

1787
oil on paper, mounted on canvas
50 × 37.5 (19¹¹⁄₁₆ × 14¾)
Inscribed on verso: "Gorge de Civita
Castellana 1787"

Nationalmuseum, Stockholm

With its muscular rock formations and
verdant foliage, the gorge at Civita
Castellana was a subject favored by
numerous artists. Valenciennes drew at
the site, and Corot undertook two cam-
paigns in the region, executing drawings
and oil studies in 1826 and 1827. The site
seems to have made a particular impres-
sion on Bidauld. In addition to this
work, he produced several finished
paintings of the gorge, which he exhib-
ited at the Salons of 1798, 1810, and 1812.
Although painted on paper, this work
has been brought to a high level of
finish, suggesting that Bidauld con-
ceived of it as an intermediary category,
between an immediate, open-air study,
and a finished studio composition. Ten
views of Civita Castellana by Bidauld
were sold in the artist's posthumous
sale in 1847.

29

30

Monte Cavo from Lake Albano

1785–1790
oil on canvas
32.5 × 45.6 (12¹³⁄₁₆ × 17¹⁵⁄₁₆)

Museum of Fine Arts, Boston,
Charles Edward French Fund

Monte Cavo and Lake Albano, in
the region south of Rome known as
the Castelli Romani, proved an attractive
site for Bidauld and Valenciennes as
well as, fifty years later, Corot. Whereas
Valenciennes painted Monte Cavo
shrouded beneath mist and clouds (see
cats. 21, 22), Bidauld demonstrates with
this study the exceptional clarity of detail
he is able to achieve, even in the darker
tonal registers. The fastidious detail of
this painting, seen through the crystal-

line atmosphere characteristic of Bidauld, reminds us of the comment offered by the British painter Andrew Robertson following his visit to Bidauld's studio in 1815:

> ...his studies from nature, in oil— finished on the spot, are delightful altho' not well chosen—the most minute parts copied exactly—these are really excellent....he showed me one picture painted on the spot, about 2 and a half by 2 feet—a cascade in Italy in a deep glen—beautiful indeed, which he had sold for 200 louis—very minutely finished.

31

Mountains and a Lake

1785–1790
oil on paper, mounted on canvas
25.4 × 48.3 (10 × 19)

Private Collection, New York

The site is not identified, but this is one of a number of oil studies by Bidauld in which the artist adopts a broad, horizontal format to depict a mountainous landscape receding into the distance. Typically, Bidauld lays a strip of dark forms along the lower edge of the painting to set off foreground from background. Here, he includes a strip of lighter water, a middleground which pushes the mountains back in space. With minimal means, the effect is expansive.

31

LOUIS GAUFFIER

French, 1762–1801

A native of Poitiers, Gauffier studied in Paris with the history painter Hugues Taraval before entering the competition for the Prix de Rome, which he won in 1784. Apart from a brief return to Paris in 1789, Gauffier remained in Italy for the rest of his life. Although no meeting between the two artists is recorded, Gauffier may well have encountered Pierre-Henri de Valenciennes in Rome, and from the elder artist learned the technique of the open-air oil study.

Following the execution of King Louis XVI in 1793, members of the French community in Rome were advised to depart the city for fear of popular reprisals. Gauffier and his wife moved to Florence, where they stayed until the artist's death. Denounced then in Paris as a royalist, Gauffier was cut off from Parisian patronage and had to abandon his career as a history painter. He supported himself instead by painting portraits, developing a clientele of English tourists in Florence. After French troops occupied the city in 1799, Gauffier found steady business painting French military officers. He is known to have produced relatively few landscapes, yet those he did paint are of considerable beauty.[1] Perhaps the best evidence for his interest in the genre is provided by the fact that in his portraits he typically sets his figures within a landscape. JS

Notes

1. Notable examples of his work can be found in the Musée Fabre, Montpellier, and the Philadelphia Museum of Art.

Literature

Marmottan 1926, 281–300.

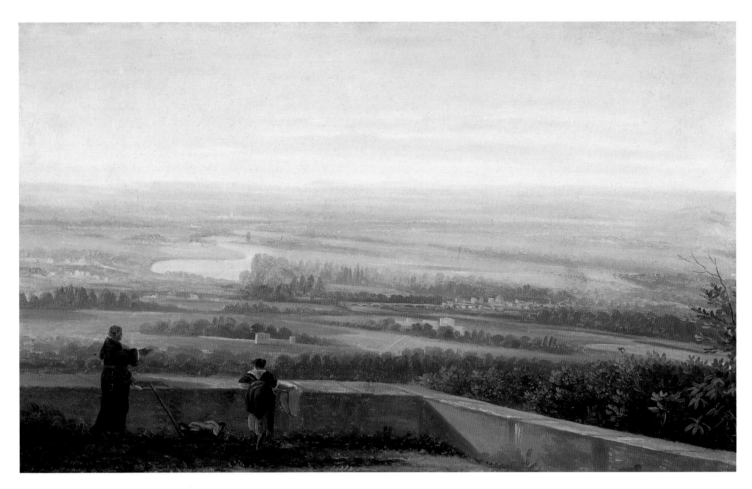

32

Attributed to Louis Gauffier

Landscape near Rome

1790s
oil on paper, mounted on canvas
35 × 47.3 (13¾ × 18⅝)

Private Collection, New York

In the 1790s, Gauffier made a number of oil sketches around the Certosa of Vallombrosa near Florence (Musée Fabre, Montpellier), which formed the basis for several finished paintings (Paris, Musée Marmottan; Philadelphia Museum of Art). The composition and the fluid manner of these sketches are the basis for the attribution of this painting to Gauffier.

Gauffier establishes this view from a terrace overlooking what may be the valley of the Tiber. The two figures in the foreground stand in for the viewer, guiding our way into the landscape. Use of such *staffage* is relatively rare in the tradition of open-air oil study. That

Gauffier employed these figures reminds us that, working for most of his career in Florence, he remained somewhat isolated from the community of painters who were enthusiastically developing a shared landscape oil-study aesthetic in Rome and its environs.

SIMON DENIS
Belgian, 1755–1812

Born in Antwerp, Denis studied in his native city with the landscape and animal painter H.-J. Antonissen. He was also influenced by the popular Balthasar Ommeganck, a painter of portraits, animals, and landscapes. Denis moved to Paris in the early 1780s, where he gained the patronage of the genre painter and picture dealer Jean-Baptiste Lebrun. Supported by Lebrun, Denis traveled to Rome in 1786.

Soon after Denis arrived in Rome, his work began to receive favorable attention. In 1787, a writer for the Roman newspaper *Giornale per le belle arti* wrote a long article in praise of one of his landscapes, noting Denis' ability to render effects of light and his convincing observation of detail. Also in 1787, he married a Roman woman, suggesting his intention to remain in Italy. Nevertheless, he maintained close ties to the Flemish community in Rome and was elected head of the Foundation St. Julien-des-Flamands in 1789. He also associated with French artistic circles. The celebrated French portrait painter Elisabeth Vigée-Lebrun resided with him for several days in 1789, and that same year Denis, Vigée-Lebrun, and François Ménageot, director of the French Academy in Rome, made an excursion to Tivoli. François-Marius Granet, who sought the Flemish painter's advice soon after he arrived in Rome in 1802, wrote: "This worthy man was of ordinary appearance, but his keen little eyes gave his expression a great deal of vivacity and wit. His manners, in keeping with his countenance, had inspired my confidence."[1]

Denis' reputation continued to grow through the 1790s and the first years of the nineteenth century. In 1803, he was elected to the Academy of St. Luke in Rome. Writing to Goethe in 1805, August von Schlegel cited Denis as one of the best landscape painters working in Rome.[2] In 1806, Denis settled definitively in Naples when he was appointed court painter to Joseph Bonaparte, king of Naples.

Denis' finished landscapes were primarily views of such sites as the waterfalls at Tivoli or the Bay of Naples. These paintings, highly finished and executed with fine detail, are close in style to works by Jean-Joseph-Xavier Bidauld, Nicolas Didier Boguet, and Jean-Victor Bertin. By contrast, Denis' open-air oil studies, painted with relative freedom and assurance, differ markedly from the tighter, more polished studies of Bidauld. Although no meeting is recorded, Denis may have encountered Pierre-Henri de Valenciennes in Paris between 1784 and 1786, just after the latter had returned from Rome. With his open-air studies of Roman rooftops, rocks, and sky, Denis seems to have followed Valenciennes' artistic program, and his sketches seem a continuation of his oil-study aesthetic. JS

Notes

1. Granet 1988, 21.
2. F. Noack, "Simon Denis," in Thieme-Becker, 9:72.

Literature

Coekelberghs 1976.

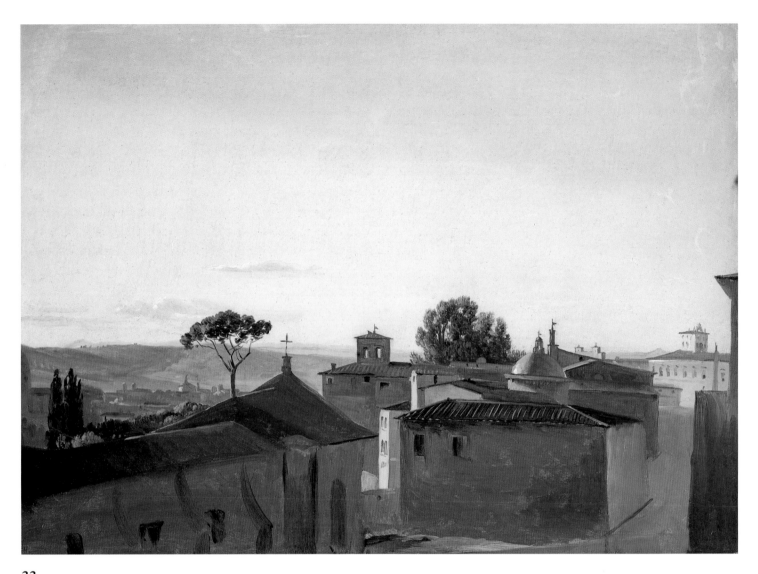

33

View on the Quirinal Hill, Rome

1800
oil on paper, mounted on canvas
29.5 × 41 (11⅝ × 16⅛)
signed on the verso: "Peint à Rome
en 1800–66–Sn Denis"

Private Collection, New York

The view is taken from the Quirinal
Hill, looking northeast, with the Palazzo
del Quirinale at right and the top of
the Villa Medici beyond it. At left, the
Pincio slopes down to the Tiber. Set
beneath a bright, almost cloudless sky,
this highly keyed study offers consid-
erable topographic description while
combining deft, fluid brushwork with
a surprisingly broad range of color.

34

Many open-air landscape painters in Italy made studies like this, close-up views of water rushing over rocks. Valenciennes recommended such studies, although he did not seem to produce any himself:

> Make several studies of transparent water through which one sees small stones. Observe the nature and variety of the stones. The form of stones found on riverbanks is far different from that of those found in the middle of a field: the latter are normally rough and angular, while the stones that one sees on the banks of streams or rapid rivers are rounded by precipitous rotation and continuous friction. These details may seem minor, but you may be sure that no such detail will prove indifferent for an artist who wishes to place truth in every portion of his works.[1]

34

Vicovaro, near Tivoli

c. 1800
oil on paper
22 × 40.3 (8¹¹⁄₁₆ × 15⅞)

Private Collection, New York

The small town of Vicovaro lies in the mountains northeast of Tivoli. Denis opposes the town's modest buildings, huddled at the bottom edge of his painting, to the vast expanse of lonely mountains, stretching beyond. While the composition of this study is close to a scheme employed by Bidauld (cat. 31), the handling of paint more closely resembles that found in Valenciennes or, more than twenty years later, André Giroux (cat. 106).

35

At Tivoli

c. 1800
oil on paper
21 × 28 (8¼ × 11)
signed on verso: "à Tivoly, Sn Denis"

Private Collection

Notes

1. Valenciennes 1800, 412.

35

36

For these cloud studies Denis adopts the formula employed by Valenciennes, anchoring his lofty views to a thin strip of earth at bottom. Denis' sky studies are more brightly colored than those by Valenciennes, but they lack the latter's sense of weight and density. Denis seems engaged more by the brilliant play of color and light offered by the cloud spectacle, less with the meteorological concerns of wind, temperature, and air pressure of which Valenciennes' studies give evidence. At the same time, Denis' studies seem considerably more delicate and carefully observed than those by Granet, in which paint is heavily applied to expressive effect.

36

Cloud Study in Rome

c. 1800
oil on paper
19 × 24.8 (7½ × 9¾)

Private Collection, New York

37

Cloud Study in Rome

c. 1800
oil on paper
22.7 × 25.7 (8¹⁵/₁₆ × 10⅛)

Private Collection, New York

37

JOHANN MARTIN VON ROHDEN

German, 1778–1868

Von Rohden, a merchant's son, began his studies at the Academy in Kassel. When he was seventeen he went to Rome with a friend who had won an artists' travel grant from the Landgrave of Hesse. In Rome he met and studied with Johann Christian Reinhart, who was working on his series of engravings of views of Italy. In 1799 he left Rome to travel north up the coast of Italy, and he was in Germany during 1801–1802. He returned to Rome in 1802, when he studied with Joseph Anton Koch and began to concentrate on landscape painting. With the exception of a trip to Sicily in 1805, he worked largely in and near Rome. Apart from a stay in Germany during 1811–1812, when he visited Goethe in Weimar and joined a reading group in Kassel run by the brothers Grimm, he remained in Rome until 1826. There he converted to Roman Catholicism and married the daughter of the well-known keeper of the Sibylla Inn at Tivoli. It was during these first decades of the century that he developed his own style, making paintings and drawings around Tivoli and in the Sabine Hills. With Georg von Dillis, he was apparently the first of the Germans to paint outdoors in addition to drawing. Though closer in age to Koch and Reinhart, whose work he admired, his practice of painting in the open air and his bent toward naturalism brought him the respect of the younger generation of German landscape painters who came to Rome in great numbers in the late teens and twenties.

Offered the post of chief painter at the court of Hesse in 1826, he brought his family to Kassel for two years. The dislocation was hard, however, and he received the Landgrave's permission to return to Rome for good. Von Rohden was regarded as a kind and sociable man, fond of hunting in the Campagna and active in the formation of such organizations as the German Academy in Rome. He also had the reputation of being not very productive even in his peak years; perhaps if he had broken with Koch's strongly held belief in the importance of "heroic" landscape, enhanced by narrative content and visual drama, he might have become a pioneer of the natural vision. SF

Literature

Nuremberg 1992, 458–460; Pinnau 1965, 27–42.

38

Campagna Landscape

c. 1807
oil on card, mounted on canvas
36.5 × 63.5 (14⅜ × 25)

Staatliche Museen Kassel, Neue Galerie

Washington and Brooklyn only

The site is at the edge of the Campagna to the east of Rome, where the foothills of the lower Sabine range begin. The study closely observes all the subtle changes in the structure of the land: the winding fold in the foreground, its trace of vegetation like the memory of a stream; the low, cut off hillocks in the middle distance, the result of geology and ancient habitation (the latter reflected as well in the random fragments of column and aqueduct); the foothills with their solid carved shapes becoming lighter as they recede.

With the structural observation is an equally complete awareness of the subtlety of tone and atmosphere in this essentially desolate environment, where the only features are hills, barren ground, and sky. Von Rohden was one of the early painters to respond to the character of the deserted countryside around Rome — so far in spirit from the usual tourist sites — and to see it in terms of the pure elements of landscape painting.

39

Landscape near Subiaco

c. 1806
oil on paper
37 × 50 (14⁹⁄₁₆ × 19¹¹⁄₁₆)

Staatliche Museen Kassel, Neue Galerie

Washington and Brooklyn only

Though published in Pinnau as *Italian Landscape*,[1] the topography appears to be that of the Sabine Mountains, and there is a faint inscription, "Subiaco," at the bottom center of the sheet. Situated about twenty-five miles east of Tivoli on the Aniene River, higher up in the mountains toward the river's source, Subiaco was a medieval town long the scene of violent struggles between the local Benedictine establishment, the papacy, and some of the oldest noble families of Rome. By the early eighteenth century it had been taken under papal authority, and the ensuing calm led to its revival as a country resort. It began to draw visitors and landscape painters, though traffic was light in comparison to what it would become by the 1820s. The sizable buildings in the near and middle distance, set on wooded hills above the town, may be country villas or the paper mills established by the Barberini family in the late seventeenth century.

The artist has chosen a viewpoint on a hillside some distance from the town, looking across at the varied shapes of the hills rising above the narrow river valley. The unfinished lower-right corner reveals the summary outline drawing of the composition, which was then painted from the top down. More of a small painting than a study, the intently observed light on the folds and hollows of the hills is evidence of its having been painted largely on site, no doubt over more than one session. The velvet surface of the hills and the delicate suggestions of rising mist are also characteristic of von Rohden's painting of Tivoli from the same decade (cat. 40).

Notes

1. Pinnau 1965, G15, 120.

40

The Waterfalls of Tivoli

1808–1815
oil on paper, mounted on canvas
45.3 × 63.3 (17¹³⁄₁₆ × 24¹⁵⁄₁₆)

Niedersächsisches Landesmuseum,
Hannover

Brooklyn and Saint Louis only

Tivoli, the hills behind it, and Hadrian's Villa were the primary sites where von Rohden sought his motifs. The beautifully sited town with its elaborate water works had drawn artists since the sixteenth century, when Cardinal Ippolite d'Este built his villa there with its intricate fountains. By the later eighteenth century, Villa d'Este, in a state of some disrepair, was a less popular motif than the natural waterfalls of the town. The Grand Cascade and the Cascatelles were formed as the waters of the Aniene River came down from the hills and fell over the high cliffs to the valley, there to wind its way west to the Tiber. Though in fact made possible in part by engineering, the steep cascade and the intricate lower falls were experienced as a marvel of nature and admired as a natural force beyond all human capacity, inciting feelings of the sublime.

Most of the open-air painters chose a vertical format that emphasized the height of the rocks. Von Rohden here uses a horizontal format, actually closer to the *vedute* compositions that showed the entire town on the top of the hill. However, unlike the earlier painters, he has included only a glimpse of the town and has focused on the rounded hills that nearly hide the waters, which reveal themselves as much through the delicately painted mists as through their own substance.

FRANÇOIS-MARIUS GRANET
French, 1775–1849

Although Granet was not unusually prolific, his *corpus* of Italian oil studies is among the most extensive of any French landscape painter. He bequeathed two hundred drawings and watercolors to the Louvre and the contents of his studio (approximately 1,800 paintings, drawings, and watercolors) to his native city of Aix-en-Provence. That bequest (the core of the Musée Granet in Aix) also included the manuscript of his memoirs. Granet is revealed as an artist fond of ancient architecture and ruins, devoted to nature, and passionate for Rome and its environs, where he spent much of his career.

Granet began his artistic education in 1791, entering the studio of a (now unknown) landscape painter in Aix. There he enrolled at the School of Drawing, where he was taught by Jean-Antoine Constantin. That same year he met Comte Auguste de Forbin, an aristocrat two years his junior, who became a lifelong friend and patron. Supported by Forbin's mother, the two men made their first trip to Rome in 1802. Arriving in July, they set about to explore the city, guided by the French history painter Guillon-Lethière.

> We went from [the Pantheon] to the Colosseum, by way of Campo Vaccino. There, all of ancient Rome spread itself out before our eyes. The temples, the arches of triumph, the handsome vaults of the Temple of Peace with their magnificent coffers. I felt that I was no longer of this world. I arrived under that spell at the [illegible] and at the foot of the Colosseum, without uttering a word. We wandered through the midst of all those monuments like shades come down from heaven.[1]

Soon after his arrival, Granet attempted an oil study of the Colosseum. Dissatisfied with the result, he showed it to Simon Denis, who responded, "My friend, you've put enough on your canvas to fill four big paintings."[2] Granet next sketched the Temple of Minerva Medica. This time, Denis approved of the result.

Granet's first trip to Italy lasted only several months, but he returned to Rome the following year, and remained in southern Italy until 1824. During his Italian residence, Granet became a leader of the community of French artists in Rome, and forged friendships with Ingres, Fabre, Pierre-Athanase Chauvin, and Boguet. Young artists frequently arrived in Rome with letters of introduction to him. His reputation in Paris continued to grow: his work at the Salon was acclaimed by the critics, patrons vied for his work, and in 1819 he was awarded the Legion of Honor. In 1826 Forbin, who was now director of the royal museums, appointed him curator of the Louvre. He was made a member of the Institut de France in 1830, and charged by King Louis-Philippe with organizing a museum of French history at Versailles. With the revolution of 1848 Granet retired to Aix, where he died the following year. JS

Notes

1. Granet 1988, 20.
2. Granet 1988, 21.

Literature

Néto-Daguerre and Coutagne 1992.

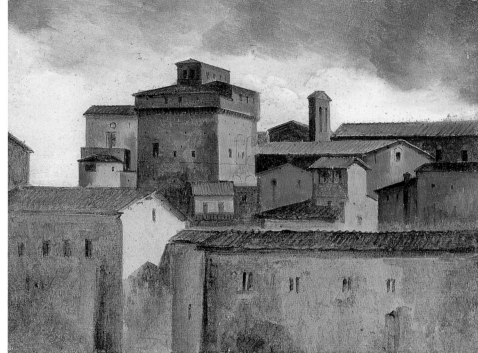

41

Roofs of Rome with a Square Tower

1802–1819
oil on paper, mounted on canvas
23.3 × 31.5 (9³⁄₁₆ × 12³⁄₈)

Musée Granet, Aix-en-Provence

Granet was fascinated both by the picturesque ruins of Rome, with their rough, irregular forms partly covered by vegetation, and by the strikingly planar geometry of the city's more recent, vernacular architecture. Pictured here are buildings and rooftops rising up the Capitoline Hill, dominated by the square tower built by Pope Paul III in the sixteenth century. While Pierre-Henri de Valenciennes painted similar images of Roman rooftops, he seemed concerned largely with the play of light and shade across their surfaces. Granet, by contrast, who came to specialize in the depiction of architecture, emphasized instead the interplay of regular shapes and volumes. The rigorous structure of paintings such as this is close to that found in Thomas Jones' images of the whitewashed buildings of Naples.

View of the Church of Santa Francesca Romana and the Basilica of Constantine

1802–1819
oil on paper, mounted on canvas
37.9 × 48.5 (14¹⁵⁄₁₆ × 19⅛)

Musée Granet, Aix-en-Provence

The church of Santa Francesca Romana stands in front of the eastern end of the Basilica of Constantine. Dating back to the eighth century, it was rebuilt in the thirteenth century, at which time the tall campanile was erected. The facade of the church, visible in this painting from the side, was added early in the seventeenth century. Granet's depiction of this site, set beneath a blue sky accented by a few clouds, seems concerned essentially with the deployment of geometric forms across the lateral surface of the painting. Two of the three great arches of the basilica are shown at left, but the wall and adjoining path, which begin in the lower left corner, lead us swiftly into the center of the picture and to a succession of variously proportioned rectangular and triangular architectural elements.

43

Ruined Columns in the Colosseum

1802–1819
oil on paper, mounted on wood
42.6 × 28.2 (16¾ × 11⅛)

Musée Granet, Aix-en-Provence

The Colosseum, the first site Granet painted when he arrived in Rome, exercised a prolonged fascination over the artist. His first study having been criticized by Denis for a too-broad vantage and an excess of detail, Granet limited most of his subsequent depictions of the Colosseum to more restricted views of specific motifs. Indeed, certain of these studies are so narrowly focused that there remains little, if any, explicit identification of them with the Colosseum.

Ruined Columns in the Colosseum is certainly among the most remarkable and dramatic of his Colosseum studies. The characteristic curving walls of the monument are not to be seen here. Instead, a great arch frames the view toward three enormous piers. Tufted with vegetation, the isolated forms of these pillars stand out against a dark sky. The scale of the framing arch and the size of the silhouetted pillars speak to the grandeur of the site, while the ruined state suggests its lonely abandon. Granet frequently framed his compositions with an arch or vault, a compositional device favored also by his teacher Jean-Antoine Constantin.

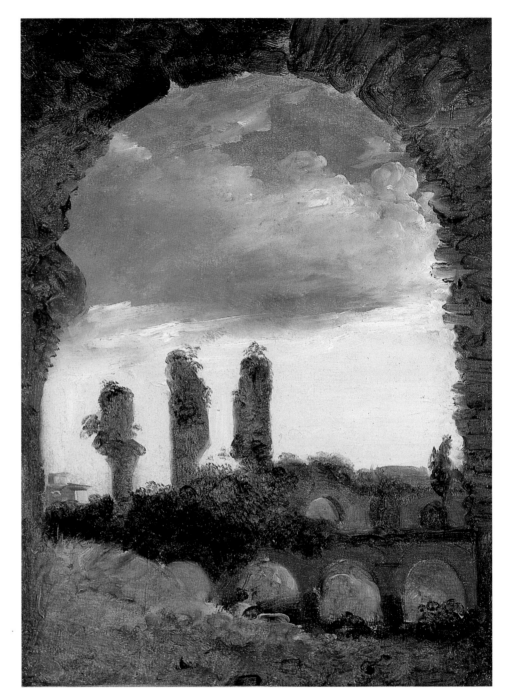

44

Tivoli

1802–1819
oil on paper, mounted on canvas
28.6 × 21.7 (11¼ × 8⁹⁄₁₆)

Musée Granet, Aix-en-Provence

From the seventeenth century onward, the circular Temple of Vesta proved an irresistible motif for the numerous artists who visited Tivoli. Granet was no exception, and among his paintings and drawings of Tivoli are several views of the temples and the adjacent chapel. Set against a bright, cloudless sky, the round temple seems a virtual crown to Granet's composition, most of which is occupied by the imposing parapet upon which the temple sits, and the steep, densely grown hill beneath. Compared to Louise-Joséphine Sarazin de Belmont's brilliant, energetic view of the same site (cat. 110), Granet's image seems dark, even brooding.

45

45

The Tiber near the Porta del Popolo

1802–1819
oil on paper, mounted on canvas
22 × 30.4 (8¹¹⁄₁₆ × 11¹⁵⁄₁₆)

Musée Granet, Aix-en-Provence

An easy day's trip for many landscape painters was to follow the Tiber north from the outskirts of Rome, into the countryside of low hills and scattered trees that lay just outside the city. Artists, including Poussin, had followed this route since the seventeenth century. Indeed, the banks of the Tiber north of the Porta del Popolo, where Granet set this oil study, was known as *la promenade du Poussin*, for the reason that the classical master had favored the area for contemplative strolls. The view selected by Granet (a similar view was chosen years later by Corot; see Faunce essay, fig. 7) allows for the juxtaposition

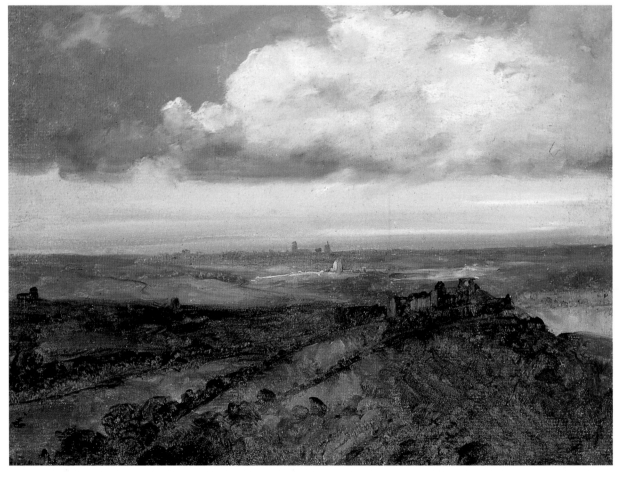

46

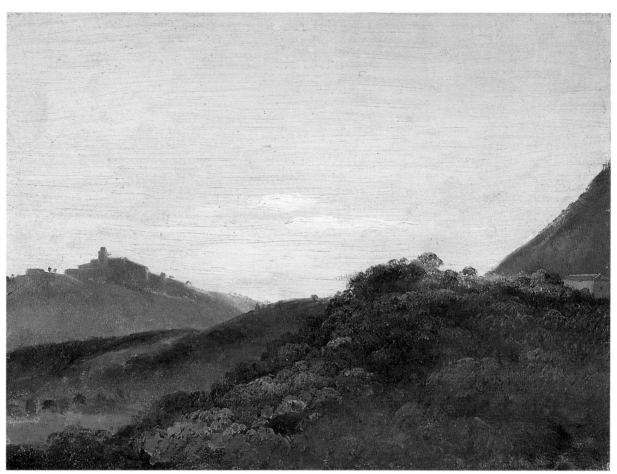

of earth, sky, and water. The artist uses relatively broad brushwork to contrast the play of light, shade, and reflection across varying surfaces.

46

The Tiber Valley

1802–1819
oil on paper, mounted on canvas
21.3 × 28.8 (8⅜ × 11⁵⁄₁₆)

Musée Granet, Aix-en-Provence

Although not firmly identified, this vast panorama may represent the Tiber valley. Divided into four horizontal zones of color and tone, the composition moves the viewer's eye swiftly through space, while carefully balancing foreground and background, earth and sky. Opposing the dark mass of the hill anchored at the lower right of the picture, a bright, white mass of cloud floats free at top. The mysterious structure atop the hill (a villa, an ancient fortress?) is answered at the horizon by the silhouette of a distant town. A broad river, which emerges from behind the dark hill at lower left, reappears as it flows into the distance at right. Through this play of near and far, horizontal and diagonal lines, Granet gives to this freely painted image a firm compositional structure.

47

Italian Hills at Dawn

1802–1819
oil on paper, mounted on canvas
21.2 × 28.8 (8⅜ × 11⁵⁄₁₆)

Musée Granet, Aix-en-Provence

During the years he spent in Rome, Granet made frequent excursions into the countryside, and produced numerous drawings and watercolors set in nearby towns and the Campagna. While many of Granet's urban studies are indicative primarily of the artist's architectural interests, those executed in the country reveal a concern for alternatively subtle or dramatic effects of light and atmosphere. Broadly painted, the present study seems above all an exercise in capturing the swiftly changing light of dawn, with a suggestion of mist rising off green hills.

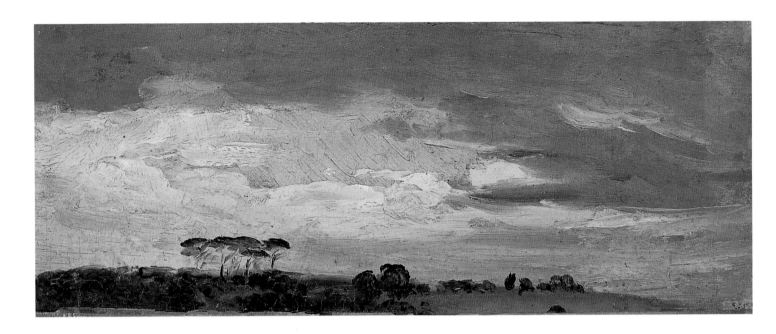

48

Hilltop with Pines, Evening Light

1802–1819
oil on paper, mounted on canvas
11.5 × 28.6 (4½ × 11¼)

Musée Granet, Aix-en-Provence

A thin strip of land at bottom, punctu-
ated by the silhouettes of several parasol
pines, is all that serves to anchor this
vigorously painted sky study. Granet's
compositional approach here is quite
close to that seen in Valenciennes'
At the Villa Borghese: White Clouds
(cat. 19). Whereas Valenciennes empha-
sizes tonal transition, however, Granet
seems more interested in highlighting
the dramatic dissonances of color and
tone that can occur at sunset.

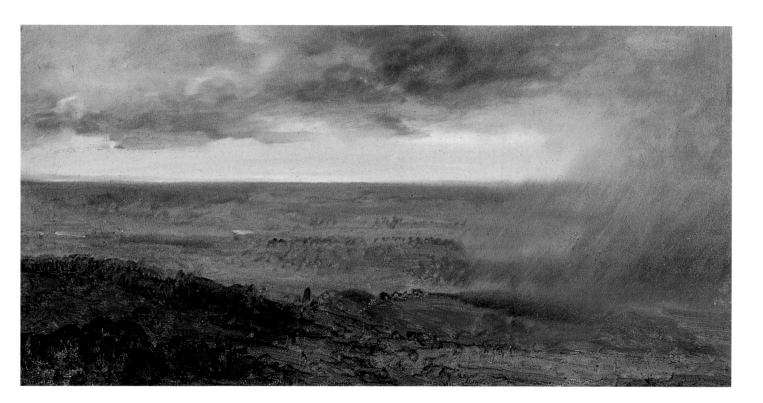

49

Storm in the Valley of the Tiber

1802–1819
oil on paper, mounted on canvas
19 × 37.5 (7½ × 14¾)

Musée Granet, Aix-en-Provence

Although Valenciennes urged painters to study rain and storms, relatively few artists took his advice so far as to produce open-air studies depicting rainfall. This remarkable study, set in the flat landscape of the Tiber valley, encloses within its modest dimensions a range of atmospheric effects, from the slanting rainfall painted at right, to the clouds at center, to the bright sunlight falling through clear air at left. The depiction of such a dramatic motif set within a flat, otherwise unremarkable landscape reminds us of the comment Granet offered in his memoirs concerning the Roman Campagna:

> I had devoured with my eyes the Roman Campagna, so rich in memories and so picturesque for the state of abandonment in which men had left it. Nature has resumed all her rights there, as if to say to man:

> "Don't force me, I'll produce enough to satisfy your needs; see how rich I am," and to the painter: "Here I am in all my simplicity; if you want to do something that resembles me, think like an innocent and observe me closely."[1]

Notes

1. Granet 1988, 50.

ANTOINE-FÉLIX BOISSELIER

French, 1790–1857

Born in Paris, and of the same generation as Corot and Achille-Etna Michallon, Boisselier remained faithful through most of his career to the neoclassical landscape style that he learned from Jean-Victor Bertin. A trip to Italy around 1811 is attested to by two oil studies signed and dated in that year. Boisselier made his first entry into the Salon in 1812, and exhibited frequently thereafter, winning a second-class medal in 1824. In 1817 he entered the first competition for the Prix de Rome for historical landscape, placing second (behind Michallon). Although he failed to win the competition, he may have traveled again to Italy soon thereafter. Many of his entries at the Paris Salon as well as those in various provincial salons consisted of views of Italian sites or of historical landscapes in an Italianate setting. Toward the end of his career he painted in the Auvergne region of France, as well as the Dauphiné and Provence. Boisselier maintained a popular studio and taught drawing at the military academy of St. Cyr, near Versailles. JS

Literature

Harambourg 1985, 62.

50

The Temple of Vesta at Tivoli

c. 1811
oil on paper, mounted on canvas
39 × 28.5 (15⅜ × 11¼)

Stanford University Museum of Art,
Committee for Art Acquisitions Fund,
1984.72

Landscape painters frequently depicted
the Temple of Vesta at Tivoli from below
and even far below (see Vernet, cat. 2;
Granet, cat. 44; Sarazin de Belmont, cat.
110; and Nerly, cat. 118). Boisselier adopts
a more unusual view of the monument,
nearly level with the top of the parapet,
and with the mountains at Tivoli seen
through its columns. Two tourists gazing
down the hillside establish the scale of
the monument, as does the sheet draped
over the side of the parapet at left.

51

View of the Benedictine Monastery at Subiaco

1811
oil on paper, mounted on canvas
38 × 28 (14^{15}⁄$_{16}$ × 11)

Minorco Services (UK) Limited,
London

The area around Subiaco, a hill town
to the east of Rome, was frequented by
landscape painters including Jean-
Joseph-Xavier Bidauld, Martin von
Rohden, Carl Blechen, Corot, and
François-Marius Granet. The only other
depiction of Subiaco in this exhibition
is by von Rohden, who uses a horizon-
tal format and does not include the
monastery. Boisselier's vertical format
and viewpoint, with the picturesque
monastery placed at top, was utilized
by a number of other artists, and also
bears a close resemblance to depictions
of sites such as Tivoli. This study is
notable for the considerable verve and
freedom of its execution.

For a history of the site see Faunce
essay and von Rohden, cat. 39.

JOSEPH AUGUST KNIP
Dutch, 1777–1847

When he was eleven years old, Knip moved with his family to 's Hertogenbosch, which in 1794 was besieged and captured by the French army. Knip's father, Nicolaas Frederik, was a decorative painter, who taught his son painting and drawing. At nineteen, the son became responsible for the family due to his father's blindness. He established himself in Paris in 1801, executing commissions for topographical paintings; he later became drawing master to the young Louis Napoleon. He was in Paris for nine years at a time of considerable artistic activity, including the formation of the Musée Napoleon, where masterworks from all over Europe were shown.

At the end of 1809, Knip went to Rome, where he stayed until 1812, traveling to Naples, the Sabine and Alban Hills, as well as in the Campagna. He made many beautiful watercolor studies of the terrain, from the smooth low hills around Palestrina to the high forests above Terni. His was a classical sensibility, with a strong feeling for the way light shapes volume and reveals surface. Returning to Holland in 1813, with his wife, the French painter Pauline Rifer de Courcelles, he established himself as a painter in 's Hertogenbosch; he later lived in Amsterdam and then Paris. In 1832 he went blind, and was granted a pension by the king of Holland. SF

Literature

The Hague 1977.

52

Lake Albano with Palazzolo

c. 1810-1812
oil on paper, mounted on cardboard
41.3 × 58 (16¼ × 22¹³⁄₁₆)
inscribed lower left: "J.K."

Hamburger Kunsthalle

Washington and Brooklyn only

This painting is a splendid example of how a place fully observed and experienced can be represented as a "landscape of the soul," not as a symbol *of* anything else, but nature as meaning in itself. The view, one that is virtually unchanged to this day, is of the Lago Albano, an ancient volcanic crater. Its steep wooded banks rise in a terrain of rounded shapes, which are revealed in the painting by the low rays of an early sun. Behind the high banks is the profile of Monte Cavo, the highest of the Alban Hills. It is this peak, from a closer perspective, that Pierre-Henri de Valenciennes painted shrouded in cloud, as it typically is in rainy weather (cat. 22). Here the image is of the silent calm of early morning, with the lake as a mirror reflecting the strong simple shapes of the land. The building on the hill at left, so deep in shadow as to be nearly invisible, is the monastery of Palazzolo, a foundation dating to the thirteenth century. Knip's view across the lake toward the east, like those by Valenciennes and Jean-Joseph-Xavier Bidauld (cat. 29), emphasizes the lake and the shape of the hills. The conventional earlier view was from the opposite bank, looking across to the picturesque profile of the town of Castel Gandolfo against the sky.

FRANÇOIS-EDOUARD PICOT
French, 1786–1868

Picot, a prominent academic history painter during the Restoration, July Monarchy, and Second Empire, was born in Paris. He began his study of art at age fourteen with the figure painter Léonor Mérimée (father of the writer Prosper Mérimée). He transferred to the studio of Vincent, and completed his studies with David. He took second place in the Prix de Rome competition in 1811 and 1812, receiving a special award that permitted him to travel to Rome. In 1813 he won first place, thereby obtaining the status of *pensionnaire* at the Academy of France. In Rome in 1817 he painted his most famous work, *Cupid and Psyche* (Louvre), which was exhibited to considerable acclaim at the Salon of 1819, winning a first-class medal. His official career off to a strong start, Picot received numerous important commissions, notably for the decoration of two ceilings in the Louvre, for the Galerie des Batailles at Versailles, and for a number of churches. In the face of the Romantic and realist revolutions, Picot adhered firmly to the principles of neoclassicism, and was regarded as one of the more conservative voices within the Academy. Made Chevalier of the Legion of Honor in 1825, he was elected to the Institut de France in 1836, and became an officer of the Legion of Honor in 1852. He opened a studio in 1820 and by the end of his career had taught more than five hundred students, among the most famous of whom were Alexandre Cabanel, William-Adolphe Bouguereau, and Gustave Moreau. JS

Literature

Chevillot 1995, 233–235.

53

View from the Villa Medici

1812–1815
oil on paper, mounted on canvas
28.9 × 40 (11⅜ × 15¾)

Private Collection, New York

Picot, who otherwise manifested little
interest in the landscape genre, executed
this study from his residence at the
Villa Medici, intending perhaps to send
it to friends or family back in Paris, or
perhaps to keep it as a memento. The
practice of producing open-air oil studies
was not limited to landscape painters.
The view is to the east over a fragment
of the Aurelian Wall, to the Sabine
Hills beyond.

CHRISTOFFER WILHELM ECKERSBERG
Danish, 1783–1853

Eckersberg was the father of the Golden Age of Danish painting in the first half of the nineteenth century. He trained at the Royal Academy of Fine Arts in Copenhagen and with the neoclassical history painter Nicolai Abraham Abildgaard from 1803 to 1809. His first ambition was to become a history painter in the classical tradition. Unusually for a Danish artist, he went to Paris in 1810, where he spent a year in the studio of Jacques-Louis David.

In Paris, Eckersberg also drew and painted modest views of the city, its environs, and daily life. He was likely influenced in these activities by contemporary French painters such as Jean-Victor Bertin, Louis-Auguste Gérard, and Léon-Mathieu Cochereau.[1] These artists specialized in small, detailed, and carefully executed urban and parkland views around Paris. Such paintings presented a more accessible and popular alternative to the classical grand manner of David and his school. From this time onward, landscapes and urban views also played an important role in Eckersberg's art.

Eckersberg reached artistic maturity during three years he spent in Rome, 1813–1816. There he became part of the international community of artists. According to his journal and correspondence, he frequented mainly the Danish and German circles in Rome. Of the German artists in this exhibition, he was acquainted with Adolf von Heydeck and Martin von Rohden.[2] The presiding genius of this circle was the celebrated Danish sculptor Bertel Thorvaldsen, with whom Eckersberg lodged at the Casa Buti on the Via Sistina, and who encouraged him by acquiring two of his small Roman views. Among the French he knew Guillaume Guillon Lethière, director of the French Academy in Rome, and Pierre-Athanase Chauvin, a landscape painter patronized by Thorvaldsen and admired by Eckersberg.[3]

Eckersberg preferred architectural subjects, and focused on ancient and medieval Rome to the exclusion of Renaissance, baroque, and modern monuments. He often chose unimportant or unimpressive sites to depict. When he painted a more celebrated site or building, it would always be in an understated way, from an unusual or oblique viewpoint. In the early nineteenth century most visitors to Rome came with expectations of grandeur conditioned by the prints of Giovanni Battista Piranesi. But Eckersberg rejected this conventional approach for the unexpected angle, partial view, intimate corner, or place of no other significance than that he chose to paint it.

Writing home on 23 July 1814, Eckersberg said that he had made about ten "small sketches," because he wanted to paint "a collection of the most beautiful of the picturesque views of Rome and its environs."[4] In another letter, he remarked that his happiest hours were spent outdoors, setting off with a box of colors and a stool under his arm, to paint from nature.[5] But he does not seem to have executed spontaneous oil sketches out-of-doors: his small finished landscapes were made in the studio on the basis of drawings. However, in the 1814 letter he added that the paintings "have all been finished on the spot from nature." This was to be an important innovation in Danish painting, which was until then dominated by neoclassical theory and studio practice.

When Eckersberg returned to Copenhagen in 1816, he soon became an important and influential teacher and introduced changes in the educational system. He encouraged a generation of young Danish painters to make studies from life and to

work on landscapes in the open air. This emphasis on the direct study of nature had a profound effect on Danish art, and accounts for the brilliant sense of observation in the work of Golden Age artists such as Christen Købke, Constantin Hansen, Martinus Rørbye, and Johan Thomas Lundbye, and their feeling for natural light and the ambience of the open air.

Eckersberg's small Roman landscapes were not well received when he exhibited them in Copenhagen in 1816: the critic Peder Hjort found their Mediterranean light too harsh and bright![6] Moreover, they seem to have had only a limited market. But when Eckersberg's students went to Italy, they saw it through his eyes. Ditlev Blunck, for example, wrote to his master from Rome on 15 May 1829:

> How often on our excursions in this tremendous city do I not find my thoughts turning to your friendly little drawing room in Charlottenborg Palace in Kingens Nytorv [seat of the Royal Academy of Fine Arts in Copenhagen], where hang all the little pictures of Rome you painted here, and many times have I enjoyed seeking out the very places where you may have sat during your work, and especially now that I myself every afternoon, almost without exception, occupy myself in accumulating similar studies from nature. Rome often seems to me as though everything has been built for the sake of painters.[7]

Apart from a commission to paint historical scenes in the royal palace of Christiansborg, after his return from Rome Eckersberg more-or-less abandoned history painting for landscapes, portraits, and genre scenes. Later in life he became very interested in perspective construction and the relationship between light and shade. He wrote a pamphlet on *The Theory of Perspective for Young Painters* in 1833, and provided illustrations for Georg Frederik Ursin's *Linear Perspective Applied to the Art of Painting* in 1841. The self-conscious perspectives of these illustrations and the marked fascination with cast shadows are already presaged in the open-air landscapes with architectural subjects of Eckersberg's Roman years. PC

Notes

1. In his journals and letters from Paris, however, Eckersberg only mentions the most celebrated artists of the day; see Bramsen 1947. For typical works by Bertin and Gérard, see London 1974, 14, no. 2 and fig. 23; 31, no. 27 and fig. 24. For a topographical landscape of Paris by Cochereau, see his *Boulevard des Capucines, Paris*, 1810, in the Musée de Chartres, inv. 3492.
2. See Bramsen 1974, 19–129.
3. For Eckersberg, Chauvin "had to be placed at the top; his coloring, his distances, in short everything, are as perfect as I have ever seen." See Bramsen 1974, 116. Thorvaldsen purchased three works by Chauvin: Thorvaldsens Museum, Copenhagen, nos. B87–89.
4. Monrad 1993, 88, citing Bramsen 1974, 57.
5. Bramsen 1974, 78, quoted on p. 20 of this catalogue.
6. Monrad 1993, 42.
7. Monrad 1993, 66.

Literature

Fischer et al. 1983; Skovgaard, Westergaard, and Jönsson 1983.

54

A Courtyard in Rome

1813–1816
oil on canvas
33.5 × 27.5 (13³⁄16 × 10¹³⁄16)

Ribe Kunstmuseum

Washington only

This courtyard may have been part of
the picturesque complex of buildings
of the Casa Buti on the Via Sistina
in Rome, where Eckersberg lived in
the company of Thorvaldsen and other
Danish and German artists.[1] If so, it was
a different courtyard than the one drawn
by Johann Anton Ramboux in 1820, for
example (Städtisches Museum, Trier),
which is said to represent the Casa Buti.[2]
There were many picturesque houses
with courtyards and roof gardens clus-
tered in the artists' neighborhood on the
Pincio, around the Villa Malta (see Dahl,
cat. 71). This painting epitomizes Eckers-
berg's fascination with architecture, the
play of perspective, and complex spaces.
He was also intrigued by the fall of light
and the various shapes cast by shadows.
This scene has all the vividness of direct
observation from nature, but it is not
a spontaneously executed sketch — rather,
it is a careful meditation on light, shade,
space, and texture.

Notes

1. Bjarne Jornaes, "Von Trinità dei Monti zur Pi-
azza Barberini," in Nuremberg 1991, 87.
2. Nuremberg 1991, 88.

55

A Pergola

1813–1816
oil on canvas
34 × 28.5 (13⅜ × 11¼)

Statens Museum for Kunst, Copenhagen

The loose handling in this painting is unusual in Eckersberg's Roman landscapes, suggesting that it may be a true open-air work. He enjoys the play of light on and through the vine leaves and the broadly dabbed, dancing shadows on the ground below. The only formal architectural element, which is more typical of the artist, is the rectangular opening in the wall framing the sar-cophagus and the view beyond. The architecture contrasts with the informal structure of the wooden pergola and the twisting vines, the shady foliage, the play of dappled light, and the distant landscape, itself a tiny oil sketch within the painting.

A Pergola has been compared with Carl Blechen's *The Studio of Sculptor Rudolf Schadow in Rome* (cat. 113), painted more than a decade later in 1828 or 1829.[1] There is indeed a visual and structural similarity in the two paintings, but they appear to represent different places. Eckersberg no doubt knew the Schadow studio on the Via delle Quattro Fontane, because he shared lodgings with Rudolf and his brother Wilhelm Schadow at the Casa Buti on the Via Sistina. These artists all moved in the Danish-German circle around Thorvaldsen. Thorvaldsen acquired two of Eckersberg's Roman views: *Interior of the Colosseum* and *The Colonnade and Piazza of St. Peter's*, both in the Thorvaldsen Museum in Copenhagen.

Notes

1. For example, in Monrad 1984, 148, no. 52.

56

In the Gardens of the Villa Albani

1813–1816
oil on canvas
27 × 34.5 (10⅝ × 13⁹/₁₆)

Statens Museum for Kunst, Copenhagen

In his typical fashion, Eckersberg does not present the magnificent Villa Albani itself, which was designed for Cardinal Alessandro Albani by Carlo Marchionni in the late 1740s. Rather, his view is across the hedges, walls, and terraces of the gardens toward the billiard house (*billomachia*), a 1770s addition, the main facade of which is visible to the left of the clump of cypresses. He views the

building from an oblique angle, allowing a play of diagonal lines throughout the composition. The villa is far left of the spectator's viewpoint.

The Villa Albani was one of the most famous in Rome in the eighteenth and nineteenth centuries, with its great collection of antiquities, formed on the advice of Johann Joachim Winckelmann, and its neoclassical ceiling painting of

Parnassus by Anton Raphael Mengs. This painting is probably based on a drawing, which was the artist's usual practice, but he most likely finished the picture in the park itself: the brilliance of the sunlight gives a real sense of being out-of-doors. Eckersberg liked the strong play of light and shade created by full sunlight, and we are conscious of the shapes and rhythms of the shadows.

57

The Fountain of the Acqua Acetosa

1814
oil on canvas
25.5 × 44.5 (10¹/₁₆ × 17¹/₂)

Statens Museum for Kunst, Copenhagen

This fountain near the spring of the Acqua Acetosa was designed by Andrea Sacchi in 1660–1661 and remained a source of mineral water for Rome until the 1950s. Beyond is a sweeping curve of the Tiber to the north of the city, between the present day Ponte Flaminio and Ponte di Tor Quinto, with a view across what was rather bleak and dusty countryside in Eckersberg's time. The foreground planes are established abruptly parallel to the picture plane, creating a somewhat neoclassical framework for the view. This work is unusual for Eckersberg in Rome, for he shows relatively little interest in the architecture. The subject is the landscape itself and the light that bathes it. Distance is established less by Eckersberg's usual insistent linear perspective than by the more painterly means of aerial perspective. Sky, river banks, and distant hills are rendered with tonal gradations of great subtlety. Eckersberg's painterly, tonal approach and the loosely handled, sketchy foreground place this work in the tradition of the Roman oil sketches done by Valenciennes in the 1780s. The similarities are increased by the fact that the foreground has been left unfinished, unusual in Eckersberg's art. It is quite possible that he knew Valenciennes during his three years in Paris from 1810 to 1813, but there is no evidence of their meeting.[1] The Danish artist would certainly have been aware of Valenciennes' important treatise on landscape painting, *Elémens de perspective* (Paris, 1800), a veritable textbook for painting from nature. *The Fountain of the Acqua Acetosa* is based on a pencil outline drawing dated 7 June 1814, the foreground of which is squared for transfer to the canvas (The Royal Print Collection, Statens Museum for Kunst, Copenhagen, inv. 7259). The painting was perhaps blocked in at the studio and completed before the motif in the open air, which, according to letters, was Eckersberg's preferred method of working at this time. It is hard to imagine a landscape of such exquisite light and tonal finesse being painted in any other way than in front of nature. Corot painted two slightly different views at this site, in December 1825 and again a year or two later.[2]

Notes

1. Valenciennes is not mentioned in Eckersberg's journal nor his correspondence in Paris; see Bramsen 1947.
2. Robaut and Moreau-Nélaton 1905, 2:38–39, no. 95, illus., and 52–53, no. 147, illus.

ADOLF VON HEYDECK

German, 1787–1856

There is very little documentation of this artist. He was a classmate of the Olivier brothers, Friedrich and Ferdinand, at the Hauptschule in Dessau, where the painter Carl Wilhelm Kolbe aroused his students' enthusiasm for landscape by taking them on "picturesque walks."[1] No additional professional training is recorded; he is referred to as an "Autodidakt,"[2] and is listed in the dictionaries as a "Dilletant" in painting and etching, especially of landscape subjects. Since *Dilletant* simply means amateur, presumably he worked without pursuing a professional career. He was in Rome from 1813 to 1820, with a second trip in 1837. He traveled to Terni and to Naples, and is documented as having been in Olevano in 1820. SF

Notes

1. Ludwigshafen 1990, 11.
2. Himmelheber 1988, 298.

58

View over the Rooftops of Rome

1815
oil on paper
34 × 47 (13⅜ × 18½)
signed lower right: "1815"

Von der Heydt-Museum, Wuppertal

This pristine view over the roofs of Rome was taken from the Pincian Hill, probably at the Trinità dei Monti, only a short distance from where Georg von Dillis would paint three years later in the Villa Malta (see cat. 62). The dome of St. Peter's is seen at the far horizon, while that of San Carlo al Corso dominates the middle distance from the right-hand side. Heydeck bathes the scene in the utmost clarity of light, choosing to leave the lower band of the paper unfinished rather than to deal, as Dillis did in his atmospheric study of this view, with the change of focus involved in indicating what lies nearer to hand. The roofs, domes, and towers are articulated with great precision, both of line and color. This type of beautifully lit and clearly delineated view over the roofs of a great city was taken up by the Berlin painter Edouard Gaertner, who composed two large Berlin panoramas in the early 1830s.

LÉON COGNIET

French, 1794–1880

Cogniet was born in Paris and entered the Ecole des Beaux-Arts in 1812. Along with the Romantic artists Géricault and Delacroix, he studied with Pierre Narcisse Guérin, one of David's most distinguished pupils. In 1817 Cogniet won the Prix de Rome for his *Helen Freed by Castor and Pollux*. He departed for Rome that same year, remaining there until 1822. Even as he followed the prescribed curriculum of the Prix de Rome *pensionnaire* — mostly copying ancient sculpture and old master paintings — Cogniet executed a number of open-air oil studies in Rome and its surrounding region. He may have learned the technique from Achille-Etna Michallon, with whom he formed a close friendship in Rome. The Musée des Beaux-Arts in Orléans has several Roman oil sketches by Michallon, which were bequeathed by Cogniet, including cat. 64 in this exhibition.

Cogniet exhibited for the first time at the Paris Salon in 1824, and participated regularly thereafter until 1855. He was awarded the Legion of Honor in 1828, and was appointed professor of drawing at the Lycée Louis-le-Grand in 1831, a position he guarded all his life (among his many pupils was Degas). Elected to the Institut de France in 1849, he was named a professor of the Ecole des Beaux-Arts in 1851.

Trained by a neoclassicist, in the company of the greatest Romantic painters of his day, Cogniet came to occupy a place somewhere between those two aesthetic poles. Respected by his colleagues and contemporaries, if not deeply admired, Cogniet is a typical representative of the *juste-milieu*, the fairly large group of French painters who sought a moderate path between conflicting artistic schools. Cogniet's Italian open-air studies suggest a talent for landscape which, perhaps unfortunately, he did not pursue.

JS

Literature

Ojalvo 1990.

59

*The Artist in His Room
at the Villa Medici, Rome*

1817
oil on canvas
43.3 × 36 (17¹/₁₆ × 14³/₁₆)

The Cleveland Museum of Art, Mr. and
Mrs. William H. Marlatt Fund 78.51

This self-portrait stands as an evocative
description of the life of a Prix de Rome
pensionnaire in Rome. The artist leans
against his bed, reading his first letter
from home.[1] Around the sparsely
furnished room are signs of the artistic
interests and pursuits that will occupy
him for the next five years. Above his
desk hangs a palette; below are stacked
portfolios and canvases. On the same
wall, next to the door, hang the studio
props of helmet, shield, and swords.
They should find their way into at least
one of the historical compositions that
the artist will execute in the studio that
lies just on the other side of the door.
On a chair next to the dresser are
casually placed a hat and cloak, and
against the chair leans the artist's walking
stick, which he will take on excursions
around Rome and into the Campagna.
Last, and perhaps most important, a
clear southern light floods into the room
from the open window, through which
we see the countryside beyond the Villa
Medici. By its subject, proportions, and
composition, that view has the character
of an outdoor oil study. Peter Galassi
calls it "a direct allusion to the repertory
of outdoor painting in Italy."[2]

That Cogniet was especially moved
by the light and landscape of Italy is
made evident by a letter he wrote to
his master Guérin soon after his arrival
in Rome:

> You ask me what struck me the most,
> ancient sculpture, painting of the
> masters, or the physiognomy of
> the Romans—What struck me more
> than all that were the beauties of
> nature, not only of the country
> I now live in but of all those I passed
> through since the French frontier.[3]

Notes

1. An inscription on the stretcher bar reads "ma
chambre à la réception de la première lettre de ma
famille 1817."
2. Galassi 1991, 95.
3. Talbot 1980, 136.

JOHANN GEORG VON DILLIS

German, 1759–1841

The son of a gamekeeper and forester, Dillis was educated in Munich with the support of the prince-elector of Bavaria. He prepared for the priesthood, but by 1786 was able to pursue his real interest in art by teaching drawing at court and to private families. In 1790 he was appointed inspector of the Hofgarten Galerie, the princely collection that was the precursor to the Pinakothek. Thus began a lifetime of curatorial work for the Bavarian court, which enabled him to travel widely, expanding his knowledge of European art, and to develop his interest in landscape painting.

In 1792 Dillis visited the collections in Dresden, Prague, and Vienna, and in 1794 made his first trip to Italy. There he made watercolor studies from nature, as he had done in Munich. A second trip to Rome, in 1805, brought him into contact with the French artists influenced by the teachings of Pierre-Henri de Valenciennes on open-air oil painting. He admired the studies of Simon Denis, and in the studio of the American painter Washington Allston he was able to see a landscape by J. M. W. Turner, whose method of catching light impresssed him.[1] These experiences fed into his own already developed feeling for the qualities of painting landscape in the open air, which in these early years of the century made him unique among the German painters.

The following year, on a trip to Paris, he visited the studio of Jean-Joseph-Xavier Bidauld, where he saw oil studies executed in the mountains near Rome in the late 1780s. In Paris he visited the Musée Napoleon with Ludwig, the young crown prince of Bavaria, whom he would advise on collecting and other artistic matters for the rest of his life. Dillis also made several trips to Italy to buy art for the crown prince. In 1816, he was charged with packing up and returning the artworks taken to Paris from Munich by Napoleon. In the fall of 1817 he traveled with Ludwig to Sicily, and then spent four months in Rome. In a letter to the crown prince before this trip, Dillis referred to Italy as "the very home country of the artist, in which the mind can attain true maturity; nature embraces him and he nature, so that the mind creates in love what may astound posterity for centuries to come."[2] Thus, although he was at this time a fully mature painter, who had been making open-air studies for a number of years entirely for his own satisfaction, he continued to look upon Italy as a source of inspiration.

The high point of his curatorial career was the opening in 1836 of the Alte Pinakothek, the collections of which he had helped to build and to arrange in a modern, historical manner. He was fortunate in that his gifts and abilities meshed entirely with the interests of his prince — who was far more devoted to art than to politics — and between them they established Munich as a major center of art. SF

Notes

1. Heilmann 1991, 26, 30.
2. Messerer 1966, 480.

Literature

Heilmann 1991; Paris 1976.

Detail, cat. 61, Dillis, *View toward the Capitoline Hill*, 1818

Three Views of Rome from the Villa Malta

60

View of the Quirinale Hill

1818
oil on paper, mounted on canvas
30.7 × 43.5 (12 1/16 × 17 1/8)

Bayerische Staatsgemäldesammlungen, Munich, Schack-Galerie

Washington and Brooklyn only

61

View toward the Capitoline Hill

1818
oil on paper, mounted on canvas
29.8 × 43.7 (11¾ × 17³⁄₁₆)

Bayerische Staatsgemäldesammlungen,
Munich, Schack-Galerie

Dillis and the crown prince Ludwig returned to Rome from Sicily early in 1818. They stayed at the Villa Malta on the Pincian Hill behind Trinità dei Monti, a center for German life in Rome in the early nineteenth century (see Dahl, cat. 71). The young prince, who often stayed there with his artist friends, bought the villa in 1827; by then its square tower had become a common motif for painters. Dillis seems to have been the first to take the tower as his point of view, to look out over Rome and paint selected panoramic scenes that favor the qualities of light and atmosphere over exact description. As Heilmann has pointed out,[1] these are not *vedute*; neither were they planned as a precisely continuous panorama, of the kind that Edouard Gaertner would later develop in Berlin. Each was painted in the morning with the sun coming in

low from the southeast. The paintings record the artist's experience of vision: in the view to the south, toward the Quirinal Palace, the light falls on structures close to hand in the visual field and delineates the powerful architectural forms of the palace and its walled gardens; much of the space between, however, is left in an atmospheric haze, from which the edges of the relatively few buildings emerge as the light hits them. The second view to the southwest toward the Capitol, over one of the more densely settled areas of the city, includes the most structural articulation; it is equal to Corot in its revelation of complex forms purely through touches of tone and color. In the view of St. Peter's to the west, clearly visible are the roofs of the buildings just below the Villa Malta. These close off the view of all the area at the foot of the Pincian Hill

until the cupola of San Carlo al Corso looms; St. Peter's is farther and dimmer but unmistakeable, to the side of a composition in which much of the left section is a monochrome field.

Notes

1. Heilmann 1991, nos. 130–132.

62

View of St. Peter's

1818
oil on paper, mounted on canvas
29.2 × 43.4 (11½ × 17⅛)

Bayerische Staatsgemäldesammlungen, Munich, Schack-Galerie

not in exhibition

ACHILLE-ETNA MICHALLON
French, 1796–1822

Despite an early death, Michallon occupies an important place in the history of French landscape painting. A precocious figure, he was regarded among his contemporaries as the most promising landscape painter of his generation, and they saw in him hope for the renewal of the genre. Even after his neoclassical style fell from favor and the artists who worked in that manner were largely forgotten, Michallon's name—if not his work—remained known, if only as the teacher of Corot. As early nineteenth-century landscape painting has come to be better appreciated and understood, Michallon's reputation has continued to rise, above all for the fact that, as a student of Pierre-Henri de Valenciennes, he provides a crucial link between the artist who in large measure initiated the tradition of open-air oil sketching in Italy, and the artist in whom that tradition saw its greatest flowering.

Michallon was raised in an artistic milieu. His father, Claude Michallon, was a sculptor who, along with a number of artists, had been awarded lodgings at the Louvre. Although Michallon was only two when his father died, he and his mother remained at the Louvre until he was six, when they moved to artist's lodgings at the Sorbonne. At an early age he copied the etchings of Claude Lorrain, and he began to take drawing lessons when he was about eight. In 1808 he enrolled as a pupil of the history painter Henry-François Mulard. At the same time, he probably received advice, if not formal lessons, from the landscape painter Alexandre Dunouy. In 1810 he entered the Ecole des Beaux-Arts, where he was taught perspective by Valenciennes. While at the Ecole des Beaux-Arts he transferred to the studio of Jean-Victor Bertin, and likely spent considerable time in the studio of Valenciennes.

Michallon exhibited for the first time at the Salon of 1812 (at the age of fifteen) and was awarded a medal of encouragement. His first collection of engravings was published in 1814, and his Salon entries of that year met with a positive critical response. In 1816, Michallon began a campaign, directed at powerful patrons and government ministers, to be sent at state expense to study in Rome. He was supported in this undertaking by members of the Institut de France and professors at the Ecole des Beaux-Arts (notably Valenciennes). As a result, the competition for the Prix de Rome for historical landscape painting was instituted. When the competition was held for the first time the following year, Michallon entered and won.

Although the program for the competition itself was quite detailed, the curriculum for the winner was vague. Michallon was forced, in effect, to develop his own course of study, which consisted in large measure of drawing and oil sketching in Rome and its environs, as well as taking extended trips to Naples and Sicily. He formed a close friendship with his fellow *pensionnaire* Léon Cogniet, and also became acquainted with the French landscape painters who were living in Rome but were unaffiliated with the French Academy, notably François-Marius Granet. He also met the Norwegian painter Johan Christian Dahl and the Swede Gustaf Söderberg, among other landscape painters then in Rome.

As demanded by the Academy, Michallon sent back paintings to Paris as indications of his progress. Entered in the Salon, these *envois* kept Michallon's name before the Parisian public, and augmented his reputation. Returning to Paris in 1821, Michallon found a ready market for his work, and soon established himself as a

teacher with a large and prosperous studio. Among his many students at this time was, of course, Corot.

Michallon's composed landscapes display a seriousness and ambition largely absent from the work of Jean-Victor Bertin or Jean-Joseph-Xavier Bidauld. Such ambition, however, is entirely consistent with the teachings of Valenciennes. In general, Michallon's work differs from that of Valenciennes (and that of Michallon's own contemporaries) by its heavier impasto, and by more dramatic contrasts of dark and light. Those qualities are evident both in oil studies and finished works. Certainly Michallon's last work offers little reason to speculate that, had he lived longer, he would have broken with the traditions of neoclassical landscape painting and developed his work in a more naturalistic direction. Nevertheless, the tradition of Valenciennes would at least have had a worthy exponent, one capable, perhaps, of carrying that tradition into a new era. JS

Literature

Pomarède 1994.

64

Arches of the Colosseum

oil on paper, mounted on canvas

39 × 27 (15⅜ × 10⅝)

Musée des Beaux-Arts, Orléans

The interior of the Colosseum was an extremely popular subject among landscape painters in Rome: Michallon may have been introduced to the motif by Granet (cat. 43), who painted there frequently; other potential sources abound. Vincent Pomarède distinguishes Michallon's interest in the technical aspects of representing ruins—the architecture, materials, and play of light—from the more poetic or literary interest manifested by such eighteenth-century painters as Hubert Robert.[1] The

63

The Colosseum, Rome

1817–1821
oil on canvas
26.5 × 39 (10⁷⁄₁₆ × 15⅜)

Private Collection, Paris

Valenciennes' prescription to begin the outdoor study with the sky is evident in this unfinished painting by Michallon, although Peter Galassi, noting the precise treatment of the tree at right, suggests that this particular work may have been painted in the studio.[1] A similar view of the Colosseum is adopted by Valenciennes (cat. 14); the contrast between Valenciennes' fluid, open brushwork and the more tightly controlled technique of Michallon shows the difference between a true open-air sketch and a small finished painting, which does not rule out the possibility that the latter was partly painted out-of-doors.

Notes

1. Galassi 1991, 152.

64

65

View of Naples from Vesuvius

1819
oil on paper, mounted on canvas
28.5 × 40 (11¼ × 15¾)

Musée du Louvre, Paris

same can be said of other painters in the Colosseum, Christoffer Wilhelm Eckersberg, Ernst Fries, and Corot.

At the sale of Michallon's estate, this study was purchased by the artist's friend Cogniet for the elevated price of 1,200 francs.

Notes

1. Pomarède 1994, 117.

While Vesuvius was frequently depicted by painters who traveled south to Naples, Michallon (who also painted the volcano during an eruption) adopts a less frequently seen viewpoint for this study. From near the summit of Vesuvius we look northwest, across the Bay of Naples to the city itself and beyond. The rocky peaks form a novel and striking *repoussoir*, framing water and sky in the distance. Michallon was particularly drawn to images of a harsh and inhospitable nature. In this we see his affinity to eighteenth-century ideas of the sublime and, perhaps, his desire to revive the heroic ideal in landscape.

GUSTAF SÖDERBERG
Swedish, 1799–1875

Among Scandinavian landscape painters active during the period covered by this exhibition, only the Norwegian Johan Christian Dahl and the less well-known Thomas Fearnley had truly international careers, spending nearly all their working lives outside their native land. Only the Dane Christoffer Wilhelm Eckersberg was seriously influenced by his studies in Paris and above all Rome, the lessons of which he took back to Copenhagen. The early nineteenth century was not an adventurous time for the visual arts in Sweden, and there was nothing like the Golden Age experienced in Denmark at the same time. Söderberg trained at the Academy in Stockholm, and then at the age of twenty went to Italy in 1819, where he remained until 1821. He painted a number of oil sketches in the open air in Italy, but as Torsten Gunnarsson has observed, these fresh little paintings "have no counterpart whatsoever in contemporary Swedish painting."[1] But if they are somewhat occasional pieces in the history of Swedish art, this exhibition shows that in Italy Söderberg became part of a European tradition.

When in Rome he met the French painter Achille-Etna Michallon. In April 1820 the two artists set off together for Naples, with Söderberg kitted out for open-air painting on the advice of Michallon, a paintbox strapped to his back, a portfolio and folding stool under his arm, and a penknife and eraser attached with twine to a button on his waistcoat.[2] They also traveled beyond Naples to Sicily, where they toured the island on mules. It was almost certainly Michallon who was the mentor on this trip, passing on the lessons of his own teacher Pierre-Henri de Valenciennes to the young Swedish painter. On at least two occasions they seem to have sat down together and painted the same sites from slightly different points of view, including the Temple of Concord at Agrigentum and the Greek theater at Taormina.[3] The artists' handling of paint is quite similar, rapid and brushy, but Söderberg's color is brighter than Michallon's more subtle and tonal approach.

On his return to Rome Söderberg stayed at the Villa Malta on the Pincio during the autumn and winter of 1820 and 1821, as guest of the Swedish sculptor Johan Niklas Byström. In May 1821 Söderberg went to Paris, where he was joined by Michallon later in the year. But Michallon was already suffering from the illness that would end his life in 1822. Söderberg's Italian studies apparently had little relevance for the rest of his career. A naturalistic approach to painting did not evolve in Sweden at this time, and only a few Swedish artists—such as Lars Jacob von Röök, Per Gustav von Heideken, and Gustaf Wilhelm Palm—continued to paint occasional oil sketches and studies in Italy later in the nineteenth century.[4] This testifies to the strength of the open-air tradition in Italy, but it was only under those warm southern skies that the artists from the land of the midnight sun were able to flourish outdoors. PC

Notes

1. Gunnarsson 1985, 89.
2. Gunnarsson 1985, 90, citing a letter from Söderberg.
3. Gunnarsson 1985, 90–93, figs. 9–12.
4. Gunnarsson 1989, with English summary, 240–256.

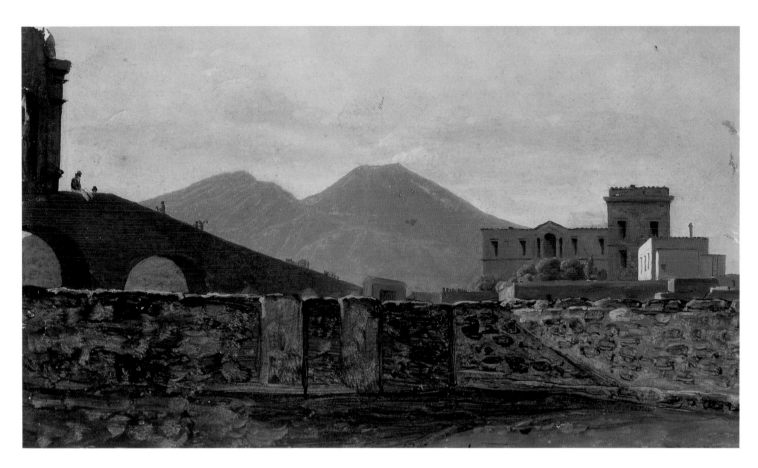

66

*View of Vesuvius from the Bridge
of St. Januarius, Naples*

1820
oil on paper
22 × 31.5 (8¹¹⁄₁₆ × 12³⁄₈)

Nationalmuseum, Stockholm

This sketch was probably painted during
the summer of 1820, after Söderberg's
trip to Sicily with Michallon.[1] The view-
point is calculated for the maximum
dramatic effect, and the freedom of exe-
cution shows the confidence with which
the Swedish artist learned to sketch in
oils while working with Michallon.

Notes

1. See Biography, and Gunnarsson 1989, 237,
fig. 27.

LÉOPOLD ROBERT
Swiss, 1794–1835

Robert was born at Eplatures, a village near La Chaux-de-Fonds. The son of a clock-maker, Robert was destined for a career in commerce, until friendship with the Swiss engraver Charles Girardet excited his interest in art. Together they went to study in Paris in 1810. Robert remained in Paris for eight years, where he enrolled as a student at the Ecole des Beaux-Arts and worked in the studios of Jacques-Louis David and Baron François Gérard. Although Robert intended a career as an engraver, he took up painting and learned his smooth, careful technique and vivid sense of observation from his neoclassical masters David and Gérard. As a foreigner he was not eligible to compete for the Prix de Rome, but he found private sponsorship and went to Italy in 1818. He remained there for the rest of his life, mainly in Rome, but died on a trip to Venice in 1835.

In Italy Robert began to support himself by painting portraits, but soon developed a specialty in depicting scenes from contemporary Italian life in villages and the country. He became a close friend of François-Marius Granet, who perhaps encouraged him as an observer of contemporary life in Rome. Artists and other visitors from north of the Alps in the early nineteenth century were fascinated by the picturesque costumes, simple ways of life, and colorful folk customs and festivals they encountered in rural Italy. Robert often produced these scenes on the large scale normally reserved for history paintings. In a sense they should be considered as modern moral subjects, with their lively casts of characters and careful observation of manners, rituals, and customs that were soon to disappear with the development of a modern industrial society in Italy. Such paintings were indeed based upon observations of everyday peasant life, yet they embodied a sense of history that seemed to have remained unchanged since ancient times. His two major artistic statements were made at the Paris Salon of 1827 with *The Return from the Festival of the Madonna dell'Arco*, and at the Salon of 1831 with *The Arrival of the Harvesters in the Pontine Marshes*, both of which were acquired by the French state and are now in the Louvre. The details of costume, type, and expression are carefully observed and painted with a precise and highly finished touch.

Robert had a ready international audience of tourists for his images of Italian country girls in regional costumes, shepherds and shepherdesses, fisherfolk, pilgrims, wandering musicians and *pifferari*, and especially bands of brigands, their associates, and their victims. Brigands were a picturesque but also a real and dangerous hazard for the visitor to the countryside around Rome and the traveler between Rome and Naples. Although Robert's landscape backgrounds are as carefully observed as his protagonists and their costumes, the landscape is always a subsidiary element in his art. He made a number of oil studies from nature in the countryside around Rome and Naples, but they do not seem to have any direct relationship with the finished exhibition paintings. Robert may have been encouraged by his friend Granet to paint such studies, but the Swiss artist was by no means as active as the Frenchman in this respect. PC

Literature

Gassier 1983.

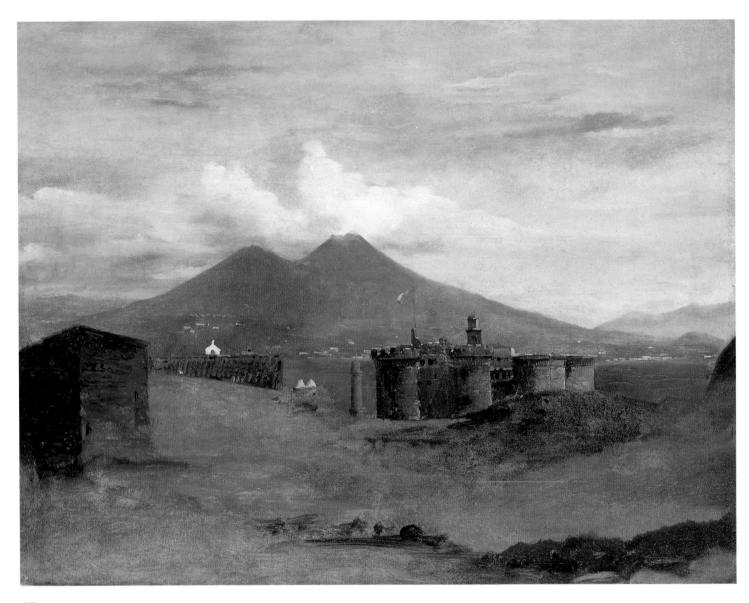

67

Vesuvius

1821
oil on paper, mounted on canvas
28.5 × 38 (11¼ × 14¹⁵⁄₁₆)

Collection Musée d'art et d'histoire de la ville de Genève

Robert went on a trip from Rome to Naples with some friends in May and June 1821, traveling by foot, by carriage, and part of the way by boat. The trip, over hills, through lush valleys, and along the magically beautiful coast, encountering a variety of picturesque country types along the way, was to have a profound effect on Robert's imagination, and during the journey he stored up many ideas for future paintings.

He wrote home to his parents that he did not much like the city of Naples:

> but the surroundings are delicious and so different in character, in nature, that you cannot help taking the greatest pleasure in going around them: Vesuvius is a marvel, like all the phenomena of nature: you cannot imagine them....I have made lots of sketches, souvenirs of the country.[1]

The present view was taken from the hill of Posilipo, looking across the towers of the Castello dell'Ovo and the bay to the distant volcanic peaks. A companion picture (private collection, Paris)[2] shows the same view at a different time of day, with the buildings seen *contre-jour*, and in hazy weather conditions.

Notes

1. Huggler and Cetto 1943, 34, under no. 2.
2. Reproduced in color, Gassier 1983, 112.

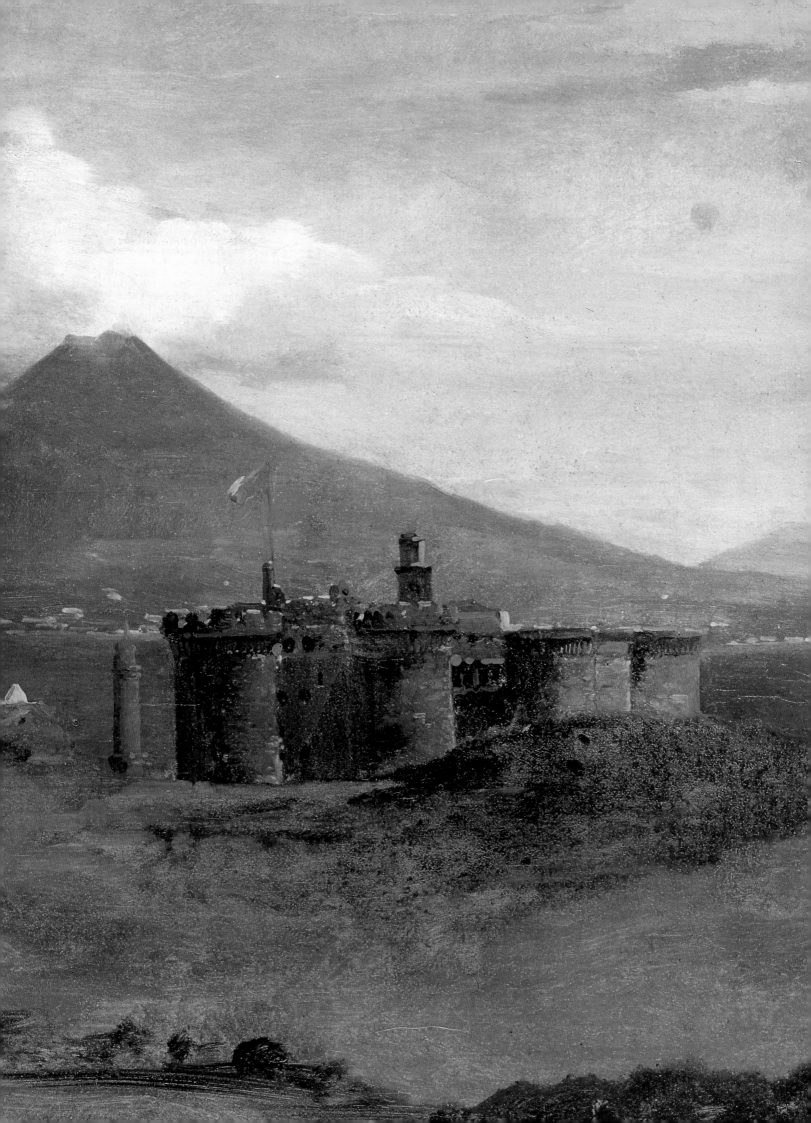

JOHAN CHRISTIAN DAHL
Norwegian, 1788–1857

Born in Bergen, Norway (a Danish possession until 1814), Dahl went to study at the Royal Academy of Fine Arts in Copenhagen in 1811, where he remained until 1817. From the start he was a landscape painter, admiring the seventeenth-century Dutch masters in the Danish royal collections and attaching himself to the pre-Romantic naturalistic landscape tradition begun in Denmark by Jens Juel (1745–1802). "First and foremost I study nature," he wrote in 1812.[1] When Christoffer Wilhelm Eckersberg returned from Rome in 1816, Dahl studied his view paintings with interest: he wrote of Eckersberg, "He has also brought from Italy a good many prospects from Rome and its outskirts, which all are masterly painted."[2] In 1818 Dahl went to Dresden, where he associated with the German Romantic landscape painters Caspar David Friedrich and Carl Gustav Carus. After several years of travel, Dahl settled there in 1825.

In 1820 Dahl left Dresden to join the Danish crown prince Christian Frederik in Italy. He spent about six months in and around Naples, staying at a summer retreat in nearby Quisisana, and then about four months in 1821 in Rome. In Naples he befriended the German painter Franz Catel.[3] In Rome he moved in the Danish and German circle around the sculptor Bertel Thorvaldsen, who acquired seventeen of Dahl's paintings (Thorvaldsen Museum, Copenhagen). Among the artists Dahl met in Rome were the German painters Johann Joachim Faber and Heinrich Reinhold, the Frenchmen François-Marius Granet and Achille-Etna Michallon, and the Belgian Simon Denis.

Following his teacher Eckersberg's example — but it was standard practice among the international group of artists in Rome — Dahl made small paintings and more spontaneous oil sketches in the open air. He was less interested in architecture than Eckersberg and concentrated more on such natural phenomena as clouds and weather, and the changing light on a landscape or at the seashore. This aspect of his work brings him closer in spirit to the Dresden Romantics. He made a free copy of Eckersberg's *The Colonnade and Piazza of St. Peter's* (Thorvaldsen Museum, Copenhagen), but rendered the scene by moonlight, a characteristically Romantic touch.[4] Dahl made truly spontaneous and often quite summary oil sketches, usually on paper. These were painted for study and are quite different from his more highly worked up finished paintings. However, some of the smaller finished paintings were probably partly executed from nature, following the practice of Eckersberg. PC

Notes

1. Bang 1987, 1:232.
2. Bang 1987, 1:233.
3. Bang 1987, 1:49–63.
4. Bang 1987, 2:121, no. 311, where it is described as a pendant to the very similar scene by Eckersberg.

Literature

Bang 1987; Jornaes 1987.

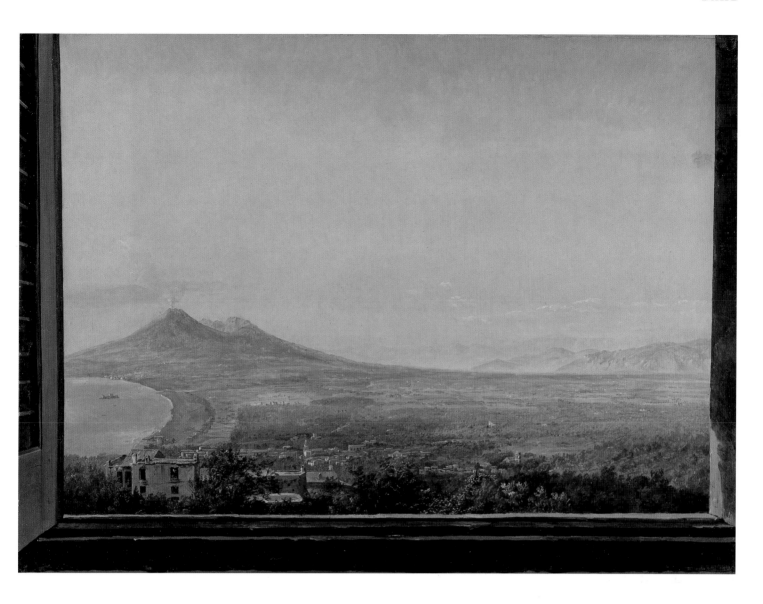

68

View from a Window at Quisisana

1820
oil on paper, mounted on cardboard
42.8 × 58.6 (16⅞ × 23¹⁄₁₆)

The Rasmus Meyer Collection, Bergen

Dahl arrived at the villa of Quisisana at Castellammare, about fifteen miles south of Naples, on 11 August 1820. The villa had been lent to the Danish crown prince Christian Frederik by King Ferdinand IV of Naples, and Dahl was joining the royal party there. The artist wasted no time, because the next day he noted in his diary, "I have begun a sketch of the view from my window."[1] If he was referring to the present picture,

it was completed three days later and dated 14 August 1820. Dahl took this view from a window looking north toward Naples, which lies out of the painting to the left; he shows the curve of the bay and the silhouette of Vesuvius. The view from an open window is a Romantic *topos*[2] and several examples are in the present exhibition (cats. 59, 123), including a small finished picture done in Naples by Dahl's acquaintance Catel (cat. 79). *View from a Window at Quisisana* is arguably too highly finished to be called a sketch, but even though Dahl may have worked on it over several days, it is quite thinly painted and still has all the freshness of direct observation. Above all the artist has responded to space, light, and

atmosphere in this sweeping panorama of the Neapolitan hinterland.

Notes

1. Bang 1987, 2:101.
2. See Eitner 1955, 281–290.

69

*Cloud Study with the Top
of Vesuvius*

1820
oil on canvas, mounted on board
7 × 15 (2¾ × 5⅞)

Göteborgs Konstmuseum

The painting is signed and dated by the artist on the back, "Dahl f. Neapel 1820," while the more precise identification of the site is made on the basis of another inscription by Dahl's son Siegwald in 1889. Dahl's interest in clouds probably began in Dresden, where he was painting studies of them by 1819. The earliest known dated example was painted in 1820, some time before his departure for Italy in July.[1] He continued to make such studies throughout his life. As the sky is the principal source of light in landscape painting, it is not surprising that artists who made open-air sketches soon turned their attention upward. François Desportes had already made a few remarkable sky studies in oil in about 1702, and even earlier examples of such studies by other artists in other media exist.[2] But as with open-air oil painting in general, there are only isolated examples of such sky studies before the end of the eighteenth century. Perhaps the most assiduous sketcher of the sky in oil before Dahl was Pierre-

Henri de Valenciennes in the early 1780s, who also went on to recommend such study in his influential treatise *Elémens de perspective* of 1800.

It was only after the systematic scientific study of cloud formations began in the first decade of the nineteenth century that artists directed specific attention to clouds.[3] The pioneer of this study was the British scientist Luke Howard, who first published his findings and his nomenclature for different types of cloud formation in 1803. Howard's work was translated into German in 1815 and thus came to the attention of such figures as Johann Wolfgang von Goethe, who dedicated a suite of poems about clouds to Howard. Another admirer of Howard was Carl Gustav Carus, man of letters, natural scientist, painter, and art theorist, and an important figure in artistic circles in Dresden. Dahl encountered this interest when he arrived in Dresden in 1818, just at the time when Carus was developing his theories of landscape painting that would eventually

be published as his *Neun Briefe über die Landschaftsmalerei* in 1831, with an introduction by Goethe. Carus believed that in the new age of scientific discovery the landscape painter must be more precise and specific in his observation of nature's effects. While not all of Carus' contemporaries followed him to his conclusion that the scientific study of nature, united with art, would lead to an understanding of the divine, without doubt he directed the attention of Dahl and other young artists in Germany to a new and more scientific interest in the formation of clouds and the way they can influence the appearance and meaning of landscape.

Notes

1. Bang 1987, 2:99, no. 209.
2. See de Lastic Saint-Jal and Brunet 1961, no. 2, fig. 13.
3. See Badt 1950, 9–40; and Werner Busch, "Die Ordnung im Flüchtigen — Wolkenstudien der Goethezeit," in Schulze 1994, 519–570.

70

Waves and Breakers in the Bay of Naples

1821
oil on paper
22.5 × 36 (8⅞ × 14³⁄₁₆)

Nasjonalgalleriet, Oslo

Dahl executed several studies of waves crashing on the shore while he was in Naples.[1] This one is precisely dated, lower left, to 4 January 1821. Such studies of specific details of the natural world–waterfalls, rocks, tree trunks, vegetation–were part of the standard repertoire of open-air painters since the time of François Desportes early in the eighteenth century. More immediately, Dahl in Italy was working in a tradition established there by Valenciennes in the 1780s. This vigorous study of the element of water is a counterpart to Dahl's ethereal sketch of clouds (cat. 69). In the consistency and handling

of his white paint the artist has found the perfect pictorial equivalent for the foaming waves.

Notes

1. See Bang 1987, 2:114–115, nos. 278–280; 3: pls. 113–114.

71

Scene from the Villa Malta

1821
oil on canvas
34.5 × 38.5 (13⁹⁄₁₆ × 15³⁄₁₆)

Nasjonalgalleriet, Oslo

Because this painting is precisely dated "Rome d. 22 Juni 1821," it has been suggested that it was executed in one day.[1] But although the handling is fresh and lively, the design seems too complex and the observation too careful for such rapid execution. *Scene from the Villa Malta* and another fairly elaborately

worked view in Rome, *The Casa del Portinaio in the Villa Borghese*, were exhibited at the Dresden Academy immediately upon Dahl's return from Rome in 1821, among a group of "Studies of Buildings in Rome."[2] This suggests that he regarded them as finished, saleable paintings, rather than mere studies. *Scene from the Villa Malta* comes closest to the small finished Roman architectural views of Dahl's master Eckersberg, which were partially executed in the open air. The vivid sense of observation and the brilliant light in *Scene from the Villa Malta* certainly suggests open-air work. The given title is confusing, because the painting is a view *of* the Villa Malta, probably taken across a neighboring garden backing onto the villa from the Via Sistina.

The villa, the monastery of San Isidro, and many houses in this part of the Pincio were inhabited by artists, especially Germans and Danes: Dahl and Thorvaldsen lived on the Via Sistina,

no. 12 and no. 48, respectively. The Villa
Malta was so named because in the 1770s
it had been the residence of the Bailli de
Breteuil, representative in Rome of the
Knights of Malta. In the nineteenth
century it was occupied mainly by
Scandinavian and German artists such
as Gustaf Söderberg and Georg von
Dillis, in the present exhibition. Dillis
painted his three famous panoramic
views of Rome from the tower of the
villa (cats. 60–62). Crown Prince

Ludwig of Bavaria stayed there on his
frequent visits to Rome. He purchased
the villa in 1827 as a retreat for himself
and his artist friends. Dahl does not
convey any of the rich historical asso-
ciations of the villa; to him it is a
picturesque site, and he is just as
interested in the unkempt, overgrown
garden in the foreground.

Notes

1. Manchester 1993, 32, no. 11.
2. See Bang 1987, 2:124, no. 324; 3: pl. 132,
The Casa del Portinaio in the Villa Borghese;
the exhibited painting, Bang 1987, 2:125, no. 329.

HEINRICH CARL REINHOLD

German, 1788–1824

Reinhold was born to a middle-class family in Gera, a market town some thirty miles southeast of Leipzig. His father was a portrait painter, with whom he first studied art. For a year he attended the Academy at Dresden, and in 1807 began studying in Vienna. In 1809 came the Austrian defeat at the battle of Wagram, and the occupation of Vienna by the French army. Reinhold's landscape etching and engraving came to the attention of Baron Vivant Denon, Napoleon's general director of the imperial museums in Paris, who was in Vienna to transfer significant artistic assets to Paris. He offered Reinhold a job of making engravings from drawings of Napoleon's military campaigns. Reinhold spent the following five years in Paris, but the drudgery of copying scenes of bloodshed, horror, and the losses of his people left him unable to do his own work.

With Napoleon's defeat in 1814, Reinhold returned to Vienna. There he joined the circle of young artists who gathered around Johann Anton Koch, the well-known landscape painter. Koch, long established in Rome, was in Vienna during the last three years of the French occupation of his city. Encouraged by the common interest in landscape of this circle, Reinhold took painting trips in the mountains, beginning in 1817 near Vienna. In the summer of 1818 he traveled with other painters to the mountains around Salzburg and Berchtesgarten; the open-air oil studies he made of "Der Watzmann," a mountain peak near Salzburg, prefigure his later Italian work.

In the fall of 1819, Reinhold arrived in Rome with his friend and fellow landscape painter Johann Christoph Erhard. During his first year he made two trips as a view recorder for patrons: one to Naples and Sicily with Prince Lobkowitz, whom he had met on the Salzburg trip; the other in Tuscany with an English traveler, John Bury. A highlight of the latter trip is a group of elegant drawings of the newly constructed harbor buildings at Livorno. In the summer of 1821 he made the first of three long stays in Olevano, a town in the Sabine Mountains that was becoming a mecca for German artists. His oil studies there were admired by his fellow painters in Rome, and are recognized today as milestones of open-air painting. When the chief architect of Berlin (and former painter) Karl Friedrich Schinkel met Reinhold on a visit to Rome in 1824, he liked the studies so much that he persuaded the artist to sell him a group.[1] That Reinhold agreed on condition that he first would make copies reveals how important these records of observation were for artists whose livelihood depended on the sale of studio works.

Reinhold died of a lung disease in 1825, at the age of thirty-six. Shortly afterward, Julius Schnorr von Carolsfeld wrote in a letter from Rome that the contents of Reinhold's studio—some fifty oil studies and many drawings—would be sold at auction, where he thought they would fetch prices beyond the reach of those artists who wished to own them as models for their own efforts in open-air painting.[2] SF

Notes

1. Schinkel 1982, 224.
2. Schnorr von Carolsfeld 1886, 481.

Literature

Borsch-Supan 1988, 238–240; Schwartz 1965, 71–96; Schwartz 1977; Winkler et al. 1988.

72

*Landscape near Olevano:
La Serpentara*

1822
oil on paper, mounted on canvas
17.8 × 21.8 (7 × 8⁹⁄16)

Hamburger Kunsthalle

Reinhold's oil studies in and around Olevano are the earliest from this region, which by the end of the decade was to become an essential stop for the open-air painters. In the summers of 1821, 1822, and 1824 he made a number of oil studies of the town itself and the steep, dry hills around it, including the village of Civitella perched on a peak a few miles to the north. Along a ridge between Olevano and Civitella was a thick grove of oak trees that came to be known as La Serpentara. Here Reinhold takes a view of these thickly foliaged trees as they move in a rhythm paralleled by the rolling line of the further ridge against the sky. Tiny figures walk near the top of the highest part of this distant ridge. The sky is a luminous study of cloud formations — solid and diaphanous, rounded and horizontal, white and gray. The sense of the trees' foliage is vivid but not highly finished, and at either end of the line of trees, at the edges of the field of vision, the foliage is very minimally brushed in. The study is dated at the bottom left, "29 Sept. 22"; Reinhold was the first German artist to use this kind of precise notation, which adds to the viewer's sense of being present at a particular moment. The quality of the vision, at once fresh, immediate, and precise, drew the attention of other young German artists who were increasingly interested in open-air painting at this time.

73

Grotto near Sorrento with Bridge

1823
oil on paper, mounted on canvas
29.3 × 21.8 (11⁹⁄₁₆ × 8⁹⁄₁₆)

Hamburger Kunsthalle

Like the study of La Serpentara, this
painting is one of the group of open-air
paintings acquired by Schinkel from the
artist in Rome in 1824. It was made
during his trip to Naples and is signed
at the lower left, "Sorrent. d. 3 juni 23."
On this trip Reinhold worked mostly
along the coast to the north and south
of the city, and on the islands. Sorrento,
close to the tip of the peninsula sepa-
rated by a narrow strait from Capri, is
built on top of high cliffs of tufa. The
natural openings in the rock, grottos,
and gorges were the kind of intrinsically
picturesque geological phenomena that
were especially attractive to artists of the
Romantic period. Reinhold is interested
in showing how these extraordinary
formations have been adapted by the
inhabitants—since Roman times to
judge by the stone blocks of the road
leading in from the left foreground. The
gorge has become a mysterious road,
over which a bridge has been built, lead-
ing to the walled structure on top of the
rock at left. In another of Reinhold's
grotto paintings in Hamburg, a stairway
has been cut into the rock. He made
several studies in this area, which was
becoming a pictorial motif; Achille-Etna
Michallon worked in the same grottos
in 1819, and Edouard Bertin was there
sometime in the early to mid-1820s
(see cat. 80).

JOHANN JOACHIM FABER

German, 1778–1846

Faber left his native Hamburg in 1797 to study art in Dresden and Prague. From 1802 to 1804 he attended the Academy in Vienna, where he studied history painting and portraiture. He made his first trip to Italy from 1806 to 1808, and there became interested in landscape through his encounters with Joseph Anton Koch and Johann Christian Reinhart, and made a number of drawings in sites around Rome. Back in Hamburg he supported himself by painting portraits, until a local foundation grant in 1816 made it possible for him to return to Rome, where he stayed until 1827. He settled in Rome with his wife; when Heinrich Reinhold and Johann Christian Erhard arrived in 1819, they were tenants of the Fabers. Though Reinhold was the younger man, he was a pioneer among the Germans in open-air painting, and Faber took him for his model in its practice. They worked together in Olevano, and in 1823 Faber traveled with Reinhold to Naples and Sorrento. He ended his career in Hamburg as a portait painter and drawing teacher. SF

Literature

Lübeck 1992.

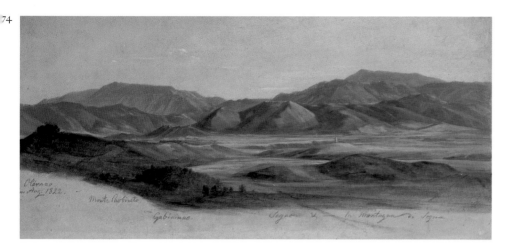

that was required of these painters of mountain views.

This work raises some interesting questions about the painters' practice and their attitudes toward their oil studies. It is a very close copy of a view by Reinhold in the Kunsthalle Hamburg, much too close to be the result of working concurrently at the same site. Hamburg also has a similarly close copy by Faber of one of Reinhold's studies of the Grotto at Sorrento (cat. 73). Faber, being close to Reinhold and eager to learn from him, made these copies as part of that learning process. After Reinhold's death, artists in Rome were eager to acquire his studies, and the chance to make copies may have been one of their motives. Another possibility is that these copies are by Reinhold himself. Both of the Hamburg studies are from the Schinkel collection, and when Schinkel bought them from Reinhold in 1824, he had to wait until the artist had made copies before he could take them. Both possibilities reveal how important it was to the painters to have in their keeping a library of the landscape motifs that they had experienced in Italy.

74

View at Olevano

1822
oil on paper
18 × 36.5 (7 1/16 × 14 3/8)
inscribed lower left: "Olevano/im Aug. 1822"

Ratjen Foundation, Vaduz

This view is from Olevano due south across the Campagna to the spur of mountains, the Monti Lupini, which run southeast from the Colle Albani. The artist has identified the view by writing on the unpainted space at the bottom: the steep hill town of Segni is just visible at the top of the central hill on the far side of the valley, and the town of Gavignano is seen on a lower rise to its left. Several of this type of view with the varied silhouettes of the Monti Lupini were made by Reinhold, whose precedent, though not the particular view, Faber is following here. Such studies document the artist's response to the desolate expanse of the Campagna, as well as to the sculptural forms of the hills.

75

Civitella from the North

1822 ?
oil on paper
21.3 × 28 (8 3/8 × 11)

Ratjen Foundation, Vaduz

The tiny town of Civitella can be seen perched on the high rock in the middle distance. This view is from the north of the village, that is, the far side on the approach from Olevano. The image gives a clear idea of the physical effort

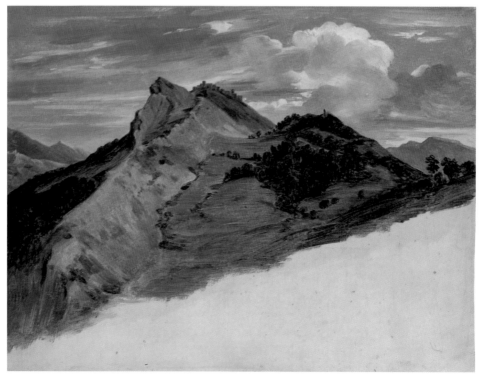

JEAN-CHARLES-JOSEPH RÉMOND

French, 1795–1875

A native Parisian, Rémond entered the Ecole des Beaux-Arts in 1814 and exhibited for the first time at the Salon in that same year. A pupil of the history painter Jean-Baptiste Regnault and the neoclassical landscape painter Jean-Victor Bertin, Rémond was honored with the Prix de Rome for historical landscape in 1821 for his painting *The Rape of Proserpina by Pluto* (among the fellow students he bested in that competition was Edouard Bertin). Awarded a four-year pension at the French Academy in Rome, from 1821 to 1825, Rémond produced oil studies and drawings in the city and in the Campagna, and traveled also to Naples and Sicily.

From 1814 to 1848 Rémond exhibited regularly at the Salon and received a number of awards and several public commissions. Even before winning the Prix de Rome himself, he maintained an atelier and prepared students for that competition, a practice he continued throughout much of his career. Two of Rémond's students stand out: Eugène Fromentin, orientalist painter, writer, and art critic, famous for his rediscovery of Vermeer in his book on Dutch seventeenth-century art, *Les maitres d'autrefois*; and Théodore Rousseau, the great master of the Barbizon School. Rousseau studied only briefly with Rémond, from 1827 to 1828, and later maintained that he learned nothing of value from his master. Indeed, much of what Rousseau attempted in his finished paintings of the 1830s and later stands as an explicit rejection of Rémond's artistic principles. There is, nonetheless, strong resemblance between the fluid technique of Rousseau's early oil studies and those of Rémond, as well as Rousseau's predilection for blond and red tones in his early oil studies, tones equally favored by Rémond. JS

Literature

Gutwirth 1983, 188–218.

76

View from the Palatine

1821–1825
oil on paper, mounted on canvas
32.4 × 27 (12¾ × 10⅝)

Private Collection, New York

According to tradition, the Palatine Hill was the site of the earliest Roman settlements. As the location of some of ancient Rome's most important monuments, the Palatine provided an excellent spot for landscape painters interested in depicting its ruins (see Giroux, cat. 105), or for those, like Rémond, who chose to exploit its high vantage to look out over the city. The view faces northeast, cutting at an oblique angle across a single vault of the Basilica of Constantine, beyond which lies Santa Maria Maggiore, and, in the far distance, the Sabine Hills. A second version of this composition exists in a private collection, France.[1]

Notes

1. Conisbee and Gowing 1980, no. 33, illus.

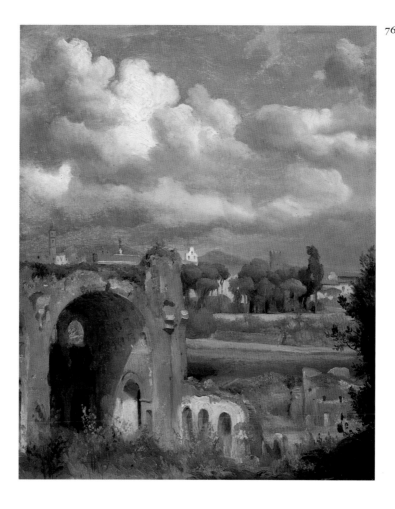

76

77

The Arch of Titus and the Colosseum

1821–1825
oil on paper, mounted on canvas
28.6 × 38.7 (11¼ × 15¼)

Private Collection, New York

Rémond adopts here an elevated viewpoint from the Palatine, looking over the Arch of Titus at bottom right, and to the edge of the Colosseum at far right. Even though Rémond eschews a traditional, complete view of the major monuments, nevertheless this painting reveals his effort to incorporate the rules of classical composition into the outdoor study. Rising landscape and building at left function as *repoussoirs*, while the composition is held firmly in place by the Forum at right.

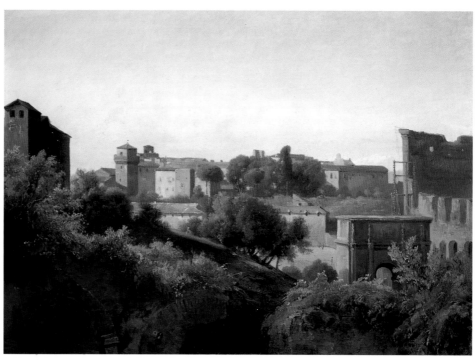

77

CARL WAGNER
German, 1796–1867

In 1804, Wagner moved with his family from the Rhineland to Meiningen, in Thuringia, when his father, a poet and novelist, was appointed cabinet secretary to the duke of Saxen-Meiningen. There he was educated, and in 1816 he was awarded a scholarship from the duke to study painting in Dresden. His first teacher was Carl August Richter, father of the painter Ludwig Richter, who was only six years younger than Wagner. His ambition from the first was to be a landscape painter. Dresden was at the time the most important art center in Germany, especially for landscape, and there he met the circle of artists that included Johan Christian Dahl, Caspar David Friedrich, and Carl Gustav Carus.

After finishing his studies in 1820, the duke put him in charge of the art gallery at Meiningen and appointed him court painter for life. This security allowed him to travel late in 1822 to Rome, where he stayed until 1825. He met Joseph Anton Koch, Johann Martin von Rohden (of whom he wrote admiringly), Bertel Thorvaldsen, and others such as Heinrich Reinhold and Ernst Fries. Like these last two, he was interested in making oil studies as well as the drawings that were still the more usual medium for the German artists. He painted in and around Rome, and traveled in the summer of 1823 to Naples. Late in 1823 Ludwig Richter arrived in Rome, and during 1824 the two worked together in the Alban Hills, Tivoli, and Civitella near Olevano. Moritz Wullen, in a recent article, argues that Richter's drawing, which already displayed an acceptable Nazarene style, influenced Wagner to abandon oil study for drawing, a medium less consonant with his true talent.[1] In any case, he did not develop open-air painting after his return to Meiningen in 1825. He was appointed gallery inspector and court councillor, and he made etchings as well as drawings, watercolors, and studio paintings of alpine and forest subjects. His work is still relatively unstudied. SF

Notes

1. Wullen 1994, 360–370.

Literature

Andresen 1867, 2:166–197; Konig 1990.

78

At the Wall of Rome

1823
oil on paper, mounted on cardboard
31.7 × 43.4 (12½ × 17¹/₁₆)

Kunsthalle Bremen

Wagner's studies, following Reinhold's example, are usually located and dated. This one is inscribed "Rom d. 12 Febr. 23" on the wall below the large agave plant. Such interest in recording the time and place is connected with a sense of the particularity, the uniqueness, or "Eigentümlichkeit," of a place or moment — a key concept of the German Romantics.[1] The word "Ausschnitt" — literally "cutting," but used also in the sense of the French "regard" — is relevant here too. This painting is a kind of cutting, or framing out, from a larger whole that the artist has come upon; it is not made into a composition, but constitutes a composition by virtue of the painter's decision to frame what he sees in just this way. This "Ausschnitt" character is present in all direct studies from the motif, but it becomes more powerful and apparent in a work like this, where the painter is close to his subject, in an almost confrontational way. The very structure of the wall reinforces the sense of the image having been "cut" from a field that continues beyond the frame.

Wagner's originality is also shown in his choice of a remote and anonymous section of the ancient city wall. The two plain buildings that close off the image are typical Roman working struc-tures set against the ancient stones. The brilliantly lit, spearlike leaves of the agave plant at the center — so unlike anything native to Germany — add to the power of the image.

Notes

1. See Koerner 1990, especially 57–60.

FRANZ LUDWIG CATEL

German, 1778-1856

Born in Berlin to a family of French Huguenots, Catel studied at the Berlin Academy and also in Paris at the end of the century. He began his career as an illustrator for almanacs and books, including Goethe's *Hermann und Dorothea* in 1800, and he exhibited landscape watercolors. He went to Paris in 1807 to learn the techniques of oil painting and to study the works in the Musée Napoleon. In 1811 he went to Rome, where he married the daughter of the poet Paretti, converted to Roman Catholicism, and settled in that city for life. He became a friend of Joseph Anton Koch and the Nazarene painters, and joined the group of German artists who were close to Ludwig, crown prince of Bavaria, who was often in Rome during the first three decades of the century.

Catel made his reputation with small paintings of scenes in and around Rome and Naples, often peopled with genre figures. These were bought by visitors to Rome, especially members of the European aristocracy whom he entertained in his house near the Spanish Steps. He also organized exhibitions of painters' work, and his prosperity allowed him to be generous to artists who came to him for assistance. At his death he left a charitable and educational foundation for Italian and German artists, the Pio Istituto Catel, which is still in existence today. SF

Literature

Krieger et al. 1986.

79

View of Naples through a Window

c. 1824
oil on paper, mounted on canvas
46.8 × 33.5 (18⁷⁄₁₆ × 13³⁄₁₆)

The Cleveland Museum of Art, Mr. and
Mrs. William H. Marlatt Fund 94.198

Catel helped develop a new portrait
format that combined two pictorial types:
the portrait with the sitter in an Italian
setting (a tradition that flourished at
least from Pompeo Batoni's portraits
of English milords to Ingres' Roman
drawings), and the interior with a land-
scape view from an open window. His
portrait of Karl Friedrich Schinkel in the
Nationalgalerie Berlin shows the subject
seated to the right of an open French
window, curtained in sheer white at
the center of the composition, with
a lightfilled view over the trees to the
Bay of Naples and Capri. The Cleveland
painting shows the same structure with
slight differences in the style of the
curtain and with a balcony rail, looking
out over the street and city to Vesuvius.
Catel did not add the figure of Schinkel
to the Berlin painting until after they
both had returned from Naples to Rome.
In his journal entry of 24 October 1824,
Schinkel notes that he has gone to sit
for Catel to complete a picture that
already represents the room he stayed in
with its view on the Bay of Naples near
the Villa Reale.[1] That the Cleveland
painting stands on its own without any
figuration—except for the dog—indicates
that the most powerful element of
this composition is the landscape seen
through the window.

Notes

1. Schinkel 1982, 227. See Paris 1976, 24.

EDOUARD BERTIN

French, 1797–1871

The second son of the journalist Louis-François Bertin, founder of the influential newspaper *Journal des Débats*, Edouard Bertin began his studies at the Ecole des Beaux-Arts in Paris with the celebrated neoclassical history painter Anne-Louis Girodet-Troison. Girodet occasionally practiced landscape painting in the open air and was unusual among history painters for his interest in and sympathy for the genre. Girodet is known to have made oil studies of landscapes during his time in Italy, of which three are in the Musée Magnin, Dijon,[1] and he collected oil studies by his peers.[2] Perhaps he pushed his young pupil toward landscape, for in 1816 Bertin entered the studio of Jean-Joseph-Xavier Bidauld, transferring in 1818 to the studio of Louis-Etienne Watelet. Bertin participated in the competition for the Prix de Rome for historical landscape painting and, although he did not place well, departed for Rome that same year at his own expense. He returned to Paris in 1823, entered the studio of Jean-Victor Bertin (no relation), where he met Corot and Théodore Caruelle d'Aligny. He traveled to Rome again in 1825, taking up residence in 1826 at the pensione Delle Lepre with Corot and Aligny, and the three artists painted oil studies together in and around Rome. Returning to Paris in 1827, Bertin entered the studio of Ingres and exhibited for the first time at the Salon. He worked together with Aligny in the forest of Fontainebleau, and when he exhibited at the Salon of 1831 critics remarked upon the resemblance between his paintings and those of Corot and Aligny. The influential critic Etienne-Jean Delécluze viewed the resemblance as favorable evidence of a new school of landscape painting.

Like Aligny, Bertin sought to renew classical landscape by purifying and simplifying his forms. A similar tendency is evident in Corot's landscapes of the late 1820s and early 1830s, but Corot's work evolved in a direction less severe than that taken by the companions of his youth. Undoubtedly Bertin's finest work consists in the numerous large charcoal drawings he executed, frequently on gray or blue paper. Many of these drawings depict Italian subjects, their forms massive and broadly drawn. An air of melancholy seems to pervade these works, which stand among the most impressive bodies of landscape drawings of the nineteenth century. JS

Notes

1. Levitine 1965, 65:231–246; the Dijon oil studies are illustrated on pp. 244–245, figs. 25–27.
2. Lacambre 1976.

Literature

Grunchec 1980, 147–152.

80

Ravine at Sorrento

early 1820s
oil on paper, mounted on cardboard
40.9 × 29.5 (16⅛ × 11⅝)

The Metropolitan Museum of Art,
purchase, Karen B. Cohen Gift, 1986

Many, if not most, of the landscape
painters who traveled to Rome eventu-
ally pushed further south, at least as far
as Naples. Vesuvius, the Bay of Naples,
and the Amalfi coast all offered numer-
ous and well-tested sites for the artist
to depict. Sorrento, which lies at the
southern end of the Bay of Naples,
near the edge of a peninsula that divides
the bay from the Gulf of Salerno,
offered, among its other attractions,
a dramatic ravine that lured Bertin and
Heinrich Reinhold (cat. 73), among
others. For this painting Bertin chose
a viewpoint that emphasized the contrast
between the dark, cool interior of the
ravine, punctuated by mysterious
caverns, and, at top, a bright open sky.
The play of the artist's brush is especially
evident in the tufts of vegetation that
grow across the hard rock surfaces and
stand out boldly against the sky. As Peter
Galassi notes, the point of view Bertin
adopted here was common to at least
several artists.[1]

Notes

1. Galassi 1991, 107.

THÉODORE CARUELLE D'ALIGNY

French, 1798–1871

Théodore Caruelle d'Aligny enjoyed considerable official recognition throughout his career. Beginning with his first entry of 1822, his paintings were accepted regularly at the Salon. He received state commissions and was decorated with the Legion of Honor in 1842. Elected to the prestigious Institut de France in 1861, he finished his career as director of the Ecole des Beaux-Arts of Lyon. Despite this official acknowledgment, Aligny was a controversial figure among his contemporaries. He maintained cordial relationships with artists of varying camps, but he was regularly attacked by critics as "an ascetic," an adherent of what many perceived to be the outmoded tenets of classical landscape, an artist who preferred to repeat and refine accepted formulas rather than engage directly with nature.

The son of a Parisian miniature painter who died before the artist's fourth birthday, Aligny was raised by his mother in the provincial city of Nevers, near his birthplace in the Château de Chaume. At the age of ten he moved to the capital to study for entry into the Ecole Polytechnique. Renouncing that ambition after several years, Aligny quit school and entered the studio of the history painter Jean-Baptiste Regnault, transferring later to the studio of the landscape painter Louis-Etienne Watelet, a student of Pierre-Henri de Valenciennes.

Aligny departed for Italy in 1822, remaining there until 1827. In 1825 he encountered Corot, and the two formed a fast friendship. Along with other young foreign artists living in Rome, they frequented the Caffè Greco and the pensione Delle Lepre, where they were often seen in the company of Edouard Bertin. More important, Aligny and Corot spent considerable time painting together in and around Rome. Their Italian oil sketches of 1825–1826 have occasionally been confused, although even at this early date one can detect a greater starkness and simplicity in Aligny's compositions, and a lesser degree of sensitivity to light and atmosphere. Some have maintained that Corot gained a new compositional assurance from Aligny's example.

Returning to Paris in 1827, Aligny began to work in the forest of Fontainebleau and the village of Barbizon, becoming a virtual pioneer for the numerous landscape painters who flooded that forest by mid-century. Aligny's drawings in pencil and in pen of Fontainebleau from the late 1820s and early 1830s, nearly abstract in their reduced means and geometric purity, are among the finest works of the artist's career.

Aligny traveled to Italy again in 1834–1835, and in 1843 stopped in Milan on his way to Greece, where he had been sent by the French government to make drawings of ancient sites and monuments. He also produced oil sketches during this second trip, as he did throughout his career. Nevertheless, the aesthetic of the open-air oil sketch, emphasizing quickness of response and the sensual apprehension of nature, proved ultimately distant from the core of Aligny's interests. Rather, in his most significant works, whether drawn or painted, Aligny seemed concerned to strip away extraneous elements, to locate in nature a clear, spiritual form frequently linked to the deepest meanings of classical and religious subject matter. JS

Literature

Aubrun 1988.

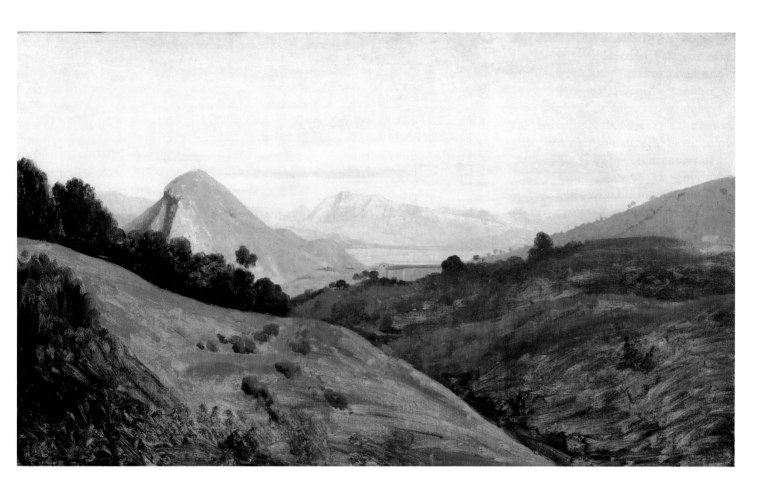

81

Italian Hills

c. 1822–1827
oil on paper, mounted on canvas
41.2 × 68.8 (16¼ × 27¹⁄₁₆)

Museum of Fine Arts, Boston,
Seth K. Sweetser Fund

Aligny's favored subjects included rocky,
forbidding landscapes, defined by strong,
simple forms. Although the outlines of
Italian Hills are rounder and the shapes
smoother than many of the artist's more
severe images, the study is marked by
a tendency toward simplification so
characteristic of the artist's work. The
landscape is defined by a series of clearly
drawn planes placed one in front of
the other, which describe a vast space.
The broad shapes of these planes are
punctuated by a few trees, which also
serve to make this relatively austere land-
scape seem somewhat more gracious
and hospitable. The specific site depicted
here has not been identified.

ERNST FRIES
German, 1801–1833

Fries was the son of a well-to-do manufacturer in Heidelberg, who was also an art collector and a cultivated man who encouraged his son's career as an artist. While still a boy Fries studied drawing with a teacher at the university, Friedrich Rottmann, the father of Carl Rottmann, who as an only slightly older contemporary of Fries was a fellow student and who would go on to become a noted landscape painter. Fries also studied painting at the Academies of Karlsruhe and Munich, and perspective and optics in Darmstadt with Georg Moller, the architect who designed that neoclassical city.

In 1816 Fries traveled on the Rhine and the Moselle to study landscape, and in 1820–1821 he and a group of fellow students, including Carl Rottmann, traveled extensively on the Rhine and in southern Germany, the Tyrol, and Switzerland, making drawings, watercolors, and oil studies. In 1823 he and Johann Heinrich Schillbach, a student of landscape painting from Darmstadt, and two others set out for Rome. There Fries sought the advice of the older generation of German landscape painters, Joseph Anton Koch and Martin von Rohden, and became acquainted with Carl Wagner and Ludwig Richter. Richter noted in his memoirs that Fries was admired for his paint handling and understanding of color.[1]

Initially, he worked in Rome and in the Campagna, but in 1825 he began to take long working trips. That year he traveled up through the Sabine Mountains to Florence and then on to the Massa di Carrara and to the coast at Rapallo. During 1826 there were three campaigns. The first was a trip north to the borders of Umbria, and along the way Fries made many stops. In May he was in Civita Castellana, where he met Corot, as documented by the sympathetic portrait he drew of his fellow open-air painter.[2] The fact that he misspelled Corot's name on this drawing shows that they were not close friends; however, one of Fries' companions on this trip was Corot's colleague Edouard Bertin, so it is possible that they had already met in Rome, where they likely became better acquainted the following winter. During that same year Fries worked in the Naples region, and in the autumn in Tivoli, Subiaco, and Olevano. In Naples he and the poet and artist Auguste Kopisch were the first in centuries to enter the Blue Grotto at Capri, which, having been avoided by the inhabitants as a mysterious source of devils and monsters, was unknown to visitors.

Fries' energy led him to work at nearly all of the sites established by the open-air tradition before his return to Heidelberg in 1827. There he married and began a fruitful career as court painter at Karlsruhe, a position which enabled him to travel and paint in the Baden countryside. An attack of scarlet fever in 1833 brought on a delerium, during which he slit his wrist and died, thus becoming one of the several gifted painters from Germany whose careers ended at an early age. SF

Notes

1. Richter 1891, 196.
2. Dresden, Staatliche Kunstsammlungen; reproduced as the frontispiece in Galassi 1991.

Literature

Bott 1978; Gravenkamp 1927; Wechssler 1972.

82

The Ponte Nomentano near Rome

1824
oil on paper
21.7 × 28.7 (8⁹/16 × 11⁵/16)

Kurpfälzisches Museum der Stadt
Heidelberg

This ancient bridge, which combines
a Roman arch with a medieval tower,
spans the Aniene River before it flows
into the Tiber, northeast of Rome, about
three miles from the city walls. It was a
favorite motif of the open-air painters,
who most often chose to paint it as Fries
does here, with a wide panorama of the
desolate Campagna framed at the hori-
zon by the Sabine Mountains.

The work is striking in the way it is
laid out in a band on the paper, cut off
in an unhesitating manner. The leaf
studies appear to have been added later,
as their pigment overlaps the penciled

color notes at the lower left that refer to
the landscape. On the reverse, Fries
dated the work February 1824 and noted
that it is his first "nature study in oil";[1]
like the other German artists (as opposed
to the French) he had more often
worked outdoors in drawing and
watercolor, so that this is his first oil
study to be made in Rome. Fries' intense
feeling for the Campagna as a landscape
theme is documented in an incomplete
diary entry for 1823–1824, in which
he described it as a place "where there
is hardly a tree to be seen for miles, but
where the most beautiful studies of the
distance, the grounds and the colors
can be made."[2]

Notes

1. Wechssler 1972, no. 4.
2. Gravencamp 1927, 17.

83

Overhanging Cliff with Cave

c. 1824
oil on paper
25.4 × 34.5 (10 × 13⁹/16)

Kurpfälzisches Museum der Stadt
Heidelberg

This powerful study of a rough mass
of tufa, supporting a rich growth of
vegetation and eroded to form a typical
rock cave, could have been made in a
number of places in central Italy. In fact,
a drawing of a similar motif in the
Heidelberg Museum is dated December
1823 by the artist on the back of the sheet
and is described as "hillock with cave in
the Campagna."[1] Such natural features
were not uncommon in the Roman
countryside; if the painting was done in
the same place it is likely that it would
have been early in 1824. There is a strong
contrast here between the broad paint

83

This accomplished and complex small painting must have been completed toward the end of Fries' stay in Rome, but the date cannot be documented. He worked in and near Rome during the late fall to early spring season for four years. Like many others he was fascinated by the Colosseum, which provided countless corners and variously structured views to what lay beyond it—in this case, a section of the ruins on the Palatine Hill. The spatial complexity of the layered planes is beautifully articulated. The eye moves from the shadowed section of wall nearest the painter at the left, to the sunlit, angled wall at the right, and then to the brick arch, under which is a lower section of the Colosseum and over which can be seen an almost self-contained composition, a landscape of ruins and foliage with its own spatial structure, painted with great delicacy and precision of touch and tone. Indeed, it is this area in particular that points to the artist's knowledge of Corot's oil studies, which would have been acquired toward the end of his stay in Rome.

handling of the rock and the delicacy of the foliage, as well as between the bright light falling on the cliff and the profound darkness of the cave. The result is a dramatic response to the natural forces that have molded the Roman landscape over time, analogous to the historical forces that brought about the creation and destruction of Rome.

Notes

1. Wechssler 1972, no. 50.

84

View from the Colosseum toward the Palatine

1824–1827
oil on paper, mounted on cardboard
25.4 × 37.8 (10 × 14⅞)

Private Collection, New York

8.

JEAN-BAPTISTE-CAMILLE COROT
French, 1796 – 1875

Born in Paris to a fashionable milliner and a cloth merchant, Corot was educated first in a small boarding school near his Left Bank home, and then at a secondary school in Rouen. Completing his formal schooling in 1814 in Poissy, near Paris, Corot began a series of apprenticeships in the cloth trade. Already interested in art, he is reported to have drawn and painted landscapes in his spare hours, and he attended evening classes in drawing at the Académie Suisse. In 1821 Corot's younger sister died and his father offered him a choice: either he could enter the cloth trade, in which case he would receive his sister's dowry, or he could become an artist, in which case he would receive only the income from the dowry. Corot chose to become a painter, supporting himself with the modest income from the dowry for many years.

In 1822 Corot entered the studio of Achille-Etna Michallon. When Michallon died six months later, Corot transferred to the studio of Jean-Victor Bertin, where he remained until 1825. Both Michallon and Bertin had been students of Pierre-Henri de Valenciennes, and from both Corot would have received a rigorous academic education, as well as an appreciation for historical landscape painting, a genre he continued to practice throughout his life. Corot first learned the technique of the outdoor oil study from Michallon, who also gave him his own studies to copy. Corot continued to work outdoors, around Paris and its outskirts, and in the forest of Fontainebleau, throughout his student years.

Freed by his annual income and additional family support from the necessity of competing for the Prix de Rome, Corot set off for Italy late in 1825, accompanied by the Latvian-born painter Johann Karl Baehr. Arriving in Rome by December, he remained in the city until May 1826, when he set off with Baehr for Civita Castellana. During May and June he worked in and around Civita Castellana, about thirty miles north of Rome, and in July, August, and September he painted around Papigno, an area ten miles farther north that includes the towns of Narni, Terni, and Piediluco. He was back in Rome during part of October, and in November traveled a few miles south to a group of towns known as the Castelli Romani (Frascati, Marino, Castel Gandolfo, Albano, Ariccia, Genzano, and Nemi). Back in Rome by December, Corot remained there until the following April, when he set out first to the west, to the area around Civitella, Olevano, and Subiaco, and then, in May, returned to the Castelli Romani. From late July through early August he worked again around Olevano, and from September through October, he returned to Civita Castellana.[1]

In painting at these sites, Corot followed a popular itinerary, often in the company of other artists. Artists in this exhibition whom Corot is known to have encountered in Rome and the Campagna, and in whose company he traveled and worked, are Théodore Caruelle d'Aligny, Edouard Bertin, Léon Cogniet, Léopold Robert, and Ernst Fries. Certainly Corot met many other artists, along the roads and at the various sites in and around Rome, at the hostels frequented by painters, and at the Caffè Greco, which he used as his mailing address. Corot's originality, then, and his lasting contribution, resides not in the subjects of his oil studies, nor in their facture, which in certain works is not far distant from that recommended and employed by Valenciennes. As Peter Galassi points out, Corot brought to the oil study a new

rigor and formality, one based not upon finish but upon structure. The studies he pro-duced on his first trip to Italy are concerned far less with effects of changing light and atmosphere than are those of many of his predecessors and contemporaries. Instead, he concentrated upon achieving "...his goal of closing the gap between the empirical freshness of outdoor painting and the organizing principles of classical landscape composition."[2]

Early in 1828 Corot traveled to Naples, and in the fall began the voyage back to Paris, stopping in Venice along the way. He had submitted his first paintings to the Paris Salon in 1827, and his work was noted favorably by critics. Through the 1830s, although his paintings were not yet a commercial success, he was regularly cited as being among the most promising landscape painters of his generation. He traveled frequently about France, making outdoor studies as he went, while in his studio he prepared finished compositions that referred back to elements of his Italian experience. He returned to Italy for six months in 1834, staying this time in the north, in Genoa and Tuscany, then Venice and the lakes north of Milan. He did not return to Rome until his third, and final, trip to Italy in 1843. During that trip, again lasting only six months, he revisited many of the familiar sights of his youth, particularly those around the Castelli Romani, and painted also at Tivoli. While Corot's first trip to Italy proved crucial to the artist's development and resulted in a body of work central to his achievement, the second and third trips were much less significant to the course of the artist's career, even as they resulted in some exceptional paintings.

In 1845, Corot was placed by Baudelaire "At the head of the modern school of landscape...."[3] Although Corot's paintings still barely sold, Baudelaire was only slightly in advance of an emerging critical consensus. In 1846 Corot was awarded the Legion of Honor, the first of many official distinctions. Through the 1840s, the style of Corot's composed landscapes remained relatively consistent. Their light was the hard, clear light of Italy, and their forms, although never highly finished, were solid. In the 1850s, however, his work underwent a marked change. Forms softened, even dissolved, in a diffused, silvery northern light. The new manner proved immensely popular, and Corot joined commercial success to his critical esteem. His reputation grew as "Papa Corot," the modest, generous *naïf* who combined an innate, instinctive sense of classicism with a heartfelt love of nature. That reputation, misleading in so many ways, persisted late into the twentieth century.

In his day, Corot influenced several generations of landscape painters. In the 1830s and 1840s, his work offered a model for those who sought to renew the classical tradition by a more frank and open approach to nature. From the 1850s onward, Corot stood in the vanguard of a new, tonal approach to landscape, in which atmosphere came increasingly to envelop, even mask, form. That approach would have some relevance, in the 1860s and 1870s, to the experiments of the impressionists. Although Corot's Italian oil studies were not widely known until after the artist's death in 1875, it is from them that Corot's relevance to the course of modern art has most frequently been asserted. By their openness to light and direct approach to nature, the oil studies were seen to anticipate impressionism. By their solidity of form

and classical structure, they look forward to Cézanne and cubism. If today we understand Corot's Italian oil studies not as precocious anachronisms, but rather as heirs to, even the summation of, the tradition begun by Valenciennes, that only serves to heighten our appreciation for the artist's achievement. JS

Notes

1. See the chronology established by Peter Galassi in Galassi 1991, 133.
2. Galassi 1991, 170.
3. Baudelaire 1965, 24.

Literature

Galassi 1991; Robaut and Moreau-Nélaton 1905.

85

View of the Roman Campagna

1826
oil on paper, mounted on canvas
26 × 46 (8⅝ × 18⅛), R 97
inscribed: "fevrier 1826"

Lent by the Syndics of the Fitzwilliam
Museum, Cambridge

With the notation "fevrier 1826" scratched into the paint (placing it among the earliest firmly dated oil studies of Corot's first Italian journey), this painting is all atmosphere and energy. Freely painted in tones of brown and gray, the image is characteristic of the work Corot produced soon after his arrival in Rome, when he explored the city itself and its immediate surroundings. The special concern for atmosphere evinced in this painting, also typical of Corot's early Italian work, reminds us of Valenciennes. The view here is of the Campagna as seen from one of the hills at the northern edge of Rome, looking east toward the Sabine Mountains.

86

View in the Farnese Gardens

1826
oil on paper, mounted on canvas
24.5 × 40.1 (9⅝ × 15¹³⁄₁₆), R 65
inscribed: "mars 1826"

The Phillips Collection, Washington, D.C.

Washington and Saint Louis only

This is one of three paintings that
Corot executed in the Farnese Gardens
(the other two are now in the Louvre).
While he painted all three studies out-of-
doors, Corot nonetheless produced them
in a novel manner. Working sequentially
for seventeen days, Corot began each
morning with this *View in the Farnese
Gardens*, which looks east-southeast
toward the small medieval church of San
Sebastiano in Palatino, just left of center.
At midday, Corot switched to the
second study in the series, which looks
more directly east, and slightly north,
with the Colosseum shown at left.

Finally, in the afternoon, he walked a
short distance west, and set up his easel
facing north, overlooking the Forum.
Rather than hasty studies, then, these
three paintings were carefully executed,
painstakingly conceived works that con-
trast markedly with such freely painted
studies as Corot's *View of the Roman
Campagna* (cat. 85), produced one month
earlier. Together, the three paintings
offer powerful evidence of Corot's intent
to fuse the sensitivity to light and atmos-
phere of the open-air study with the
ordered compositional structure of clas-
sical landscape. Indeed, the trees at left
and right in *View in the Farnese Gardens*
appear as perfect Claudian *repoussoirs*,
and in their indeterminate mass of leaves
they anticipate the generalizing effects
Corot favored in his later years, even as
the light which falls on the middle-
ground and background of the painting
seems entirely specific to the appearance
of an early spring morning in Rome.

87

88

The Roman Campagna with the Claudian Aqueduct

1826–1828
oil on paper, mounted on canvas
21.6 × 33 (8½ × 13), R 98 bis

The Trustees of the National Gallery, London

Brooklyn and Saint Louis only

Among the best known of Corot's Italian oil studies, this is also among the most unusual. The suave harmonies, fine gradations of tone, and smooth spatial transitions that characterize so many of his oil studies contrast with the abrupt changes of color and tone, and the spatial jumps in this painting. The composition is organized into a grid of horizontal and vertical lines, which tends to diminish the sense of spatial recession, flattening the composition, and thereby lending it a precociously modern appearance. This painting once belonged to Degas, an artist who, early in his career, followed in Corot's footsteps and painted open-air oil studies in Italy.

87

Temple of Minerva Medica, Rome

1826
oil on canvas
21 × 26 (8⅝ × 10¼), not in R
inscribed: "mars 1826"

Musées d'Angers (legs Bodinier au Musée Pincé, 1872)

What remains of the Temple of Minerva Medica stands not far from the current site of Rome's railroad station, east of the Esquinale. Originally a ten-sided hall, the building may have served originally as a nymphaeum, and received its present name after the discovery within it of a statue of Minerva with a serpent. The great cupola of the temple collapsed in 1828, two years after this painting was made.

Relatively few of Corot's Italian oil studies are composed, like this, of views of single buildings.

Long attributed to Corot by the Angers museum, this vivid oil study and another, *Piazza at Marino, near Rome* (oil on board, 21 × 27 cm), were bequeathed to the museum in 1872 by

Corot's friend and contemporary, the painter Guillaume Bodinier (1795–1872). It is significant that these works do not feature in Robaut's standard catalogue of Corot's works, and Vincent Pomarède has suggested, orally, that in fact they may be by Bodinier himself. However, the form of the inscription, scratched into the paint, is similar to that on cat. 85 in this exhibition.

89

Basilica of Constantine

1826–1828
oil on canvas
24 × 34 (9⁷⁄₁₆ × 13³⁄₈), R 80

Private Collection

This once vast structure at the eastern end of the Roman Forum was long known as the Temple of Peace; during the early nineteenth century, however, its identity as the Basilica of Constantine (or Maxentius, who began its construction) was established.

The composition here is a compressed variant of that found in Corot's *View of St. Peter's and the Castel Sant'Angelo* (cat. 90). Similarly, although they depict separate subjects, Corot's composition in this *Basilica of Constantine* is quite close to that found in an oil study by the German painter Ernst Fries, *View from the Colosseum toward the Palatine* (cat. 84). Fries befriended Corot, and drew his portrait when they painted together at Civita Castellana.

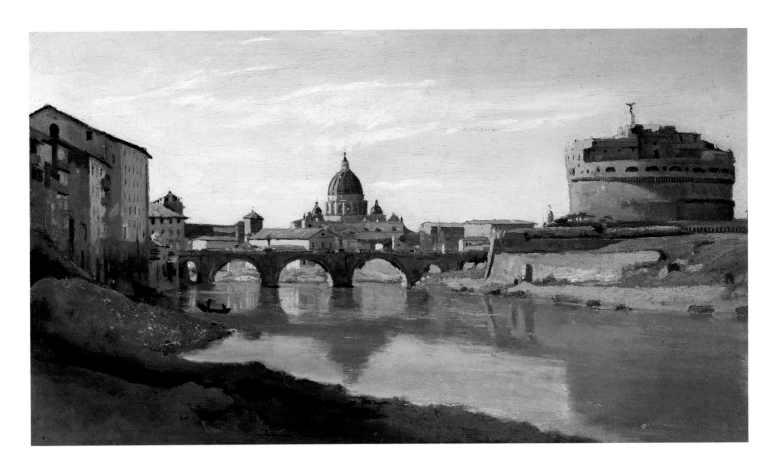

90

*View of St. Peter's and the
Castel Sant'Angelo*

1826–1828
oil on paper, mounted on canvas
21.9 × 38.1 (8⅝ × 15), R 70

The Fine Arts Museums of
San Francisco, museum purchase,
Archer M. Huntington Fund

Corot establishes this view from the
eastern bank of the Tiber, looking across
the river to the Castel Sant'Angelo
on the right, and beyond the Ponte
Sant'Angelo to the dome of St. Peter's.
As he does in the slightly smaller *Island
of San Bartolommeo* (cat. 91), Corot sets
the buildings of Rome between reflective
water and a light-filled sky. The composi-
tional structure of this cityscape is much
like that Corot employed for his land-
scape oil studies: high, massive forms
at left and right are spanned by a lower
form (here a bridge) that runs between
them. The dome of St. Peter's punc-
tuates the span, and balances both sides
of the picture.

91

Island of San Bartolommeo

1826–1828
oil on paper, mounted on canvas
27 × 43 (10⅝ × 16¹⁵⁄₁₆), R 75

Private Collection, Japan

The island of San Bartolommeo, also called the Isola Tiberina, sits in a bend of the Tiber River, not far from the Capitoline Hill. The perimeter of the island was once faced with travertine, a portion of which remains at its very eastern end. Linked to the city by two bridges, the Ponte Cestio to the south, and the Ponte Fabricio to the north, the island provided the central motif for this, one of Corot's most famous and remarkable paintings.

Corot takes his view here from the northern bank of the Tiber, looking toward the eastern end of the island, where we still see a trace of the ancient travertine facing. Roughly one-third of the composition is taken up by water, another third by sky. Between them stands the island and its two bridges, treated as a multitude of geometric facets. Although their forms are regular, the proportions vary. Indeed, Corot's painting is a miracle of scrupulous variation and subtle modulation. Even while limiting himself to a relatively restricted range of color, Corot seems to have carefully studied the fall of light across each surface he describes, lending to the painting an extraordinary complexity within its overall unity and harmony. The painting abjures obscuring effects of atmosphere or a dramatic fall of light, but it is light itself that appears to be its ultimate subject. Sandwiched between shimmering water and blue sky, every facet of the island and its bridges is defined by the precise measure of light that crosses it. The entire image, solidly constructed and carefully calibrated, is as evanescent as the passing of a shadow.

92

Cascade of Terni

1826
oil on canvas
36 × 32 (14³/₁₆ × 12⅝), R supp. 3.6

Banca Nazionale del Lavoro SpA

From the eighteenth century, waterfalls served as a staple of picturesque iconography. The Cascate delle Marmore at Terni was no exception: the high cascade was frequently depicted and often described in contemporary travel accounts. No depiction of the Cascate delle Marmore equals this by Corot, certainly one of the masterpieces of the artist's first Italian trip. Corot worked in the region of Terni from July to September of 1826, and his painting shows the hard, clear light of summer seemingly absorbed by thick vegetation along the steep hillsides. While topographic detail is not ignored, the feature that especially impressed other painters (including Corot, in one of the two other versions of the subject that he painted) — a great fan of water that flares out as the fall reaches its bottom — is absent. Instead, the artist concentrates on the play of light and shade, and the dynamic structure of a composition neatly divided into two unequal zones: a thin strip of blue sky at top, and the broad vertical expanse of cliffs and hills down which water courses.

93

*Civita Castellana and
Mount Soracte*

May 1826
oil on paper, mounted on canvas
27 × 36 (10⅝ × 14³⁄₁₆), R 124

Collection Musée d'art et d'histoire
de la ville de Genève

Dominating the Campagna north of
Rome stands the isolated form of Mount
Soracte. The mountain, which lies south-
east of Civita Castellana, was visible in
the nineteenth century from the higher
hills of Rome. Celebrated by poets,
and frequently depicted by landscape
painters in the late eighteenth and early
nineteenth centuries, it also served as the
focus for a series of paintings executed

by Corot in May of 1826 and in the fall
of 1827.

Civita Castellana, inscribed by Corot
with the date May 1826, is easily the
artist's most compact statement of the
subject. The viewer is placed on the edge
of a ravine, looking directly across dense
foliage to the fortress and the purple
slopes of Mount Soracte beyond. The
mountain stands directly in the center
of the composition, with the fortress
of Civita Castellana largely contained
within its profile. The edge of the ravine,
which dips at center toward the lower
border of the painting, seems to mirror
the shape of the mountain. A clear blue
sky contrasts with the dark, vigorously
brushed and scumbled foreground
and middleground. Peter Galassi notes
that the structure for this composition

repeats a drawing Corot produced as
a student, in which he copied a detail
from a painting by Gaspard Dughet.
In that drawing an Italianate building
is largely contained within the silhouette
of a craggy mountain.[1]

Notes

1. Galassi 1991, 185.

94

middleground, defining the space of the composition, and contrasting with the rugged rock formations behind it. Corot's fascination with the trees and vegetation at Civita Castellana is evident in the many drawings he produced of those subjects. Frequently executed with a fine pen, those drawings analyze the most dense, complex foliage, tracing the interweaving of curving tree trunks and looping branches that emerge from a rock-strewn landscape.

94

Mount Soracte

1826–1827
oil on paper
22.4 × 37.8 (8¹³⁄₁₆ × 14⅞), R 171

Bayerische Staatsgemäldesammlungen, Munich, Neue Pinakothek

Brooklyn only

In the series of oil studies executed of Mount Soracte in the spring of 1826 and fall of 1827, Corot depicted his motif from several sides and at different angles and distances. This painting is distinct for its contrast of the flat plateau at right with the serrated profile of the mountain at left. The view of the mountain is from the area around Castel Sant'Elia, a few miles to the west of Civita Castellana.

95

Rocks at Civita Castellana

1826
oil on canvas
32 × 44 (12⅝ × 17⁵⁄₁₆), R 135

From the collection of Howard F. Ahmanson, Jr.

The structure of this painting is close to that of *Civita Castellana* (cat. 97). There the composition is organized according to the architectonic character of the cliff faces; here a large tree dominates the

96

Rocks at Civita Castellana

1826–1827
oil on cardboard
26.6 × 21.2 (10½ × 8⅜), R 174

Bayerische Staatsgemäldesammlungen, Munich, Neue Pinakothek

Washington only

Although fascinated by the cliff faces and complex interplay of rocks and vegetation in the countryside around Civita Castellana, only with this study did Corot investigate that subject in such close-up detail. Works of this sort, which focus closely upon a single land-

95

scape element, are relatively rare in Corot's painted oeuvre, and in certain respects harken back to the analytic spirit of such pioneers of the landscape oil study as Valenciennes.

97

Civita Castellana

1827
oil on canvas
36 × 51 (14³⁄₁₆ × 20¹⁄₁₆), R 137

Nationalmuseum, Stockholm

In the numerous drawings and oil studies that he executed during his two campaigns at Civita Castellana, Corot's attention was drawn repeatedly to the dramatic cliff faces and outcroppings of rock that are among the region's most distinctive features. Characterized by a rectilinear, even architectural quality, this landscape allowed Corot to depict motifs possessed of the clear order and heroic proportions appropriate to classical composition, while remaining truthful to an unidealized nature that defined the ethos and the aesthetic of the landscape oil study. Among his favored compositional strategies was the placement of a cliff face in the upper quarter of a painting, with sky dominating the adjoining upper quarter, and the lower half of the picture taken up by various landscape elements. As Peter Galassi notes, Corot tested and refined this strategy in a multitude of drawings, a process which lent to oil studies such as this a magisterial grandeur and assurance.[1]

Notes

1. Galassi 1991, 183–193.

98

Olevano, the Town and the Rocks

1827
oil on paper, mounted on canvas
27 × 45.7 (10⅝ × 18), R 163

Kimbell Art Museum, Fort Worth, Texas

Corot first visited Olevano in April 1827,
traveling there with Aligny. Altogether,
he is known to have made seven oil stud-
ies in the region of Olevano, including
this painting, probably produced in the
company of Aligny, who executed a
study very close to the left side of this
image. Painters were drawn to Olevano
by the wild, untamed quality of the land-
scape. In contrast to the work of certain
artists who portray the town of Olevano
precariously perched among towering
peaks, however, Corot chooses to show
the town comfortably nestled within a
gently sloping hillside, a landscape more
pastoral than sublime.

99

Olevano, La Serpentara

1827
oil on canvas
33.5 × 47 (13³⁄₁₆ × 18½), R 162

Rudolf Staechelin Family Foundation,
Basel

For this panoramic oil study Corot
pulled back from the close-up view
of the rocky hillside of La Serpentara
found in *Trees and Rocks at La Serpentara*
(cat. 100), to focus on the vista of hills
and distant mountains near Olevano,
with La Serpentara at center. Long shad-
ows now fall across the landscape and
the image seems bathed in a soft, cool
light. Coinciding with this more atmos-
pheric treatment of the subject, Corot's
handling of paint here is especially fluid.

100

Trees and Rocks at La Serpentara

1827
oil on paper, mounted on canvas
30 × 44 (11¹³⁄₁₆ × 17⁵⁄₁₆), R 166

Private Collection

In the first half of the nineteenth century, the grove of oak trees named La Serpentara became one of the most popular and frequently depicted sites in the region around Olevano. Corot, who painted there in 1827, was drawn to the rugged, rocky terrain set off by massive oak trees. In this oil study that terrain is described by a hard, bright light and dark contrasting shadows. The hilly, rock-strewn landscape is ordered by crossing diagonals anchored at center by two large trees.

101

Ponte Nomentano

1826–1828
oil on canvas
28.5 × 28.5 (11¼ × 11¼), R 72

Museum Boymans-van Beuningen, Rotterdam

The picturesque Ponte Nomentano, rebuilt by the Byzantine general Narses and later topped by a medieval watchtower, crosses the Aniene River northeast of central Rome. The bridge, which punctuates an otherwise nearly empty landscape, proved an attractive motif for many open-air landscape painters. Corot's version is especially muscular and striking. By limiting the landscape exclusively to shades of brown, Corot depends upon shifts of tone and clear structuring elements to carry off his composition. The path at left curves quickly into the middleground, over which looms the bridge, with its elegant arch and mysterious, hulking tower. In the distance, the sharply drawn horizon is cut only by the minute silhouettes of two trees, and by the crumbling crenellations of the tower.

101

102

Aqueducts in the Roman Campagna

1826–1828
oil on paper, mounted on canvas
24.1 × 43.8 (9½ × 17¼), R 74

Philadelphia Museum of Art, The Henry
P. McIlhenny Collection in Memory of
Frances P. McIlhenny

This painting employs a compositional
formula that often served Corot: a hill
rises in the foreground on one side of
the painting, balanced by a lower hill on
the opposite side to define the middle-
ground. Between them stretches a distant
line of hills, delimiting the background
while uniting the two sides of the com-
position. With this formula, classic in its
symmetry, Corot was able to represent a
surprising range of locales, motifs, and
topographic features.

103

*The Roman Campagna,
with the Tiber*

1826–1828
oil on paper, mounted on canvas
23.3 × 44.7 (9³⁄₁₆ × 17⅝), R 103

Private Collection

Panoramic views of the Roman
Campagna were common among
Corot's contemporaries in Italy. This
study of Corot is as striking for its
simple division into two equal zones
of earth and sky, as it is unusual in
the artist's Italian oeuvre for its dark,
even moody tone. A study of light and
atmosphere as much as topography, this
work can be compared to similar views
by Blechen and Valenciennes.

104

The Tiber near Rome

1826–1828
oil on paper, mounted on canvas
22 × 34 (8¹¹⁄₁₆ × 13⅜), R 76

The Phillips Family Collection

Pictured is the Tiber River immediately
north of Rome, the path alongside
it named for the nearby mineral spring
Acqua Acetosa. This study was sold
posthumously in the Vente Corot
of 1876, where it was purchased by
Corot's friend, the landscape painter
Charles Daubigny.

104

ANDRÉ GIROUX

French, 1801–1879

A native of Paris, Giroux studied with his father and began to exhibit at the Salon in 1819, submitting landscapes with figures painted by Xavier Leprince. Giroux entered the Ecole des Beaux-Arts in 1821, and won the Prix de Rome for historical landscape painting in 1825 for *The Hunt of Meleager*. In Rome he joined the circle of young landscape painters that included Corot, Théodore Caruelle d'Aligny, Edouard Bertin, and Léon Fleury, and he accompanied members of this group on excursions into the countryside.

Giroux returned to Paris in 1830, and for his entry in the 1831 Salon was awarded a first-class medal. In 1837 he received the Legion of Honor. He continued to exhibit at the Salon until 1877, his landscapes frequently reflecting his travels around France, as well as through Switzerland and Austria.

Not surprisingly, many of Giroux's oil studies are close in subject and point of view to those of Corot, Bertin, and Aligny. Of those artists, Giroux possessed perhaps the most fluid touch, a relatively broad range of color, as well as a particularly strong interest in effects of light and atmosphere. He was captivated more by the spectacle of nature than the sights and ruins of ancient Rome. JS

Literature

Harambourg 1985, 165.

5

105

Ruins on the Palatine Hill

1825–1830
oil on paper, mounted on canvas
22 × 31.2 (8¹¹⁄₁₆ × 12¼)

Private Collection

The popular motif of ancient architecture overgrown with vegetation is taken up by Giroux in this study, which is probably set on the southeast corner of the Palatine Hill. With its subject, sharply restricted focus, and fluid

handling, this painting stands squarely in the tradition established by Valenciennes fifty years earlier.

106

Civitella

1825–1830
oil on canvas
26.5 × 38.5 (10⁷⁄₁₆ × 15³⁄₁₆)

Private Collection, Paris

Approximately forty miles due east of Rome, the fortress town of Civitella sits in the mountainous region near Olevano and Subiaco. Drawn by the wild, rugged character of the mountain landscape, painters came to this area beginning only in the early nineteenth century. The area was especially favored by German artists, many of whom set up camp at the Casa Baldi near Olevano. German artists who worked at Civitella include Johann Wilhelm Schirmer (cat. 128) and Heinrich Reinhold (cat. 72). Johann Karl Baehr, the Latvian-born artist with

106

107

Forest Interior with an Artist,
Civita Castellana

1825–1830
oil on paper
29 × 44 (11⁷/16 × 17⁵/16)

National Gallery of Art, Washington,
Gift of Mrs. John Jay Ide in memory of
Mr. and Mrs. William Henry Donner,
1994.52.3

whom Corot made his first trip to Italy, also worked there. In addition to this painting, Giroux executed at least one other oil study at Civitella. Of nearly the same dimensions as the present oil study, it employs a similar spatial strategy that depends upon three ranks of hills and mountains: a barren, rocky foreground summit contrasts with a range of dark green hills in the middleground, which contrasts in turn with a more lightly colored mountain peak in the distance.

With so many artists setting up their easels in the countryside around Rome, it is not surprising to find a number of images showing artists at work in the landscape. This became, in itself, something of a modest genre. Giroux's painting is set at Civita Castellana, the hill town north of Rome that Corot found to be a particular inspiration. The region of Civita Castellana possessed a considerable variety of landscape motifs, all within close proximity, from

the powerful form of Mount Soracte, to the rugged cliffs by the edge of the town, to the cool, overgrown region at the bottom of the ravine. It is that last area that Giroux made the subject of this study, and it is there, too, that Corot painted at least one oil study (North Carolina, Ackland Art Museum). Corot and Giroux certainly could have crossed paths at Civita Castellana. Idle speculation might have it that the figure in the foreground is possibly Corot himself.

GILLES-FRANÇOIS CLOSSON
Belgian, 1798–1842

Little is known about Closson's early years, except that he probably studied with Hennequin in Liège in 1813, and in 1817 went to Paris to study in the atelier of Baron Gros. In 1824 he received a foundation grant, which enabled him to go to Rome. Though trained as a history painter, he clearly had an interest in landscape, which was stimulated by the open-air painting community in Rome. There he would have met his countrymen Simon Denis, Martin Verstappen, and François Vervloet. Closson returned to Liège in 1829; he was thus in Rome during the same years as Ernst Fries, Edouard Bertin, Corot, and many others. He made many drawings and a considerable number of oil studies in and around Rome, including Tivoli, and in the region of Naples. On his return to Liège he made a serious effort to succeed with paintings of Italian landscapes, but the market favored local scenes, history painting, and genre. After 1838 he taught in the new Academy of Liège. An important group of his Italian drawings and small oil sketches are in the Cabinet des Estampes of the Musée des Beaux-Arts in Liège.

SF

Literature

Coekelberghs 1976; Coekelberghs and Loze 1986.

108

*Roman Ruins
(Baths of Caracalla ?)*

1825–1829
oil on paper
29.2 × 38.1 (11½ × 15)

Private Collection

The two studies shown present an impressive blend of precision and a strong, painterly feeling for light, color, and touch. Closson conveys the effect of brilliant sunlight without exaggeration. The unfinished area at the lower left only serves to heighten the solidity of the structures, represented in various stages of ruin. The arch at center, with its slight curve, and the shadow of a higher arch on the brick wall above it, recalls similar archways in the ruins of the Baths of Caracalla, southeast of the Palatine Hill. It was then located in the countryside, though within the walls of Rome. Now fully excavated, the Baths of Caracalla in the early nineteenth century had, like the Forum, a much higher ground level than that found today, as well as more extensive plant life. Larger in area than the Forum, the Baths were an impressive sight, with all structures dating from the early third century A.D.

109

Cliffs at Tivoli

1825–1829
oil on paper
55.9 × 39.4 (22 × 15½)

Private Collection

The unfinished area around the sides and bottom of the sheet accentuates the fact that this is a study in which the artist has focused on a specific range of vision, omitting what is peripheral. It also heightens both the brilliance and spatial depth of the painting. The theme of vegetation richly growing out of stone is the same as that of the *Roman Ruin* study, but here the stone is the rock cliff itself, a natural form eroded by time and the vagaries of the waterfall.

The falls here are the Cascatelli, on the eastern slope of the town. This site had long been of interest to artists, with its multiple patterns of falling water. Closson has chosen the vertical format most favored by his contemporaries, but applied it to a different part of the hill, away from the Temple of Vesta. Here the stress is upon the very complex patternings of the rough tufa with its caves, patches of mossy foliage, and tumbling foam.

LOUISE-JOSÉPHINE SARAZIN DE BELMONT
French, 1790–1870

Born in Versailles, Sarazin de Belmont later studied in Paris with Pierre-Henri de Valenciennes. She made her Salon debut in 1812 with *The Festival of Juno, Morning Effect*, and two views of Malmaison. Thereafter she exhibited regularly, winning a second-class medal in 1831 and a first-class medal in 1834. Typically, her Salon entries comprised both composed landscapes and larger view paintings, many of which were reproduced as lithographs.

Sarazin de Belmont proved also to be an inveterate and adventurous traveler. She made her first trip to Italy from 1824 to 1826, venturing as far south as Sicily. Her second trip took place in 1839, financed by a sale of the Italian oil studies from her first trip still in her possession. She also traveled to Germany and explored many parts of France. She was among the first French landscape painters to work in the Pyrenees. JS

Literature

Harambourg 1985, 313–314.

110

The Falls at Tivoli

1826
oil on paper, mounted on canvas
72 × 42.2 (28⅜ × 16⅝)

The Fine Arts Museums of San Francisco, museum purchase, Art Trust Fund and The Fine Arts Museums Foundation

Sarazin de Belmont's depiction of the Temple of Vesta and the waterfalls at Tivoli is among the most dramatic representations of a motif favored by numerous landscape painters. The artist skillfully opposes the diagonal, upward thrust of the composition, which culminates in the circular temple in the top right corner, with the rush of water flowing diagonally from upper left. Even though the largest part of the composition is in shadow, the bright sky at the top of the painting and the white jet of water near its center set the tone for a high-keyed image.

JACQUES-RAYMOND BRASCASSAT

French, 1804–1867

Brascassat achieved considerable success in the mid-nineteenth century as a painter of animals, especially bulls and cows. Born in Bordeaux, he studied with a local painter at the age of twelve and took courses in drawing at the municipal school. In 1819 he met Théodore Richard, an engineer and sometime landscape painter who had studied with Jean-Victor Bertin. Richard took Brascassat under his protection, eventually adopting him as his son. The two painted together in the province of Averyon and along the Atlantic coast. In these early years Brascassat supported himself by painting portraits.

In 1824 Brascassat went to Paris, enrolled in the studio of the history painter Hersent, and entered the competition for the Prix de Rome for historical landscape painting. Surprisingly, considering his relative lack of academic training, he placed second in the contest of 1825 (André Giroux placed first). This showing gained the attention of the duchesse de Berry, who arranged for King Charles X to award him a five-year pension at the French Academy in Rome. There he was particularly close to the landscape painter Léon Fleury, himself a friend and outdoor painting-companion of Corot. From Italy in 1827 Brascassat sent to the Salon a historical landscape painting representing Mercury and Argus, for which he received a second-class medal, and several Italian views.

Having returned to Paris in 1830, Brascassat submitted six landscapes to the Salon, including *Landscape with Animals*, for which he received a first-class medal and considerable public praise. Henceforth Brascassat specialized in animal subjects, while continuing to paint landscapes with figures or picturesque sites. In 1846 he was elected to the Institut de France, taking up the chair in landscape left vacant by the death of Jean-Joseph-Xavier Bidauld.

Brascassat's eventual dedication to the animal genre might not be counted a tremendous loss to landscape painting. His finished landscapes generally seem compromised by a heavy, insensitive execution. Nevertheless, his Italian oil studies, less ambitious perhaps than those of Corot or Théodore Caruelle d'Aligny, are yet exemplary, marked by clear colors and a confident, attractive, and fluid execution. JS

Literature

Marionneux 1872; Miquel 1975.

111

View of Marino, Morning

1826
oil on canvas
43 × 59 (16¹⁵⁄₁₆ × 23¼)

Musée des Beaux-Arts, Orléans

Marino, a town twenty-four kilometers southeast of Rome in the Alban Hills, figures in a number of oil studies painted by Corot. Several of those, like this view by Brascassat, look up at the town from the valley below, emphasizing the cubic volumes of the vernacular architecture as they stand out against the southern sky. *View of Marino, Morning* may be a study for a painting of the same title that Brascassat exhibited at the 1827 Salon. The Salon version, which failed to sell, was destroyed in a fire in 1855. However, the relatively highly finished character of this study suggests it may have been completed in the studio, a common practice of the open-air painters.

JOSEPH MALLORD WILLIAM TURNER
British, 1775–1851

From humble beginnings Turner rose to become one of the greatest landscape painters of the nineteenth century. Admitted to the Royal Academy Schools in 1789, he began as a landscape draftsman and watercolorist, exhibiting for the first time in 1790. Throughout his career Turner was a voracious student of nature, making thousands of drawings and filling hundreds of sketchbooks. He exhibited his first oil painting in 1796. In 1802 he took advantage of the brief Peace of Amiens during the Napoleonic wars to visit Paris to see the great art collections assembled by Napoleon. He traveled as far as the Swiss Alps, the landscape of which provided him with subjects for many years. With the end of hostilities he was able to travel often to the Continent from 1817 onward. He made his first trip to Italy in 1819–1820, visiting especially Rome, but also going as far south as Naples and north to Venice. He returned to Rome in 1828–1829. He made many visits to France, Germany, and Switzerland, and two more trips to Venice in 1833 and 1840. In addition to his continental tours, Turner made annual trips throughout England, Scotland, and Wales.

His output in drawings, watercolors, and oil paintings was prodigious and embraced every kind of landscape, from the slightest pencil sketch to ambitious historical landscapes with literary and philosophical overtones. He exhibited regularly at the Royal Academy. In this vast production, painting in oils from nature had only a very small part. During the second decade of the century Turner painted two groups of works in the open air, probably working from a boat on the Thames: eighteen sketches on mahogany veneer panels and seventeen large oils on canvas.[1] But painting out-of-doors was contrary to his usual working methods. Turner had a highly developed visual memory and preferred to work from slight pencil sketches and hasty notations made with broadly handled watercolor. The son of Turner's friend the architect John Soane, who was with the artist in Italy in 1819, wrote home to his father:

> Turner is in the neighbourhood of Naples making rough pencil sketches to the astonishment of the Fashionables, who wonder what use these rough drafts can be—simple souls! At Rome a sucking blade of the brush made the request of going out with pig Turner to colour—he grunted for answer that it would take up too much time to colour in the open air—he could make 15 or 16 pencil sketches to one coloured, and then grunted his way home.[2]

On this Italian trip in 1819 Turner noted in a sketchbook the names of more than a score of foreign landscape painters he encountered, including in the present exhibition Johann Martin von Rohden, Franz Catel, and Achille-Etna Michallon.[3] PC

Notes

1. Butlin and Joll 1984, 120–123, nos. 177–194; 115–120, nos. 160–176; and see Brown 1991, 19–20, for a recent discussion of Turner's oil sketches on the Thames.
2. Bolton 1927, 284–285.
3. Gage 1969, 245–246, citing the list of names in the 1819 Roman sketchbook in the Tate Gallery, London, Turner Bequest CXCIII, fol. 99.

Literature

Butlin and Joll 1984.

112

*Hill Town on the Edge of
the Campagna*

1828?
oil on millboard
41 × 59.4 (16⅛ × 23⅜)

Tate Gallery, London. Bequeathed by
the artist, 1856

This is one of a small group of oil
sketches on millboard which seem to
show landscapes of Rome and Naples.[1]
Usually dated to Turner's second visit
to Italy, in 1828–1829, they could also
have been executed during his first trip
in 1819. *Hill Town on the Edge of the
Campagna* has been compared with
drawings and watercolors done on the
earlier visit.[2] Turner is not concerned
with the particularities of nature here,
but with broad effects of light and
shade and aerial perspective, which are
rendered in broad bands of delicately
modulated hues, as in some of his
watercolor studies. If this modest but
exquisitely tonal painting was indeed
made in Italy, it recalls Sandrart's
descriptions of Claude's atmospheric
studies, "fading away towards the
horizon and the sky."[3]

Notes

1. Butlin and Joll 1984, 179–181, nos. 318–327.
2. See Butlin and Joll 1975, no. 471; and Butlin and
Joll 1984, 180, no. 318.
3. See the essay by Philip Conisbee in this
catalogue, 32–34; and Brown 1991, 57, no. 35.

CARL BLECHEN
German, 1798-1840

In 1815, at the age of seventeen, Blechen moved to Berlin from his native town of Cottbus to take a job in a bank. His family was unable to support him in a professional education, though he had received local encouragement to pursue his interest in drawing, which he continued to do on his own. After five years, during which time he completed a year of military service, he enrolled in a landscape class at the Academy, and decided to risk the insecurity of an artistic career. In 1823, he visited Johan Christian Dahl in Dresden, where he was able to see the landscapes of Caspar David Friedrich, as well as Dahl's oil studies from Italy and around Dresden, and to gain a fuller conception of painting from nature.

In 1824, Karl Friedrich Schinkel—whose own drawings from Italy Blechen would have seen, as well as the oil studies by Heinrich Reinhold that Schinkel had bought in Italy—recommended him for a job as a scene painter at the royal municipal theater in Berlin. By the end of 1828 he was able to go to Italy in pursuit of his own aesthetic goals, a liberty he had not known until then. In Rome he lived in the same building as Joseph Anton Koch and Johann Christian Reinhart, but he never studied with them. More important was the community of landscape painters of his own generation, for whom the sites of Italy had become the place to learn, not as classical norms but modern realities, expressed in the experience of rendering landscape through the immediacy of light and color.[1]

In the month of his arrival, December 1828, J. M. W. Turner was in Rome exhibiting landscapes; Blechen must have been struck by their power to convey the intensity of light. For the first six months of 1829 he worked in Rome, with trips to Tivoli and Subiaco and to the Alban Hills; the summer months were spent in and around Naples, especially in Amalfi. He worked constantly, filling sketchbooks with drawings and making watercolors and wash drawings, pure studies in the brilliance of light on form. He also made many small oil studies, often creating space and light with a bold minimum of form. His own report of his trip reads like a marathon of satisfied activity; he returned in September of 1829 only because his money ran out.[2]

In his subsequent work, Blechen was the first of the German artists to use his Italian studies and especially his Italian experience. He continued to work directly from the contemporary urban scene as well as in the landscape, and he made exhibition pictures that had the qualities of direct perception found in his oil studies. But these qualities of real experience were not marketable, and though Blechen had a position as professor of landscape at the Academy, and though his work was admired by connoisseurs, he became subject to depressions in the later 1830s from which he never recovered. SF

Notes

1. See Peter-Klaus Schuster, "Vielfalt und Brüche," in Berlin 1990, 15-16.
2. Berlin 1990, 293-297.

Literature

Berlin 1990; Krieger et al. 1986.

113

The Studio of the Sculptor Rudolf
Schadow in Rome

c. 1829
oil on cardboard
21.5 × 30.5 (8⁷⁄₁₆ × 12)

Kunsthalle Bremen

This studio on the Via delle Quattro Fontane, not far from Blechen's lodgings, had belonged to Rudolf Schadow, son of the renowned Berlin sculptor Johann Gottfried Schadow and elder brother of the painter Wilhelm Schadow. Schadow was born and made his career in Rome, but died young in 1822. In 1829 the studio was occupied by Emil Wolff, whom Blechen mentions in his memoirs as one of the sculptors, along with Bertel Thorvaldsen, whose studios he had visited in Rome.

The work is a freely painted, direct view of the studio courtyard, the principal feature of which is a typical Roman arbor with climbing vines. In its immediacy and quality of framing an everyday experience it is akin to a small painting he made after his return to Berlin, depicting the view from his window over roofs and gardens.[1] Blechen sold the Roman study to Johann Gottfried Schadow early in 1830. It has been suggested on the basis of perceived symbolic features that the study may have been

made later, early in 1830, as an intended memorial to Rudolf Schadow.[2]

Notes

1. *View of Roofs and Gardens*, reproduced in Berlin 1990, no. 68.
2. Berlin 1990, no. 36.

114

*Bad Weather in the
Roman Campagna*

c. 1829
oil on paper
27.5 × 44.5 ($10^{13}/_{16}$ × $17^{1}/_{2}$)

Staatliche Museen zu Berlin,
Nationalgalerie. On loan from the
Bundesrepublik Deutschland

This impressive image of a rainstorm moving across the Campagna is similar in spirit to Blechen's smaller, more informal studies of the changing effects of light and clouds. A small work in Bremen shows the same motif of the contrast between dark clouds above and bright sunlight on the ground. The unusually large size and higher degree of finish in this work might be accounted for in one of two ways. In his memoirs, Blechen refers to the fact that after a lot of outdoor work, the landscape painters would spend time at home making their works more finished.[1] Thus, he may have tried a larger format, found it too difficult to handle, and finished it back at his lodgings. Or, he may have painted it after his return; he is known to have used his drawings and studies to make studio pictures that retained the freshness and realism of the site. Indeed, it was a source of painful disappointment to him to discover that the public in Berlin did not like this kind of realism, preferring in paintings of Italy the well-known monuments and tourist sights to the barren Campagna or an anonymous corner of a park.

The attribution to Blechen has been questioned,[2] largely on the basis of size and degree of finish, but the picture has also been published fairly widely by the Nationalgalerie in recent times under his name.

Notes

1. Berlin 1990, 294.
2. Berlin 1990, 109.